LIGHTS, CAMERA,
CAPTURE

Creative Lighting Techniques for Digital Photographers

BOB DAVIS

WILEY

Lights, Camera, Capture: Creative Lighting Techniques for Digital Photographers

Published by

Wiley Publishing, Inc.

10475 Crosspoint Boulevard

Indianapolis, IN 46256

www.wiley.com

Copyright © 2010 by Wiley Publishing, Inc., Indianapolis, Indiana

Published simultaneously in Canada

ISBN: 978-0-470-54953-7

Manufactured in the United States of America

10 9 8 7 6 5 4 3 2 1

For general information on our other products and services or to obtain technical support, please contact our Customer Care Department within the U.S. at (877) 762-2974, outside the U.S. at (317) 572-3993 or fax (317) 572-4002.

Wiley also publishes its books in a variety of electronic formats. Some content that appears in print may not be available in electronic books.

Library of Congress Control Number: 2009940876

About the Author

Bob Davis isn't a newcomer to the photography industry. In fact, he's been a professional photographer for over 25 years. Bob has always been intrigued by photography and felt from an early age that being a photographer was what he wanted to do with his life.

Bob's passion for photography began back in high school when he became the editor of the school newspaper. As he proceeded on to Columbia College, he was honored with the title of College Photographer of the Year. With this honor came a full time job at a daily newspaper in Chicago. This experience launched Bob on to a career at the *Chicago Sun-Times* newspaper for 14 years.

Bob states, "My cameras have always been like a passport allowing me a front seat to history." He feels continually honored when doors open and people invite him in to document their life. While at the paper, he covered countless amazing events, such as presidential elections, Michael Jordan's entire career with the Chicago Bulls, many faiths celebrations and rituals. He's traveled around the world to places such as El Salvador, Taiwan, Lithuania, Romania, Moldova, Kenya, Italy, Tanzania for human interest stories.

Bob has since moved on from the newspaper industry. Today, he has the privilege of photographing the most important events in his client's lives and he couldn't be happier to have this honor. Additionally, he has the pleasure of traveling the world photographing weddings. Bob feels fortunate to have photographed the weddings of Eva Longoria and Tony Parker, Eddie Murphy and Tracey Edmonds, and many others. He also photographs events for Oprah Winfrey.

Bob is a member of Canon's Explorers of Light, a recognized Pro by Westcott and a part of Apple's Aperture Advisory Board.

Photography... It's what he's passionate about.

Credits

Acquisitions Editor
Courtney Allen

Project Editor
Heather Harris

Technical Editor
Brian McLernon

Copy Editor
Heather Harris

Editorial Director
Robyn Siesky

Business Manager
Amy Knies

Senior Marketing Manager
Sandy Smith

Vice President and Executive Group Publisher
Richard Swadley

Vice President and Executive Publisher
Barry Pruett

Media Development Project Manager
Laura Moss

Media Development Assistant Project Manager
Jenny Swisher

Media Development Associate Producer
Shawn Patrick

Acknowledgments

First, I want to thank my wife Dawn Davis for supporting me and encouraging me to follow my dreams and to share in my passion for life. She has blessed my life with 18 wonderful years of marriage and now I have the good fortune to be able to sleep with my business partner. We now share a passion for wedding photography, design, teaching and sharing. Dawn says, "We are all blessed with certain gifts and once we know what those gifts are; they are no longer ours to keep, but pay it forward and share those gifts others." Thank you to our two beautiful children Bobby and Alli, you are the light in my heart. I love my family always and forever, Amen.

I would like to dedicate this book to my father, Robert C. Davis, for fostering my love of photography at an early age. He always had some type of camera, movie 8mm or Super8, still cameras such as, Polaroid's, Kodak Instamatics, Pocket 110 and Disc cameras. It wasn't until later, in my sophomore year of high school when I got my first 35mm SLR film camera and took my first photography darkroom class, that I realized the love affair I would have with photography. I quickly became hooked on the magic of watching an image appear in the developer. Once I learned I could make a living in photography, I knew photography would be my life's work. I want to thank John H. White, Pulitzer Prize winning photojournalist of the *Chicago Sun-Times* who I had the great pleasure to learn from at Columbia College Chicago and later work alongside covering the daily news together as colleagues at the *Chicago Sun-Times*. John H. White always encouraged me to soar on the wings of eagles.

Thank you to all of my friends, family and photo heroes who have helped my reach my goals and fulfilling my dreams of becoming a professional photographer. Thank you to God for blessing me indeed!

To my father, Robert C. Davis, for fostering my love
of photography at an early age.

CONTENTS

...made cap-

...in the most

...to treat their

...minute, often

...hey assume that

...envelop everyone

...a few colleagues

...and whose chil-

...reason I chose these

...er tantrum story with

...ely doesn't include the

...a break at a recent semi-

...arly bursting to compare

...habits, school issues, and

...married women in the

...w lame we are)

...mention

...OUGH LUCK?

...Vectin-SD's functional... ...already backed... ...documenting their abil... ...reduce the appearance... ...marks (prominent be... ...length, discoloration... ...the success of StriVectin... ...cream was "dum... ...Gray, spokesper... ...maker of StriVec... ...first handed out... ...formula to... ...as part of our...

1

Introduction

Lighting is easily the most important aspect of photography. I would even go as far as saying that lighting is photography. It is even in the word itself; "Photography" is Greek for "light drawing" or "drawing with light". Without light, you cannot take photos.

Figure 1-1: As a photographer, your challenge is to use light and absence of light in your favor. Can you see the heart in the photo above? Keep your eyes always ready to spot unique possibilities! This photo was taken with a Canon EOS 5D Mark II, 24-105mm IS lens at 105mm, 1/60 sec, f/5.0 and ISO 200, in Manual exposure mode.

Figure 1-1 was taken with one Canon 580EX II flash, off-camera from the top center pointing towards the lens to create the shadow of the heart in the crease of the book. The flash was set to E-TTL II mode and was triggered via a Canon Speedlite Transmitter ST-E2.

It is perfectly possible to take amazing photographs with a very simple camera - as long as the lighting is good – like in **Figure 1-1**. The corollary is that the opposite is true as well: If you are taking photos in a situation where the lighting is truly appalling, having the fanciest, most expensive camera in the world isn't going to help you capture the photographs you want.

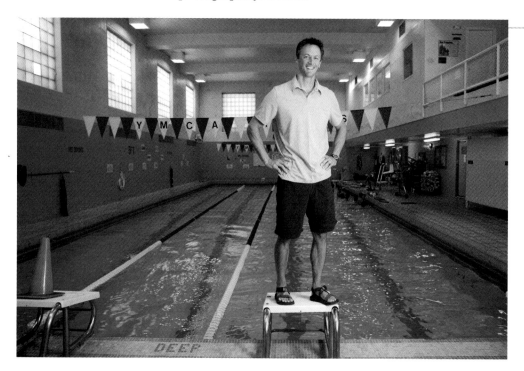

Figure 1-2: Look how natural this photo looks! — The swimming coach stands out, slightly brighter than the rest of the scene, as if a separate beam of light is highlighting him! Photo was taken with a Canon EOS 5D, 24-70mm lens at 24mm, 1/60 sec, f/3.5 and ISO 250, in Manual exposure mode.

Light, like the finest Italian ice cream, comes in many flavors. But, like ice cream, not all flavors play well together. One of the things you'll learn in this book is how to train your eye and also the way you 'see' light. Does that sound difficult? I won't lie to you; it can be a little bit tricky at first, but stick with it. Few things are as satisfying as taking in a location and automatically assessing the scene in your mind.

For example, while on a shoot, you may think, "We can create a dramatic effect by adding a little bit of side-light just over there. And if we take this photo from below, the model will

look like a god among men." See how this thought processed was applied to the swimming coach in **Figure 1-2.**

At first, it'll be conscious. Then, eventually, you'll find yourself making adjustments to your flashes without knowing why — just because you intuitively feel that if you nudge that soft box just a little bit to the left (see **Figure 1-3**), the image will come to life.

One day, you'll take a step back and think, "Wow, this photo came out amazing, and I'm not even sure why." You'll feel like superman, superwoman, or, at least, a super-photographer.

Figure 1-3: The photo looks natural, but the lighting got a little bit of help. Here, you can see how the equipment was set up. Compare this photo with the lighting diagram to start getting a taste for how the diagrams can help you improve your photography.

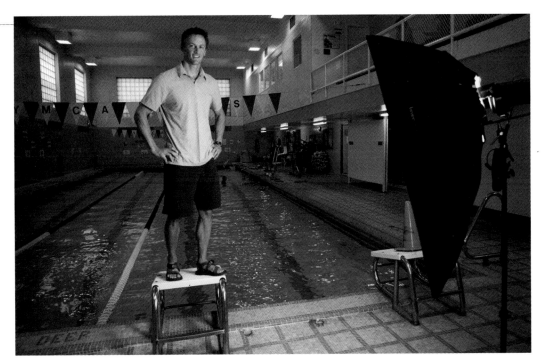

Figure 1-2 was not particularly complicated from a lighting standpoint. You can see what it looks like in **Figure 1-3. Figure 1-2** was taken with a Canon 580EX II flash set to E-TTL II mode, fired through a soft-box to the right of the coach, and triggered using a Canon Speedlite Transmitter ST-E2.

The 'flavors of light' is something we'll get back to extensively in the rest of the book — especially in Chapter 2, "Understanding Light".

TRIGGERING FLASHES

> You will notice that throughout the book we are talking about a variety of ways of triggering flashes. The details can be found in Chapter 4: "Lighting Equipment", but your basic options are this:
>
> - Physical connection between your camera and a flash connected directly to the camera via the hot-shoe or a cable
> - Slave flashes which fire optically in response to a blink of light

Become a seeker of light

To become photographic superheroes, the most important thing we have to do is to learn how to "see the light".

The color of light is essential — and some of the biggest challenges you'll meet in photography are the issues that arise when you start mixing different light sources. Sunlight, for example, has a drastically different color from the light that comes from your flash, the light that comes from car headlights, or the light in your house. While it can be incredibly difficult to get your photos to look "right", light sources of different colors offer an opportunity too. With the right mixture of types and colors of light, you can achieve some beautiful creative effects that will make your photos really 'pop'.

There are other factors that come in to play as well. The distance between light source and your subject affects the final results in ways that can be a little counter-intuitive. The size of a light source is an important factor. A big light source can give beautiful, even illumination, for example. The direction of light - where does it come from, where is it going — and the resulting shadows will also impact your photos. We will discuss these factors more in depth in Chapter 2, "Understanding Light".

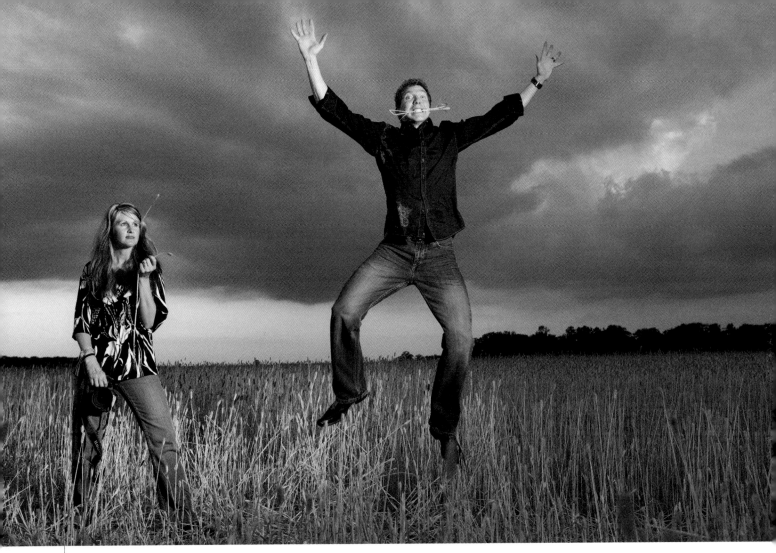

Figure 1-4: Here I'm fooling around in a wheat field – as I say practice, practice, practice! The picture is a great example of how different light sources (in this case, the setting sun and the flashes) can work together to make an appealing photo. Photo was taken with a Canon EOS 5D Mark II, 24-70mm lens at 34mm, 1/320th sec, f/5.0 and ISO 160, in Manual exposure mode.

Figure 1-4 lighting included one off-camera Canon 580EX II flash set to E-TTL II mode triggered using a Canon Speedlite Transmitter ST-E2. Attached to the flash was a Gary Fong Lightsphere.

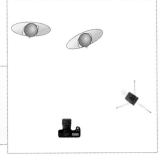

Reading lighting diagrams

Where possible, I'm including lighting diagrams showing how the lights were set up for each photo. To get full benefit from this book, I would recommend you spend a bit of time with each photo, and compare it to the lighting diagrams.

The diagrams are relatively straight forward, and should include all the information you need to recreate the photos. They show the position and direction of the light sources I've used.

While the diagrams will come in very handy in visualizing how I've set up the lights, it is also quite important to keep in mind that not everything is shown in the lighting diagrams. Because they are overhead views, you can't see how high each light is, and in addition you can't see how bright each of the lights is – that's why there are more in-depth descriptions with each of the lighting diagrams. To help you along, I am including as much information as possible about the shutter time, aperture, ISO, camera mode, and flash settings.

Finally, remember that the diagrams and technical information are there to help you get a deeper understanding. I'm not encouraging you to make exact duplicates of the photos in this book. That might be fun as an exercise, but even if you are creating a perfect copy of a photo, you still haven't created anything new.

Being a seeker of light is to learn to compose images in your mind's eye. Creating these before setting out to take the picture is part of the fun. The lighting diagrams are a tool you can use to help develop that 'eye' for photography!

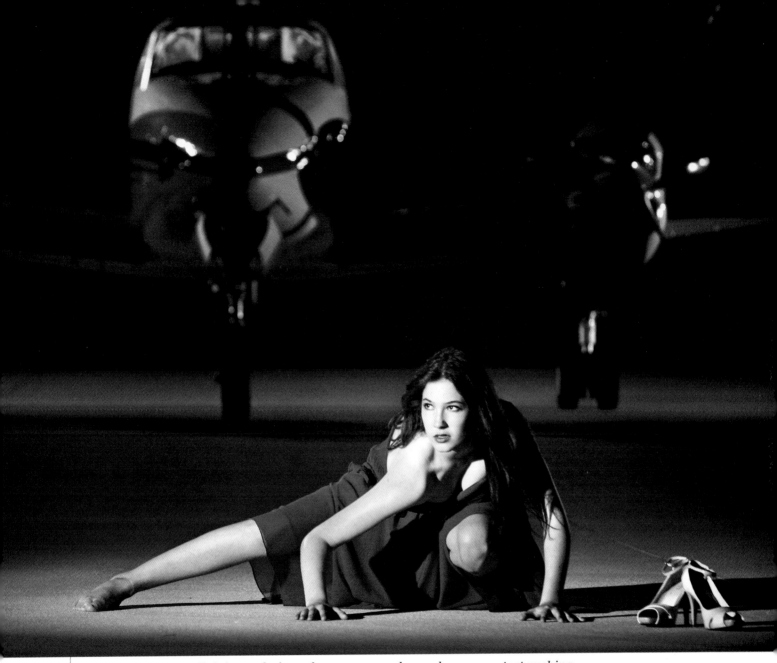

Figure 1-5: *As your lighting techniques become more advanced, you can start pushing the envelope to take some truly astonishing photos. Rest assured, by the time you're finished with this book, you'll be able to shoot scenes like this with your eyes closed! Well, almost... Photo was taken with a Canon EOS 1D Mark III 70-200mm IS lens at 110mm, 1/30th sec, f/4 and ISO 800, in Manual exposure mode.*

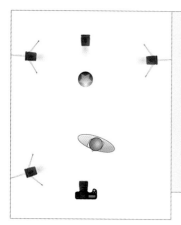

Figure 1-5 looks like a simple shot, but it's anything but I used four strobes to accomplish it. The lighting for **1-5** was with off-camera strobes: a Canon 580EX II inside the cockpit of the airplane in group C, E-TTL II mode, triggered via RadioPopper; two Quantum Q flashes in group B, E-TTL mode, triggered via Radio Popper to light the sides of the aircraft; and one Canon 580EX II Speedlite up high and to left of the model in group A, E-TTL II mode. All the flashes were triggered via a Canon 580EX II Speedlite on-camera set as the Master flash. The Speedlite only acted as a trigger and did not contribute light to the scene. Note the circle in this diagram represents the airplane.

Quality over Quantity

A lot of this book will be talking about the concept of quality over quantity. In most of my work, I only use relatively inexpensive, highly portable light sources, like the flashes you can buy which will fit into the hot-shoe of your camera.

Don't get me wrong, you can see the benefits of working in a studio environment where you are in full command of every single photon of light, with controllable studio strobes that have a light output that would make the sun blush in embarrassment. Having said that, I have to admit that's simply not my shooting style — when you look at the photos in this book, I'm sure you'll agree that the results are an excellent illustration of why.

I'm a firm believer of quality over quantity — it is much nicer to have half a scoop of absolutely divine ice-cream than a bucket of extra value frozen goop from your local supermarket. Or, to skip the ever-so-slightly convoluted comparison: it is more important how strong the light sources are in relation to each other.

Remember that you have control over the exposure of a photograph in your hands. Adjust the ISO, shutter speed and aperture, and you can change your exposure. If you have one light source at full output and one at half output, your photo will have a particular look. However, the quality of your picture could be improved if you have the same scene with lights that are twice as bright. In this scenario your photo will look the same from a lighting perspective, and you will have the luxury of shooting at a lower ISO value, slower shutter speed, or smaller aperture.

This book is all about how you can use relatively simple lighting equipment to create absolutely gorgeous scenes. Your photos will leap out at the observer because they have a show-stopping, jaw-dropping quality to them. Your models will look alive, intense, and at the center of their universe.

Your viewers will never believe you when you tell them how you did it, but that doesn't matter: You're now a photographic superhero, looking for your next maiden in distress and a scoop of mango gelato.

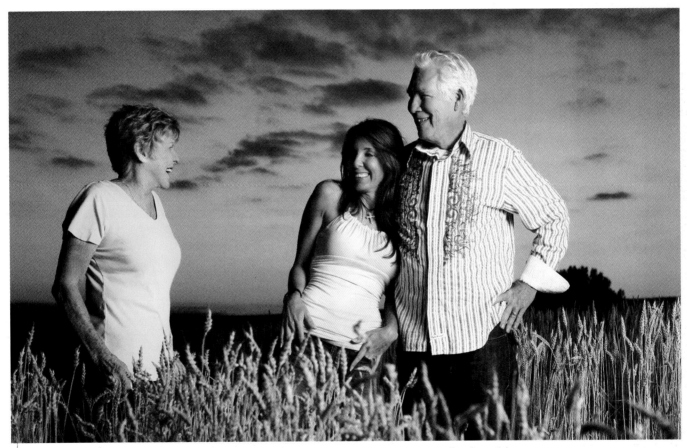

*Figure 1-6: The same setting as in **Figure 1-4**, this image is another example of combining different light sources (once again the setting sun and flashes). The flashes provided an appealing glow on the subjects' skin. Photo was taken with a Canon EOS 5D Mark II, 24-70mm lens at 50mm, 1/160th sec, f/5.6 and ISO 320, in Manual exposure mode.*

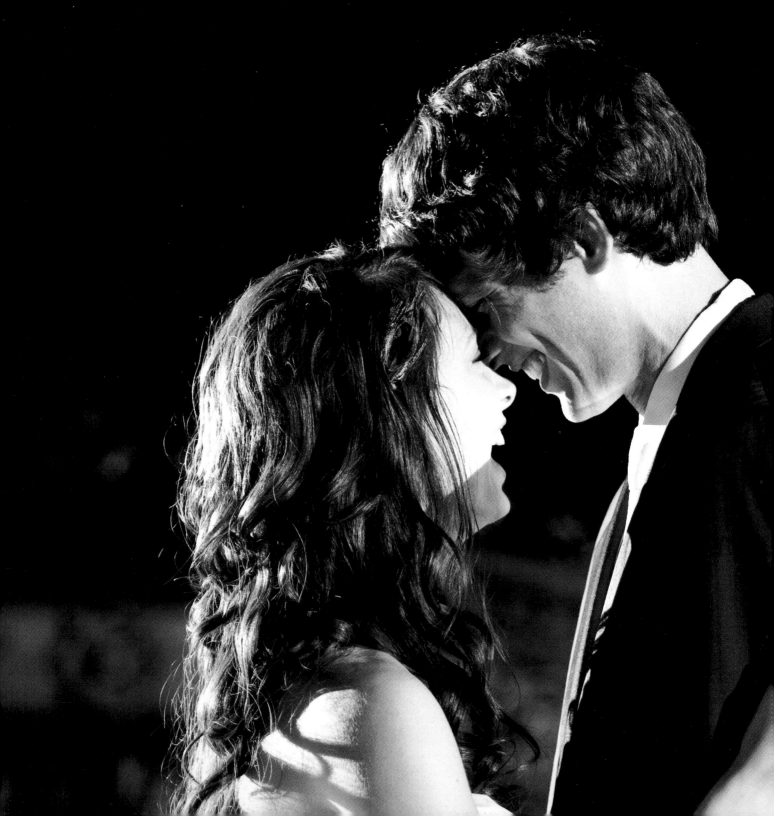

Figure 1-7: Sometimes, you can spend all day trying to get the photo that really hits the spot, and then it happens, as one of the last photos you were planning to take. In this photo, you can just tell how much they are in love — a perfect illustration of the perfect day. This photo was taken with a Canon EOS 1D Mark III, 70-200mm IS lens at 130mm, 1/30 sec, f/2.8 and ISO 1000, in Manual mode. Two Canon 580EX II Speedlites off-camera were triggered by a Canon Speedlite Transmitter ST-E2 with RadioPopper transmitter and receiver.

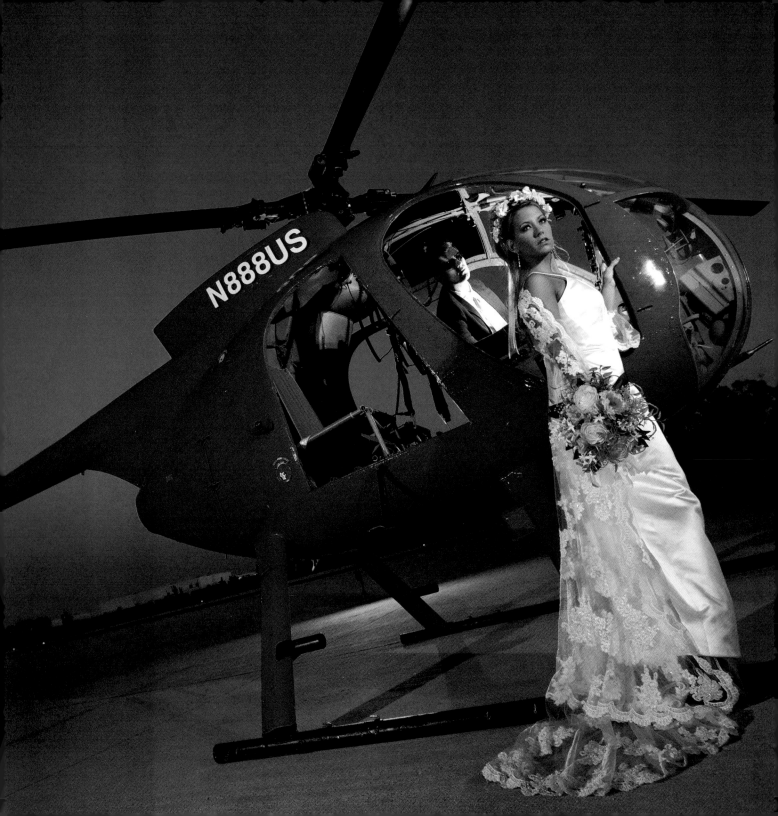

2

UNDERSTANDING LIGHT

LEARNING A NEW SKILL CAN BE A FUNNY PROCESS. Think about the first time you learned to tie your shoe laces, for example. First, someone was tying your shoe laces for you. Then, they showed you how to do it. You may have had a piece of paper, a sentence, or even a song reminding you how to move the laces in the apparently mysterious and intricate pattern that would end in a gorgeous little bow keeping your shoes on your feet. After a while, you notice that you don't need the reminder anymore; put simply, tying your shoes has become something you've learned to do instinctively. Learning to understand the nature of light is the similar. Currently, you need help knowing how to use it to your advantage, but soon this knowledge will become natural impulse.

Figure 2-1: Creating the light in this photo was so much fun. See how the people really seem to leap out of the picture? That's all lighting. This picture was taken with a Canon EOS 5D Mark II, 16-35mm lens at 17mm, 1/125 sec, f/4.0 and ISO 400, in Manual exposure mode.

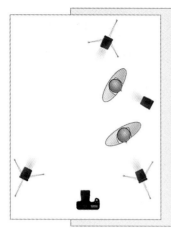

Figure 2-1 was taken with four flashes. Two Quantum Qflash T5D-R with QNexus TTL wireless adapters allowed communication with Canon or Nikon strobes and two Canon 580EX II. All flashes were set to TTL mode, with Gary Fong Lightsphere flash modifiers. All the flashes were triggered via a Canon 580EX II Speedlite on-camera set to be the Master flash, but only as a trigger and not contributing light to the scene, E-TTL II mode, using RadioPopper transmitter and receivers. All flash output was controlled from camera. The Qflashes were in group A lighting the sides of the helicopter The model was lit using one Canon 580EX II with a snoot in group B, with the bulk of the flash output biased to the B group. The cockpit was lit with a 580EX II in group C using a Gary Fong Lightsphere set to -1 stop EV (exposure value).

I am always looking for light, even when I don't have a camera in my hands. It's the most important thing about my style of photography; you have to start looking at the world in a different way. You have to become a seeker of light. Once you've mastered the dark art — or light art, I should say — of being able to identify what light is relevant to the scene you are trying to photograph, it becomes interesting to start thinking about how you can manipulate that light to your advantage. Next, you can start introducing additional light sources to achieve the effect you are aiming for. You can guide the way people see a scene, like I did in **Figure 2-1**, for example, based on the way you have illuminated it.

If you take nothing else away from this book, make it this: Become a seeker of light. Make it your mantra. What light is here? How can I use it? How can I improve it?

Seeing and Knowing Light

You would be surprised how many photographers don't think further away than the single piece of equipment they're holding: the camera. Even more surprising is the reality that lighting is so frequently overlooked. Unfortunately, lighting ignored during the shoot will be glaringly obvious when viewing the resulting weak images.

In order to capture the light, you need to be able to see the light, to be able to predict where the light comes from, where it is going, and what impact a lighting situation has on your scene.

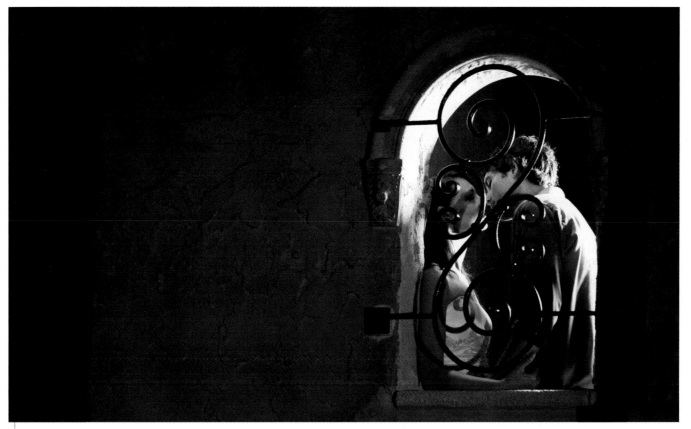

Figure 2-2: A simple touch of light makes this photo. Simple, for sure, but look how effective it is! Photo was taken with a Canon EOS 1D Mark III, 70-200mm IS lens at 150mm, 1/25 sec, f/3.5 and ISO 1000, in Manual exposure mode, automatic white balance.

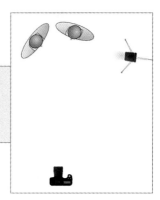

Figure 2-2 was lit using a very simple set up. I used one off-camera Canon 580EX II flash set to E-TTL II mode, with a Gary Fong Lightsphere, triggered using a Canon Speedlite Transmitter ST-E2 with RadioPopper transmitter and receiver.

Chapter 4, "Lighting Equipment" will provide more information about equipment options.

It may be useful to see lighting as something you build upon layer upon layer. As a base, you have available light. From here, you can start building beautiful lightscapes. Through

the use of diffusers and reflectors you can, of course, manipulate and adjust available light to your heart's content; this becomes your second layer. Then your flashes can contribute an additional layer to the scene. Don't worry about over thinking things. Sometimes, the simplest set-ups make fantastic photos – just check out **Figure 2-2** to see what I mean!

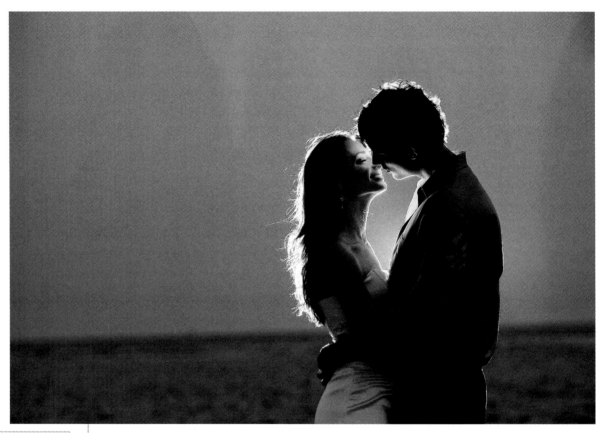

Figure 2-3: A single light behind this couple was all it took, but doesn't it look awesome? Photo taken with a Canon EOS 1D Mark III and a 70-200mm IS lens at 100mm, 1/125 sec, f/3.5 and ISO 160, in Manual exposure mode.

Figure 2-3 was taken with one off-camera Canon 580EX II flash set to E-TTL II mode, with +2/3rd flash exposure compensation, direct bare flash with the flash manual zoomed into 50mm to focus the light on the subjects. Again here we triggered the flash using a Canon Speedlite Transmitter ST-E2 with Radio Popper transmitter and receivers.

There are many ways you can use your on-camera flash to improve the lighting. It can be used as a fill flash to lift shadows in your model's face on a sunny day, for example. You can bounce it or add a light modifier such as a Gary Fong Lightsphere. From here, you can go many different ways: Use a single, carefully positioned Speedlite (like in **Figure 2-3**), use two or three flash setup, or use multiple wireless flashes to add depth and dimensionality to your lighting if that's what the scene demands.

In much of my work, I'm thinking primarily about the quality of my light, rather than about how much of it I have available.

Quality over Quantity

The current generation of digital cameras is nothing short of incredible. If your lighting is decent, you can use most of the ISO range of your camera and get fantastic results. A side-effect of being able to shoot at faster ISO values is that you no longer need to use full-size studio lighting to get extraordinary pictures. Put simply, you need a lot less light than you might think to achieve the results you're gunning for.

Try to think less about how much light you think you need and more what you are trying to achieve. To use light effectively, try to envision the scene you're hoping to capture, assess what light is available, and from there work backwards.

TIP:

As I'm discussing in further depth in Chapter 3, modern cameras can take photos at higher ISOs than you might be used to, especially in scenes well-lit with Speedlites. Using different lighting setups, take multiple shots of the same scene increasing the ISO with each picture. See how high you can go. Try it out, you might be surprised.

Your thought process might be: "My goal with this shot is for the car (in **Figure 2-4**) to be a key part of the image, but it's bright red, and I don't want it to dominate the image completely, as the model is more important." That is a great goal! Nowhere in it does it say anything about how much light you want on each element as an absolute value — but you do have an order of importance: The model is priority, meanwhile the car has to be featured,

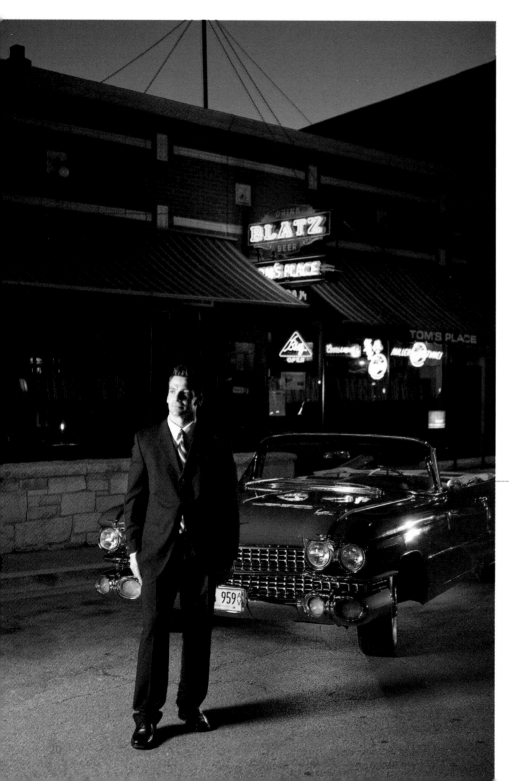

but blend into the background despite being cherry-apple-red.

Instead of worrying about quantity ("Do I have enough light?"), you're thinking quality ("Where do I need the light I have available?"). Suddenly, it isn't the overall amount of light which is important, but the amounts of light relative to each other. You want more light on the person than on the car. Once you have made that decision, yeah, you guessed it: you've started seeking your light and you've taken an important step towards building your photograph.

Now that we agree that it's all about quality, let's take a look at what determines its excellence!

Figure 2-4: I felt it best here to high-light the person rather than the car. Lighting the car might have made it stand out too much due to its bright color, so I decided to get creative. A Speedlite underneath the car, with a red gel to accent the color of the car, provided a creative touch. Photo was taken with a Canon EOS 5D Mark II, 24-70mm lens at 46mm, 1/50 sec, f/3.2 and ISO 50, in Manual exposure mode.

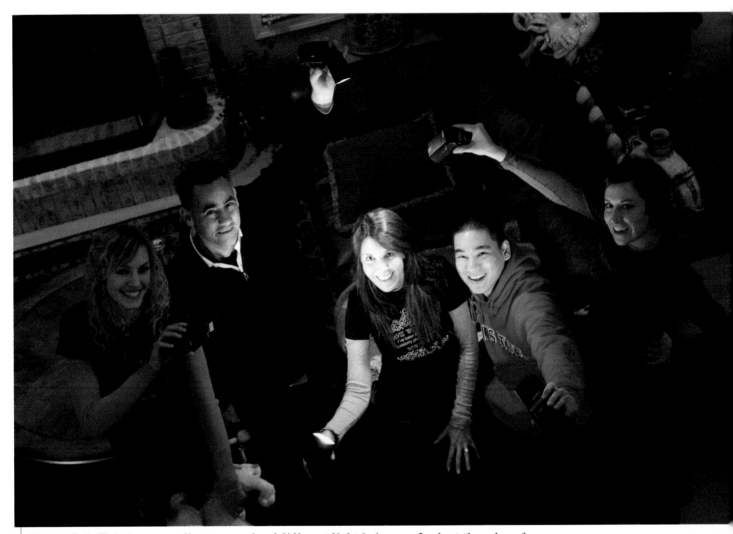

Figure 2-5: This is an excellent example of different light balances: Look at the color of the background compared to the color of light provided by the Speedlites. Photo was taken with a Canon EOS 1D Mark III, a 50mm lens, 1/15 sec, f/4 and ISO 800, in Manual exposure mode. Lighting was done by five Canon Speedlites in E-TTL II mode triggered with a Canon Speedlite Transmitter ST-E2.

Color temperature

When we are talking about photography, the concept of "white" immediately becomes bafflingly complicated.

In normal life, we don't really have to worry about what color our light is. The human eye is very good at adjusting to what "white" is because our brain is constantly comparing all the aspects of the light we have in front of us, so we perceive a particular color as 'perfect white'.

A camera is really just a pretty simple machine. At the core of it, there's an imaging sensor, which is built up of thousands upon thousands of tiny little light sensors. These sensors don't have any intelligence; they'll measure how much red, green, and blue light is in a scene. Based on that measurement, it will put together an image file for us. The challenge is that light our eye perceives as "white" might, to the camera, appear to have a relatively strong color cast.

"Cold" light, for example, makes your scene look blue. "Warm" light introduces a reddish tone. In **Figure 2-5**, you can see that the background has a warm color cast due to the house lights being Tungsten in the kelvin range of 3000 degrees.

The 'temperature' of light — known as the 'color temperature' is measured in kelvin. This is a scale works unfortunately the opposite way as you would expect. Normally, we say that red is 'hot', and blue is 'cold', but on the Kelvin scale, the higher the temperature, the bluer the tone. Why?

— 20000 K Cloudless Sky

— 10000 K Cloudy Sky

— 6500 K Sun at Noon
— 3100 Incandescent Lamp
— 1800 K Sun at Sunrise

Figure 2-6 represents the Kelvin scale. Note that reddish tones (which we tend to call 'warm colors') are actually at the cold end of the Kelvin scale, while bluish tones (which we tend to call 'cold colors') are on the hot end of the Kelvin scale.

Take a look at **Figure 2-6**. The scale is based on the color of a piece of perfectly black metal warmed on a burner. If you've ever held a needle over a lighter, you've seen it change color. First, it turns black (because of the soot). Then it changes to red hot. If you continue

making it warmer, it goes 'white hot', and eventually it turns 'blue with heat'. The kelvin scale, then, works as follows: If the light in a room appears to be the same color of a piece of metal heated to 3000°, we say that the light is "3000 K" — which is a reddish hue. Daylight is around 5500 K and colder light is even higher up on the scale.

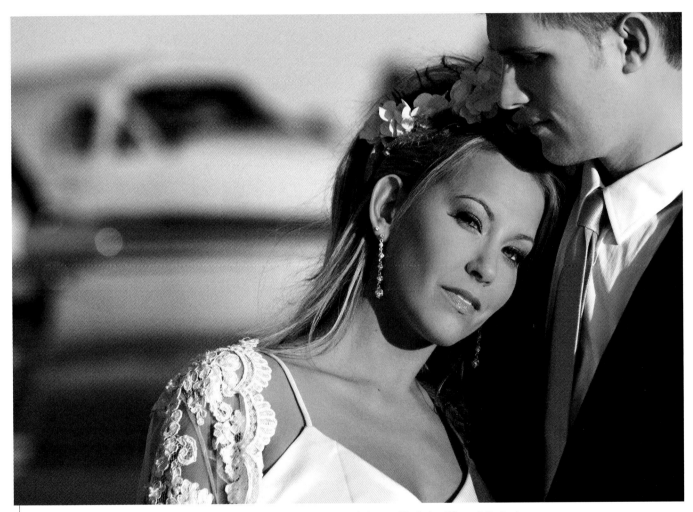

Figure 2-7: See here the combination of using the natural light and kelvin. The white balance is set for the foreground, which is how the people in the picture look 'warmer' than the background. This can be used creatively and create a warm, friendly atmosphere. Photo was taken with a Canon EOS 1D Mark III, 70-200mm IS lens at 145mm, 1/320 sec, f/4.5 and ISO 200, in Manual exposure mode.

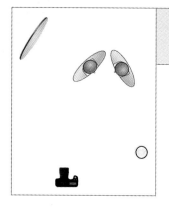

Figure 2-7 was taken with a good old fashioned sunlight and reflector at sunset, but using kelvin settings in my camera to warm up the subjects.

White balance

Color temperature becomes important when we're taking photos because we generally prefer photos to be relatively neutral. It means that the grays look gray, and humans look, well, human-colored.

In your camera, you can select the kelvin temperature of light directly, but there are many other ways to select color balance. Your camera probably has a series of color balances built in as standard settings. These are usually flash, sunlight, cloudy, shade, tungsten lighting, and fluorescent lighting, and possibly a few others too. Your camera will also have manual white balance, where you can set the white balance based on a reference point.

TIP: ————————————————————————
To find out how to select a kelvin color temperature on your specific equipment, check your camera manual.

To set your manual white balance, set your lighting up the way you want it and take a photo of a gray card. You can then set this photo to be your reference photo and all subsequent photos will be adjusted to reflect this reference photo. To get a pure color, it is a good idea to slightly de-focus your camera; it gives the camera a simpler color to work from.

Here it is sunlight and a reflector. Let's add another example since we have it to show the power of creating the light you want, even after the sun has set.

Figure 2-7: This picture was a fun challenge. As you can see, the people are rather well separated from the background. It's all done using lighting! Picture was taken with Canon EOS 5D Mark II, 16-35mm lens at 17mm, 1/640 sec, f/4.0 and ISO 200, in Manual exposure mode, auto white balance.

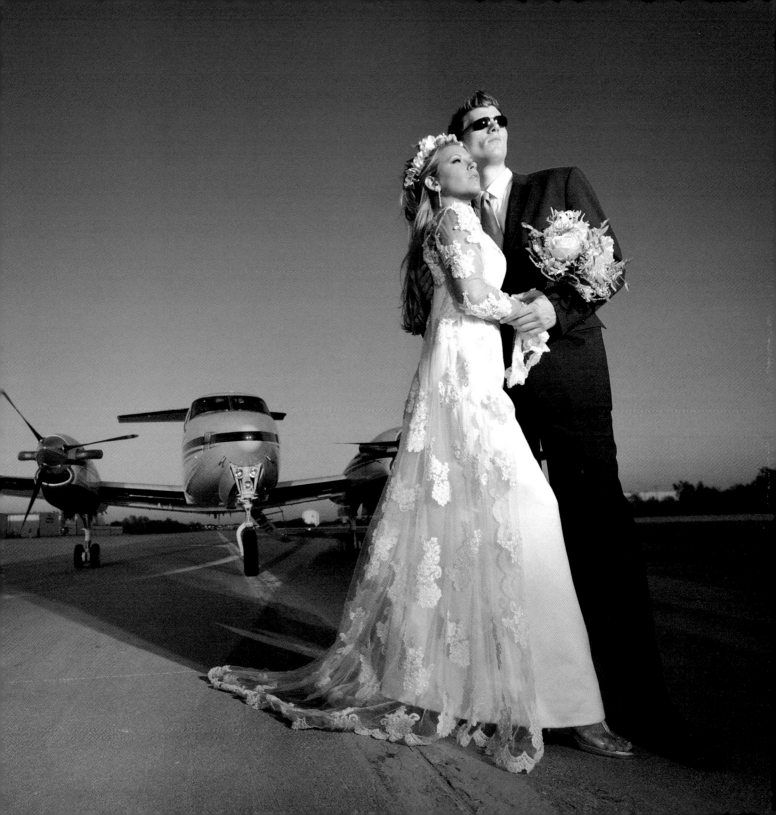

Figure 2-7 was taken with one off-camera Canon 580 EX II flash set to E-TTL II mode, high speed flash sync, with a full CTO filter over the flash to warm the flash like a late afternoon sunset, no light modifier just bare flash, the flash head was manually zoomed to 70mm to create a natural vignette, triggered using a Canon Speedlite Transmitter ST-E2 with RadioPopper transmitter and receiver.

Finally, your camera will also have an automatic white balance setting, which is usually surprisingly good.

TIP:

Get your photos as perfect as possible straight out of the camera, so you spend as little time as possible in the digital darkroom. Most issues you run into in the darkroom are better solved at the photo-taking stage.

It's important to note that white balance adjustments only affect JPGs saved by your camera. If you're shooting in RAW, the white balance will affect the way the image is shown initially, but all the data captured by your imaging chip will be saved, and you can make your white balance adjustments at a later date. That being said, it's always a better idea to get your white balance as perfect as you can when you originally take the photo and before the editing process begins.

Both Canon and Nikon cameras offer the option of choosing white balance bracketing. What this feature does is that it takes a single photo, and processes the JPGs slightly differently, saving multiple files with different white balance settings for each file. This helps you to 'hedge your bets' against your white balance being off.

Canon's cameras, for example, tend to run a little bit hot (i.e. have a reddish cast on the photos), so a I frequently shoot with four points of blue added in as a global setting. Everything is cooled it off by four points of blue, giving a more natural look right out of the camera. Check your camera manual for more information about how to set up white balance bracketing.

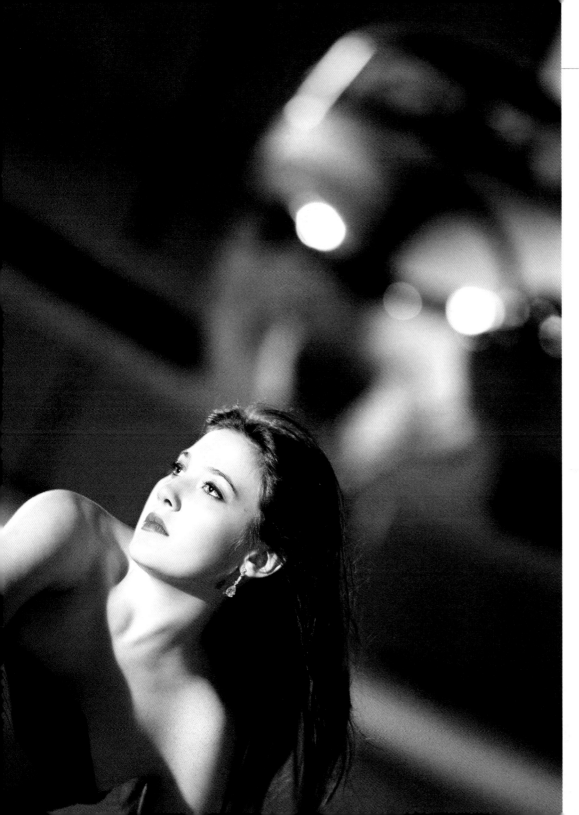

Figure 2-8: When the foreground is brightly lit, the background seems to fade into insignificance. In this case, of course, the shallow depth of field also helped. Photo was taken with a Canon EOS 1D Mark III Camera, 70-200mm IS lens at 200mm, 1/30 sec, f/3.2 and ISO 800, in Manual exposure mode.

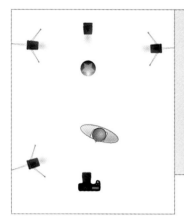

Figure 2-8: Mixing light sources creates beautiful effects. Four off-camera strobes were used to accomplish this gorgeous shot. A Canon 580EX II inside the cockpit of the airplane in group C, E-TTL II mode, triggered via RadioPopper; two Quantum Q flashes in group B, E-TTL mode, triggered via RadioPopper; and one Canon 580EX II Speedlite up high and to left of the model in group A, E-TTL II mode. All the flashes were triggered with a Canon 580EX II Speedlite on-camera set as the master flash. The Speedlite only acted as a trigger and did not contribute light to the scene. Note the ball in the lighting grid represents the airplane.

Mixed light sources

If we put this much time into getting the color temperature right for one light source, it'll come as no surprise that it becomes even more involved as we start adding multiple light sources — of different types, no less.

You may find yourself shooting a concert indoors at a venue, for example, which has a series of tungsten lights, which are really reddish. The color temperature of a Tungsten lights is around 3200 K — which is actually the temperature the filament burns — 3200 K. In addition, the band may have installed some LED light rigs in one corner, which are notoriously tricky, because the color saturation is unusual if the color is bright. Even when it is white light, it can wreak havoc by giving unexpected results because they don't dim evenly. Then you may have some halogen lights in another part of the room. Finally, you have your flash lights.

It's a proper challenge, compounded by the fact that you have to choose one light source to balance for. You can add gels to your flash lights to make them warmer or colder, but often you only have one option: Light your subject as best as possible and live with the strange color balances in the background.

Having said that, you can often get some very creative effects (see Figures **2-5** and **2-7**, for example) by just letting the background lights do their thing and concentrate on your foreground. This situation can occur in all sorts of lighting situations, of course, but it happens most frequently at or after nightfall, when you run into a greater variety of

lighting sources. The great thing is that if your camera is balanced to your flashes (which generally are balanced to be roughly the same as daylight), your background will come out very warm — which often is a pleasing photographic effect.

You can, of course, ensure that your foreground is lit more than the background. In **2-8**, for example, the background seems to be relatively darker than your foreground, which reduces the effect of the disparity in color balance

Working with natural light

Natural lighting is simply the light you have available to you without adding light sources. It's all good and well to start unpacking dozens of lights out of the back of your car, but if you want to be a good location photographer, you have to work with — not against — the natural light.

So, what is natural light? You might be taking photos in a garden. The dappled sunshine which comes through the trees? That's natural light. What about the light reflecting off a building on the other side? Natural light. Or you may be inside a building (or, like in **Figure 2-9**, a car), and light is spilling through a window. Again, that's natural light.

For the purposes of setting up for a photo shoot, don't forget that it's not just the sun that offers 'natural' light. Street lights, stage lights and any lights at your location are, for our purposes, 'natural light'.

Manipulating natural light

There are so many things you can do to manipulate natural light. If light that's spilling in through a window from a street light outside has a detrimental effect on your photo shoot, dealing with it is quite easy: Break out a garbage bag and your trusty duct tape, and cover the window up. Remember that you can block light at several places. You can block the window, of course, but if you want to feature the window, get a ladder, and block the street light at source: Taping a piece of cardboard to the side of the street light might be all it

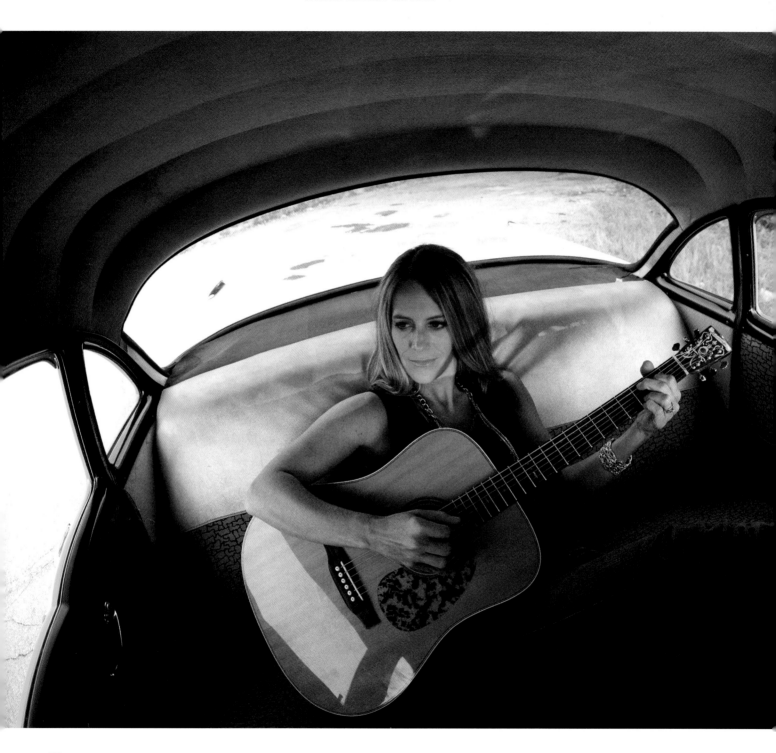

takes to stop the light from falling in through the glass. If you do need some light, you can always consider lighting the scene separately, from the outside.

You can block out the sun as well, but, depending on the situation, that can be trickier. Some photographers use enormous light tents (or a large gazebo) to manipulate sunlight, but there are other solutions, too. You can buy a diffuser with a stand which can be used both as a reflector or a diffuser. Diffused sunlight gives a nice, even light without the harsh shadows characteristic of sunlight.

If you want to block it out altogether, using black paper or fabric can help take the edge off the sun. If you're a location photographer, then the size of the tent you need to manipulate the sun can be prohibitive. In that case, it might be better to move the shoot to an overcast day. You might want to move the shoot to another location, or wait until the sun moves along to a more suitable part of the sky. In any case, when working on location, it is a good idea to scout the location to get a feel for the place ahead of time.

You can read more about reflectors and diffusers in Chapter 4, "Lighting Equipment" which discusses lighting equipment in greater detail.

Figure 2-9: *This picture is all done with natural available light. The only modification I made was to have an assistant use a warm reflector to bounce some light into the car. Photo was taken with a Canon EOS 5D Mark II , 15mm f/2.8 fisheye lens at 1/60 sec, f/4.5 and ISO 400, in Manual exposure mode.*

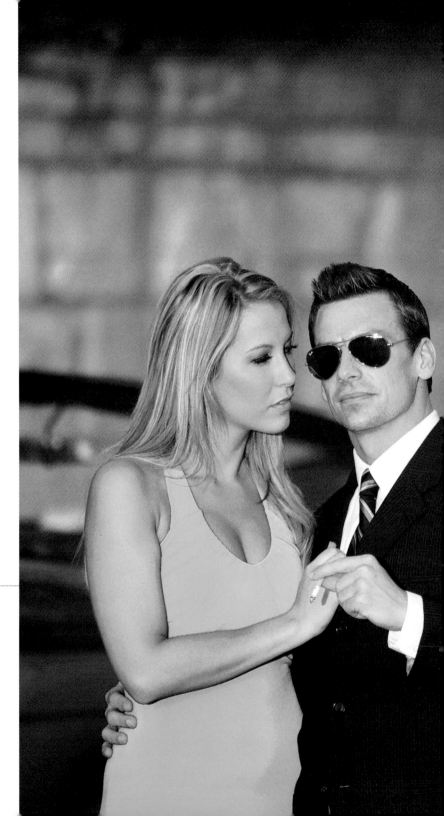

Figure 2-11: Using the Golden Hour to its full effect can give absolutely fantastic results. Photo was taken with a Canon EOS 1D Mark III, 70-200mm IS lens at 200mm, 1/500 sec, f/3.2 and ISO 320, in Aperture Priority exposure mode.

I have already mentioned a diffuser in passing. Basically, what a diffuser does is give the illusion that a light source is much bigger than it is in physical size. Light that comes from a relatively small point (like a portable flash, the sun, or a light bulb) is extremely directional, which can give harsh shadows. To avoid this, use a diffuser such a large piece of fabric or plastic which is spanned across a frame. When light shines through the diffuser, it significantly softens it, creating light which often is much more flattering for people featured in your photographs.

The reason why a diffuser gives flattering light is essentially the same reason why your photos tend to come out better on overcast days than in full, direct sunlight. A thin layer of clouds between you and the sun give the same effect as an enormous diffuser; instead of coming from one very bright and concentrated light source, the clouds disperse the sunlight, creating stunning, soft light which tends to make people look much better than direct sunlight.

In addition to blocking or diffusing light, you can reflect it, using a reflector. Reflectors come in a large series of colors, shapes and sizes, but they are usually white, silver or gold. Whereas a diffuser goes between the light source and your subject, a reflector is used to reflect (or 'bounce') light back onto your subject.

If you need to photograph a person in full sunlight, for example, you can either use a diffuser to make the light softer, a reflector to 'lift the shadows' on the dark side of your model, or a combination of both.

The golden hour

The Golden Hour is often quite difficult to use in portraiture, if you get it right, you can get some truly incredible results. Depending on where you are in the world, the golden hour can last anything from a few minutes up to about an hour, and happens just after sunrise, or just before sunset. During this period, sunlight becomes warmer (i.e. more red) and softer than usual, and it can look as if whole landscape are swathed in a gorgeous golden glow: hence 'Golden Hour'.

Because the light is constantly changing at this time of the day, it can be a challenge to utilize it to its full effect. With a bit of planning, however, and careful use of additional

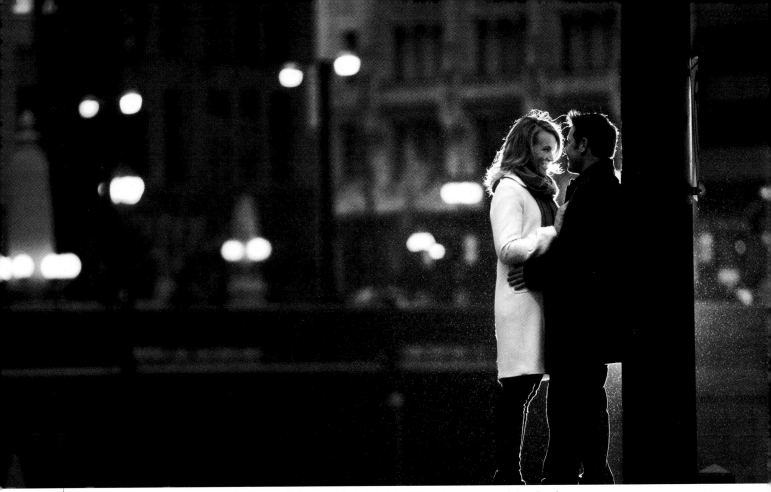

Figure 2-12: Using the streetlights and the artificial light of the city along with a backlight created this dramatic image. The light outlining the couple makes this image magical. This photo was taken with a Canon EOS 1D Mark IV, 70-200mm IS lens at 200mm, 1/500 sec, f/2.8 and ISO 500, in Manual exposure mode.

lighting, you can achieve some truly glorious effects, like the glorious portraits of the couples in Figures **2-7** and **2-11**.

The golden sheen which happens during this time is often very complimentary to people. It is naturally less harsh than sunlight and the warm light brings out the color in people's skin and eyes in a unique way. Of course, it is a very specific look, and you may find it doesn't work for you, but it can't harm to experiment with it to find out. If nothing else, photographing during the Golden Hour is a serious challenge to your lighting skills and might make for a good exercise for one evening.

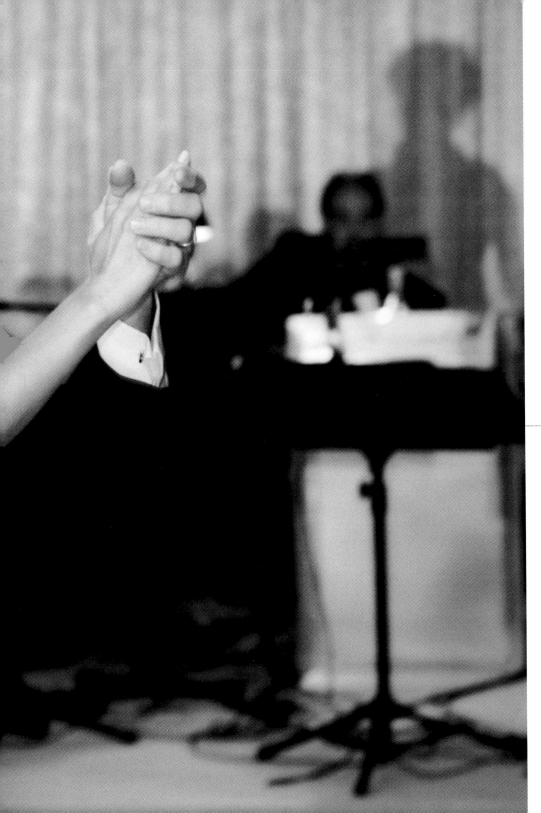

Figure 2-13: A classic shot taken with my classic set up: a great lens with a Gary Fong Lightsphere on a Speedlite. This photo was taken with a Canon EOS 1Ds Mark III, 85mm prime lens, 1/40 sec, f/3.5 and ISO 1000, in Manual mode. One on-camera Speedlite was enhanced with a Gary Fong Lightsphere.

3

GETTING THE BASICS RIGHT

AS WE'VE ALREADY COVERED, YOU GAIN PHOTOGRAPHIC POWER ONCE YOU'RE ABLE TO 'SEE' LIGHT CORRECTLY. However, before you can draw full benefit from your new-found ability to analyze a scene in your mind, it's important to also have the basics of photography down perfectly. I understand that many of you know all this like the back of your hand; in that case, feel free to skip past it. However, if you aren't completely confident, then here's your chance for a quick-fire refresher!

Figure 3-1: The diamonds are a little bit overexposed (which is very difficult to avoid in photos like this), but apart from that, this image is an excellent example of a well-balanced photo. Note the beautiful tonality, deep blacks, and well-defined highlights. Lovely! The photo was taken with a Canon EOS 1D Mark III, 100mm Macro lens, 1/50 sec, f/13 and ISO 500, in Manual exposure mode.

Exposure and how it works

An exposure is a measure of how bright a photo is as it is saved to your memory card. Exposure is affected by four things: light, shutter speed, aperture, and ISO.

A digital camera imaging chip is basically just a series of thousands of tiny little light meters. These meters measure the light that is reflected off your subject, through your lens, and onto the imaging chip. For digital photography, the most important lesson is to try to avoid overexposing your photos. If your photo is significantly overexposed, there is not a lot you can do about it, so keep an eye on your histogram (more about that later in this chapter) and your light meter.

Figure 3-1 was taken with two Canon 580EX II Speedlites. One was off-camera left in group B, for fill, and one was on camera, with a Ray Flash ringflash adapter flash set to E-TTL II mode, triggered via line of sight with the on-camera flash as the master in group A. The flash output was biased towards group A.

The amount of light reflected off your subject is the most obvious aspect of how bright your photo will be. As you have learned, you control this light with flashes, diffusers, and the like. Light is also the only facet of exposure that is controlled outside the camera settings. The rest of the factors that affect your exposure are how you manipulate the available light using the shutter speed, aperture, and ISO settings on your camera.

A photo which is overexposed will have suffered from 'burned out' areas, where the imaging chip detected too much light. These areas will appear as solid expanses of white.

An underexposed photo has the opposite problem. It is too dark overall. By not

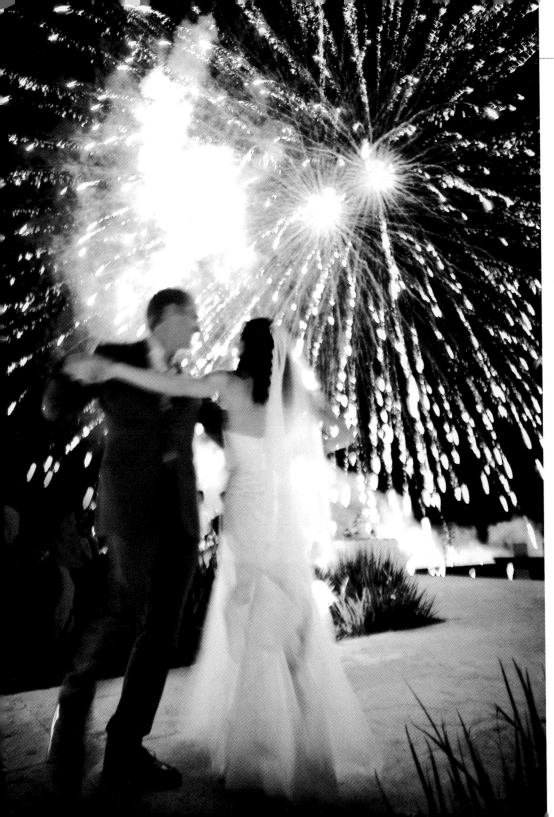

Figure 3-2: *Your camera continues to record the light for as long as the shutter is open. If something moves while the shutter is open, it will be blurred. That's how the fireworks in this photo can look so fantastic! Photo was taken with a Canon EOS 5D, 24mm lens, 1/8 sec, f/1.4 and ISO 800, in Manual exposure mode.*

utilizing the full range of the sensor, you are not getting the optimal photos, and if you try to brighten them in the digital darkroom, you'll get unwanted digital noise.

You adjust your exposure by adjusting one or more settings on your camera, so let's take a closer look at them individually.

Shutter speed

Let's discuss shutter speed next. Light can be a little bit abstract, so let's think of it in terms we can relate to more easily. Imagine you have a glass you need to fill to the rim with water and your available light is the water pressure. If you are taking photos on a sunny beach, your water pressure is high as you have much available light. You could only open the faucet for, say, five seconds to fill the glass. If you were photographing the same subject in a dimly lit church, you would have less water pressure. You would have to open the tap for at least ten seconds for the glass to be full.

The filling of the water glass is analogous to our exposure. An empty glass is unexposed and would come out completely black. A full glass is properly exposed and would be well-balanced. An overflowing glass is overexposed because too much light ended up hitting the imaging sensor.

Figure 3-2 was taken with two flashes. One on-camera Canon 580EX II was pointed straight up with a Gary Fong Lightsphere light modifier set as master in group A and the second flash is a Qflash off-camera in group B. All the flash power was biased towards the master flash, flash set to E-TTL II mode, triggered via line of sight from the master flash.

Ignoring flash for a brief moment, when you are photographing in natural light, you can manipulate how much light hits your imaging sensor by manipulating the duration your shutter is open. The most important rule to take away here is that you control the ambient light with your shutter speed.

In summary, faster shutter speeds mean less light on the image sensor. Slower shutter speeds mean more light.

Aperture

The next control you have available in your in-camera lighting arsenal is the aperture. Aperture comes from Latin for 'opening'. Inside your camera lens, there are a series of blades that can open and close to create a bigger or smaller hole for the light to pass through.

To go back to our water analogy, imagine you have a series of different water hoses, varying in diameter from that of a drinking straw to one so large that it barely fits inside the glass. If we equalize the shutter speed (the time that the water hose is open) between each scenario, then it becomes obvious will happen. In five seconds, the glass with the biggest hose will overflow and the glass with the drinking straw will be only partially full.

So, if you want to get a perfect exposure, you need to think, "I know I want to spend five seconds to fill up this water glass. How big should the water hose be, given the current water pressure?" Or, to take it back to photography language, "How big does my aperture need to be, so I can use a 1/60th of a second shutter speed, given the current lighting conditions?" At first you'll get there through experimentation and guesswork based on the lighting sensor built into your camera, but over time, you'll start to notice that your guesses become more 'educated', and that you start getting a 'feel' for your exposures. Practice, practice, practice!

TIP: ————————————————————————————
> You can train your exposure 'eye' with a simple game. Guess what you think an exposure might be, then check with the light meter in your camera. When your guess is off, try to determine what made you miscalculate. You'll be surprised how quickly your 'guesswork' improves!

To get a perfect exposure, you need to ensure that your shutter speed and aperture are correct for the amount of light you have available. From an exposure point of view you have a choice as to how to do this. The extremes are to use a long shutter speed and a small aperture or use a short shutter speed and a large aperture – but of course everything in between is also possible.

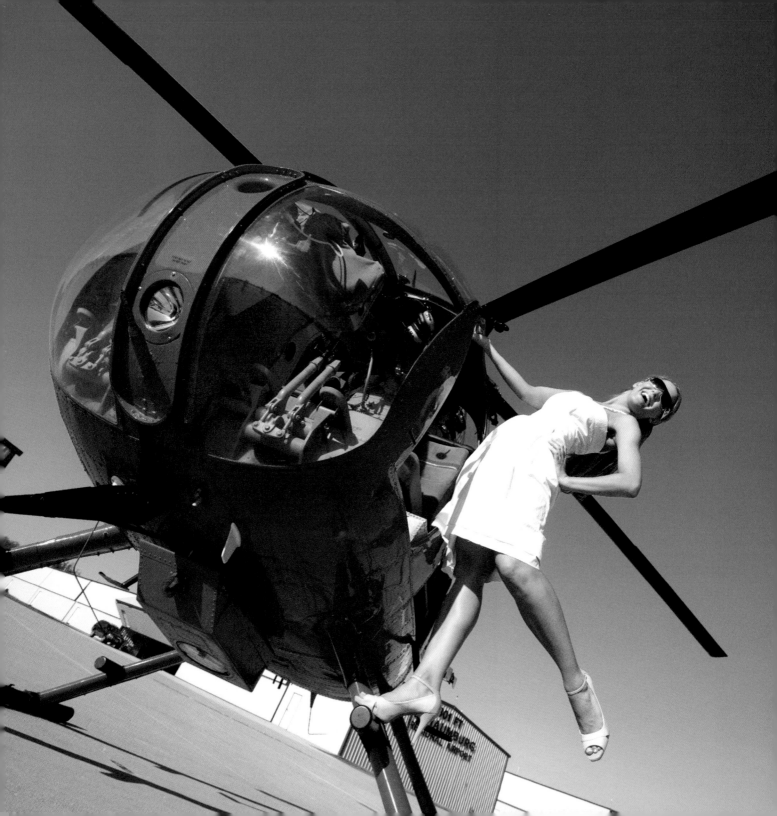

Figure 3-3: A small aperture gives you great depth of field. The larger f/9.0 aperture in this photo allowed both the helicopter and the hangars in the background to be in focus. This photo was taken with a Canon EOS 5D Mark II, 16-35mm lens at 16mm, 1/400 sec, f/9.0 and ISO 200, in Program exposure mode.

Figure 3-3 used all natural light. It was taken during a lovely sunny day, which means that there is plenty of light available. The combination of lots of light and a white reflector used to fill in the shadows is what gives the lovely result in this image.

ISO

The last thing which affects your exposure is your ISO. Interestingly, the ISO setting doesn't affect what the camera does mechanically. Instead, it affects how the files from your camera are written to the memory card.

Imagine we have a lighting situation where the perfect exposure at ISO 100 would be 1/30 second shutter speed at f/4.0 aperture. Yet, when we review the image, we see that the 1/30 second shutter speed is a problem, because it introduces blur into the image. Now, if we changed the shutter speed to 1/60 second and f/4.0 aperture we can get rid of the blur by reducing shutter speed, but now we're capturing only half the light we "need". This is where ISO comes in.

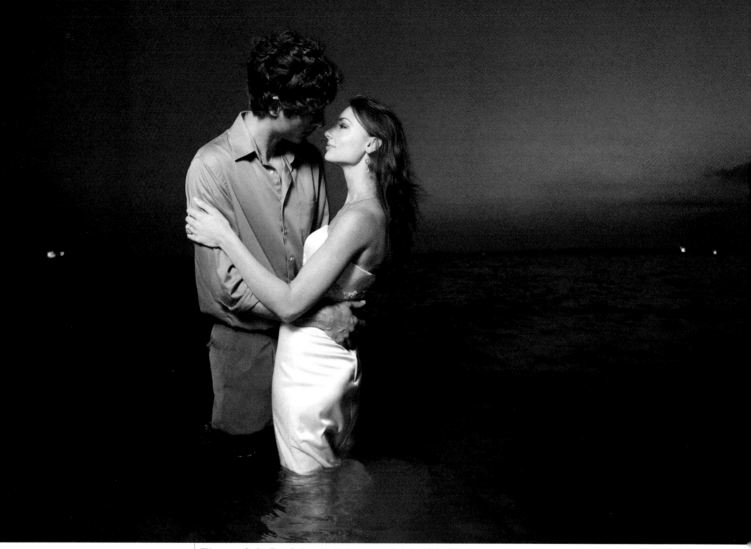

Figure 3-4: Don't hesitate to use a high ISO. Modern cameras are capable of using higher ISOs with beautiful results. This photo, for example, would have been impossible without cranking the ISO to 1000. This photo was taken with a Canon EOS 5D Mark II, 16-35mm lens at 21mm, 1/3 sec, f/4.0 and ISO 1000, in Manual exposure mode.

Figure 3-4 was taken with a Canon 580EX II Speedlite, flash set to E-TTL II mode. The flash was modified with a Westcott, Bruce Dorn Select Asymmetrical Strip light soft box, held by an assistant. The flash was triggered with a Canon Speedlite Transmitter ST-E2 with RadioPopper transmitter and receiver.

If you set the ISO to 200, the camera takes the same reading as at ISO 100, but it does a bit of processing. Before it writes the image to the card, it multiplies all the readings from the tiny little meters by two.

ISO, then, can be compared with dropping a false bottom into our water glass. At ISO 200, we've reduced the depth of the glass by half, so you only need half the exposure - so you can use half the shutter speed, an aperture half the size, or a combination somewhere in between. The ISO continues up the scale — at ISO 400, you need a fourth of the shutter speed. At ISO 800, you need an eighth. And so on.

The potential downside to using faster ISO values is the possibility of what we call "grain" on the image. However, in my experience, the advantages outweigh the disadvantages. Without higher ISO, **Figure 3-4** would have been impossible, for example.

How to measure light

Back in the day of photographing with film, we would measure light with an external light meter - it's a meter you hold near your subject. You'd connect your flashes to the light meter, press a button and the flashes would fire. The light meter would then tell you what the optimal shutter speed and aperture settings for a given ISO.

Photography equipment has come a long way. The in-camera light meters are much, much better than those previously built in. However, this is only part of the story as there's one innovation on digital cameras which means has resulted in the fact that I haven't even bothered bringing with me a separate light meter for many years.

When you're shooting with a digital camera, one of the huge advantages is that you have a screen on the back on the camera, so you can see immediately what your photo looks like. Yet your digital camera has an even better piece of technology in the form of the histogram. To photographers, the introduction of histograms is one of the greatest tools in your arsenal on the road towards deliciously perfect exposures.

TIP:

Never trust the LCD monitor on the back of your camera for exposure or white balance. It's only useful to inspect the framing and the design of the lighting. To see if you've got everything else spot-on, use the histogram function.

A camera histogram (see **Figure 3-6**) is a graph representing what amount of brightness you have in a photograph. At the left end of the histogram, you get the dark portions of the photograph. The right end is the bright portions of the image. If your histogram is indicating that most of the data is dark (what we usually refer to as a histogram being 'skewed to the left'), this is an indication that your photo is underexposed. A histogram peaking on the right would be an indication your photo is overexposed.

In the case of **Figure 3-5**, this is a very bright photograph, also known as a 'high key' photo. Notice the histogram spikes up like mountains towards the right, highlight side, with a slight spike off the chart to the far right indicating that some of the highlights are blown out or overexposed.

The histogram is a true representation of the scene. The histogram **Figure 3-6** tells me I have a good exposure. Not too much information is lost to the right, so the photo isn't significantly overexposed.

In this particular photo, the skylight and the unusual shapes in the photo can 'fool' the camera's built-in light meter. I knew this, of course, and chose to shoot the photo in manual mode for complete exposure control.

TIP:

Check with your camera manual how you can access the histogram and split-level histogram of your images on your camera.

The way a histogram shows the data in your photograph means that you can use the histograms as a very accurate light meter Simply take a test shot, and look at the histogram. If you get a nice distribution across the curve, with good coverage across your histogram, without a huge spike on the far right or left, you have a good exposure.

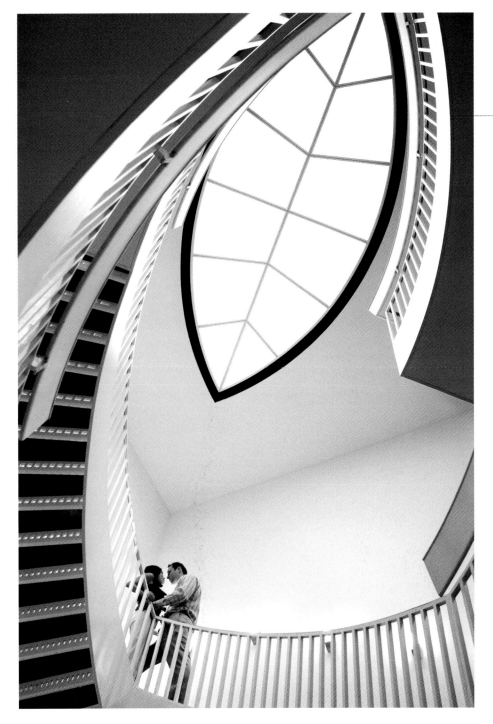

Figure 3-5 *was taken with a Canon EOS 1D Mark III, 24-70mm lens at 28mm, 1/80 sec, f/4 and ISO 640, in Manual exposure mode. The picture was taken with one off-camera Canon 580EX II backlighting the couple to create separation from the background, bare flash, no modifier, flash set to E-TTL II mode, triggered via Canon Speedlite Transmitter ST-E2 with RadioPopper transmitter and receiver.*

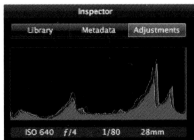

Figure 3-5 and 3-6: Take a look at the histogram and how it matches up with the photograph. This is a high key image, meaning most of the tones leaning towards the right of the histogram.

Set your camera to manual, and as long as the lighting situation doesn't change, you can snap perfect exposures all day long.

Especially if you're shooting in varying lighting conditions, it's worth it to check the histogram every now and again. The light meter in your camera is incredibly accurate, but it can get things wrong. By remaining aware of what is capturing, you ensure you get the best possible photos.

The simple histogram on most cameras shows a combination of all colors which is great for checking your exposure. Many cameras also offer a second type of histogram, as shown in **Figure 3-7**, called the split-level histogram. This is quite similar to the simple version, but shows each color (red, green and blue) in a separate curve on the histogram. This is useful for many things; most of all for getting your white balance right.

Using histograms to perfect your white balance

When you're using a split-level histogram, you'll see that your colors are reading differently across the histogram. That's fine - if they were all perfectly stacked, that would mean you have a grayscale photograph. However, if you can see three trends (say, three bumps which fall in sequence) it is the sign that your white balance might be off. If the bumps are roughly equal — like in **Figure 3-6** — your white balance is spot-on!.

For a better explanation of the kelvin scale, check out Chapter 2. "Understanding Light".

You can use the split-level histogram to your advantage to set your white balance. To do so, set your camera to manual white balance, and pick a kelvin value that you feel might be just about right. Take a test shot and look

***Figure 3-7**: A split-level histogram can help you get your white balance right in your photos.*

at the histogram. If the right-side of your histogram is primarily red, your images will have a red cast, so your photo is 'running hot'. To adjust this, you have to tell the camera that the light is warmer than you had expected — so reduce the kelvin value, and take another test shot. Repeat until your split-level histograms roughly align, and you've white-balanced your photographs by hand!

Aperture and depth of field

The aperture does more than just control the amount of light that hits the sensor - the size of the aperture affects the way an image looks as well. Specifically, it affects the depth of field you can achieve. Depth of field is an expression describing how much of a photo is in focus. If you use a large aperture (a smaller f-number), you get a shallow depth of field, which means that if you take a portrait photo, your subject will be in focus, but the background will be out of focus (see 2-8 in the previous chapter for a good example of this).

TIP: ———————————————————————————————————————
Apertures are measured in f-numbers, which are a fraction. F/4 means 1/4 and f/8 is 1/8. Therefore, f/4 is a larger aperture than f/8.

If you use a small aperture (signified by a larger f-number), you achieve a greater depth of field, as shown in **3-3**.

You can use this functionality for creative effect. Throwing the background out of focus is often appealing in portraits. For other photos - group shots, for example, or landscapes - you might want a greater depth of field to get everything you want to capture clearly in focus.

Shutter Speed and motion capture

Like with aperture, shutter speed affects more than just the amount of light. It also affects motion in a photo, which makes sense, when you think about it. Your camera chip is measuring light as long as the shutter is open. If the shutter is open for a second and if

scene changes in the duration of that second, the light reflecting off your subject will also move across the frame.

To freeze motion, then, you need to ensure that your subject moves across the frame as little as possible while the shutter is open. How far something 'moves across the frame' depends on how fast something is moving, and how wide a lens you are using. **Figure 3-8** is an example where something moves very fast in the frame, but the 1/2500 sec shutter speed helps freeze the motion.

It's worth noting that as far as motion blur goes, it's not just your subject which might move. If your camera moves, that also introduces motion blur also (often known as 'camera blur' or 'camera shake'). The rule of thumb for which speeds you can shoot hand-held (i.e. without using a tripod) is that your lens focal length should be the same as your shutter speed — so if you are shooting with a wide-angle, 30mm lens, you can shoot at 1/30th of a second. If you're shooting with a 200mm tele lens, the minimum shutter speed is 1/200 of a second. Modern image stabilization systems complicate matters a little, and of course, some people have steadier hands than others. Experiment with what you're able to pull off handheld.

Finally, since you're reading this book, you're likely to use flashes, which changes matters as well — because the flash only lasts for a fraction of a second, the flash can help you 'freeze' motion, even at slower shutter speeds, but we'll talk about this in more detail in Chapter 7, "Getting Creative."

Figure 3-8: *The airplanes in this photo are moving at high speed, but using a fast shutter speed means that they are sharply visible in the sky. This photo was taken with a Canon EOS 1D Mark III, 70-200mm lens at 110mm, 1/2500 sec, f/4 and ISO 200, in Program exposure mode with + 1/3rd exposure compensation.*

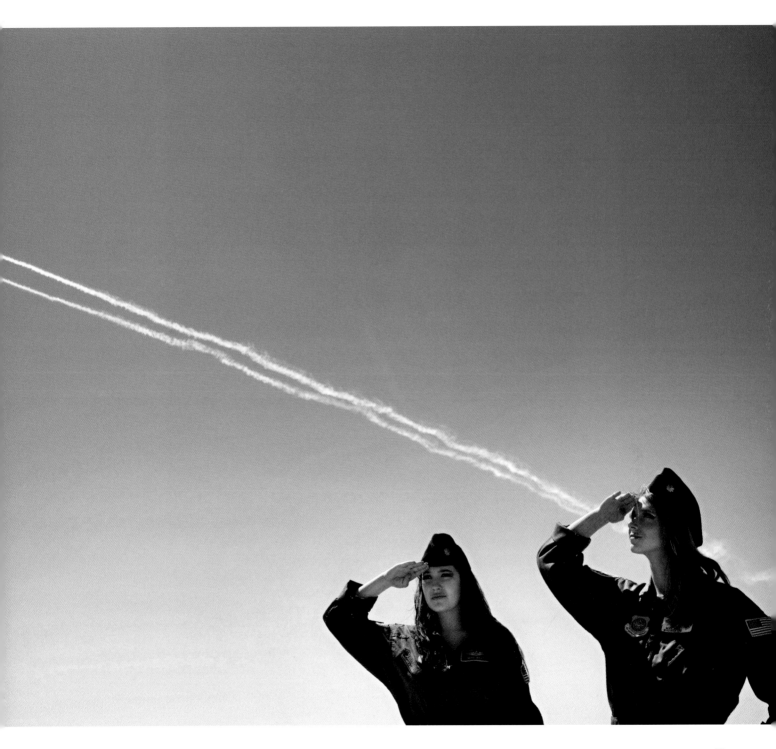

ISO and digital noise

We've already spoken about how ISO works. You can use the ISO to your advantage in several different ways - you can crank it up to achieve smaller apertures or faster shutter speeds, of course, but you can also increase the ISO without touching any of the other settings when you're working with flashes. "Why?", I hear you ask, "Won't that cause the images to be overexposed?" In theory, yes, but you forget that there was one more element to the exposure: the light!

When you are shooting with your flashes E-TTL, the light is measured as follows. The flashes will fire, reflect off your subject, and then be measured in your camera. Your camera will make a calculation and adjust the output of the flashes to ensure that you get a good exposure. Because you're shooting at a higher ISO, less light is needed, which means that the flashes will flash less brightly. This is handy, because they will recycle faster (the time between each flash goes down), which means you can take photos faster. This is clearly a good thing. There's nothing as annoying as having to wait for flashes to be ready to take a shot or, even worse, missing a shot because a flash didn't recycle and fire properly when you needed it most.

Figure 3-9: Don't let appalling weather get in your way – wrap your flashes in plastic bags if you have to, but keep taking photos. Photo was taken with a Canon EOS 1D Mark IV, 70-200mm IS lens at 155mm, 1/60 sec, f/3.2 and ISO 8000, in Manual exposure mode. The lighting was provided by two Canon 580EX II Speedlites in E-TTL II mode backlighting the subjects triggered via a Canon Speedlite Transmitter ST-E2 with RadioPopper Transmitter and receiver.

High ISO shots in black and white can look fantastic, as the digital noise takes on a quality which is quite similar to film grain.

There is a downside to higher ISO settings, however. No imaging chip is perfect, which means that their measurements are ever-so-slightly off. This is barely noticeable when you take photos at ISO 100, but as you go up the ISO settings, the weaknesses in the chip are multiplied along with the light measurements. This manifests itself as digital noise. Sometimes, this can look beautiful. High ISO photos in black and white can look almost like old-fashioned film grain, which can be a desirable effect in itself. The amount of noise varies from camera to camera, and increases at slower shutter speeds. The best thing to do is to experiment with your camera.

TIP:
> Find out at which ISO your camera delivers a good compromise between speed and noise and try to stick below that ISO value.

Having said all that, I often shoot at higher ISOs - 1000, 2000, etc - if the lighting is good, the noise is not disturbing. Shooting at higher ISOs gives you a level of freedom which photographers could only dream of a few years ago!

When you look at the photos throughout this book, pay special attention to the ISO values noted with each photo. You might be surprised to see how high ISO some photos are taken with, without really showing much noticeable noise!

In general, I aim to shoot in the lowest ISO I can. There's no reason to shoot in ISO 1000 if you have enough light available to take photos in ISO 400, for example. If you need the bigger aperture or faster shutter time, don't hesitate to crank your camera up to a higher ISO. Only on a rare occasion would I try to generate digital noise for affect.

File formats

Most digital SLR cameras will take photos in multiple file formats. The important ones are Camera RAW and JPEG.

My personal philosophy is to try to shoot my pictures as accurately as possible right out of the camera. Make sure that your exposures and lighting are as good as possible, that your

white balance is spot-on, and so on. You want your photos to be as good as possible right out of the camera. Doing so saves the most time when it comes to post-processing, and it means that if you need to send a photo to a magazine or an agency, they can use it right away. If you send them an image that they need to fiddle with to make it look good, they may never use you again.

Camera RAW has many distinct benefits. In a JPEG, you only have 8 bits of information. Depending on your camera, the RAW file has between 12 and 16 bits of information so the color gamut is much wider.

When you're out shooting, it's best to expose for the highlights. If you overexpose the image slightly, you have a lot of extra information to fall back on in the RAW file. If you have to err on the side of caution, it's better to over-expose ever so slightly because RAW will save you. If you are underexposed and you try to add something where there is nothing - even with RAW - you are going to get noise. Aside from high ISO settings, trying to recover image data from underexposed areas is one of the largest contributors to digital noise.

The strength of RAW is that it stores all the information that was captured by the camera, without any modifications beyond the ISO calculation. If you get the white balance wrong, for example, this can be corrected on your RAW file because all the information is still there.

In an ideal world, you could shoot every shot as a perfect JPEG, but more realistically, shooting in RAW allows you more flexibility to adjust for shooting mistakes at the processing stage. So, in summary, shoot as perfect as you can, use the JPEGs as previews, but use the RAW files if you need to make further adjustments.

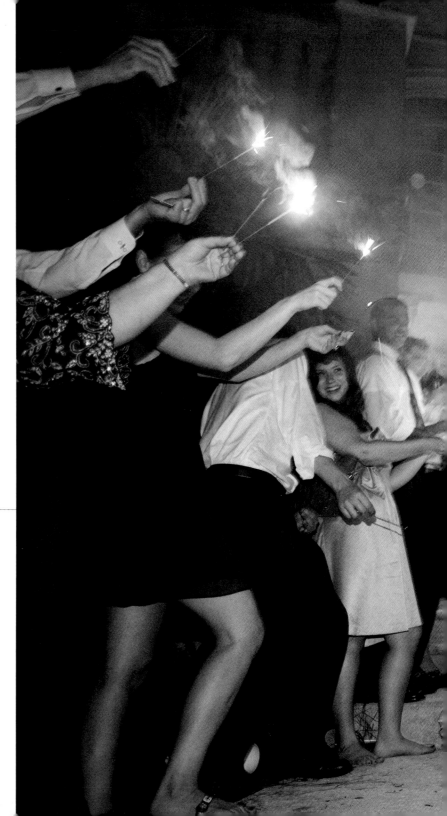

Figure 3-10: Getting good photos is all about getting motion and a feel of 'being there'. If that means getting on your knees to get a cool angle, then so be it. A suit can be cleaned, but a great photo lasts forever. This photo was taken with a Canon EOS 5D Mark II, 16-35mm lens at 25mm, 1/30 sec, f/3.2 and ISO 1250, in Manual mode. One on-camera Speedlite was used for fill using rear curtain sync to capture the glow of the sparklers.

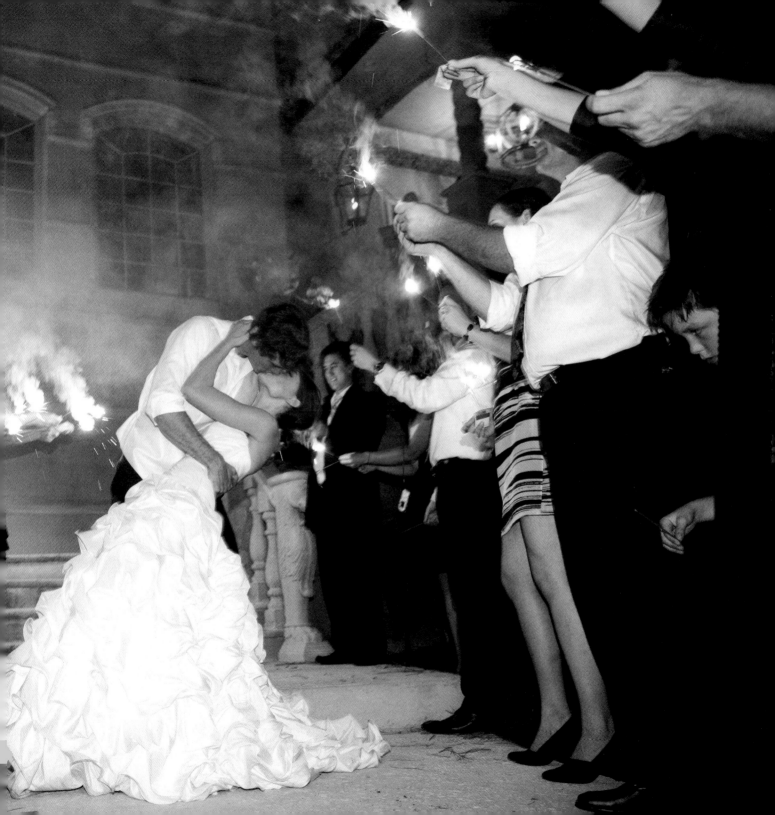

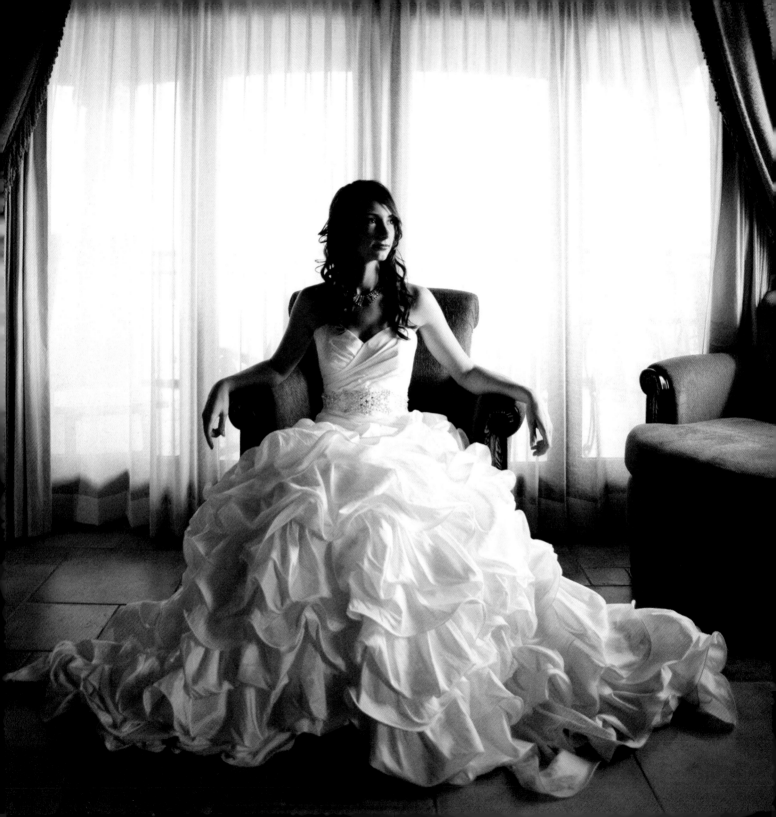

4

LIGHTING EQUIPMENT

IT OFTEN SEEMS AS IF PHOTOGRAPHERS ARE FONDER OF TALKING ABOUT PHOTOGRAPHY EQUIPMENT THAN ACTUALLY TAKING PHOTOGRAPHS. Hours are wiled away discussing the virtues of the Canon 50mm f/1.4 versus the f/1.2 variety of the same lens. Every now and then the never-to-be-sE-TTLed discussion of Canon versus Nikon rears its useless little head, and if you want a crowd of photographers really fired up, throw "Mac or PC" into the mix.

Figure 4-1: A wise old photographer once said that if you photograph a bride's dress well, all else is forgiven. I'm a believer in photographing everything perfectly, but he might have been on to something. What bride wouldn't be happy with a photo like this one? This photo was taken with a Canon EOS 5D Mark II camera and a 16-35mm lens at 24mm, 1/25 sec, f/2.8 and ISO 1000, in Manual exposure mode. One Gary Fong Lightsphere was on the off-camera Speedlite

Personally, I think differently about my photographic equipment. Photography is a craft. The equipment I use to do that craft are merely the tools I have at my disposal. As a photographer, you'll find yourself in myriad situations and as the conditions of a photo shoot changes, so do the requirements we have of the tools we are using.

I've been a lifelong Canon shooter, but I had a short affair with Nikon during my years at the *Chicago Sun-Times*. I liked both; but I love my Canon gear. I use an array of different lenses and lighting equipment because they are the best for the job. I work to stay on top and informed of all the new technology available; if something comes along that is better for the job than what I am using currently, that's what will find itself onto the shopping list when the time comes. The most important thing is to use the right tool for the right job. The debate can go on forever: Canon verses Nikon, Mac or PC. I'm confident it's possible to deliver amazing photos with both, but do your research and use what works best for you.

Having said all that, there's a ridiculous amount of equipment out there, and some of it is better than others. While I wouldn't presume to put together a shopping list for you, this chapter is designed to give you some insight into how I like to work, and some context for why I am currently using this equipment. The intention is that, armed with this chapter, you'll have enough knowledge to put together your own lighting kit which is suitable to take you, and your photography, to the next level.

Figure 4-2: The hot shoe on a digital SLR camera is used to communicate between the camera and the outside world. In this picture, you can see a Canon 580EX II Speedlite in the hot shoe of my Canon EOS 1D Mark IV. Often, you'll use a flash in the hot shoe, but you can also connect radio triggers or other remote control devices to the hot shoe.

On-camera flashes

I am a huge fan of using small Speedlites; specifically the type that sit in the hot shoe of your camera (see **Figure 4-2**). They are remarkably versatile without being crazy expensive. By their nature, they are extremely portable, too. They are physically smaller than any set of studio lights. They come with their power source built in. And they are remote controllable from your camera. What's not to love?

Whatever the brand of your camera, the manufacturer will create some fantastic flashes to go with your camera system. The advantage of using the flashes made by the same manufacturer as your camera is that they are fully integrated. Additionally, they are guaranteed to work well, both with your camera and each other.

Using a flash on-camera is easy. Simply turn it on and slip it into the hot shoe; the flash and camera use the hot shoe to communicate with each other, and (depending on camera mode) they will co-operate to ensure that your exposures are correct, too.

Controlling on-camera flashes off the camera

As useful as on-camera flashes are, their real power lies in using them in combination with more Speedlites. You can get people to hold them (like in **Figure 4-3**), put them on lighting stands or tripods, and move them around independent of your camera. Where else will they work? In the studio! So, by using two or more of these Speedlites, you can get creative with lighting your subject to your heart's content.

TIP:
> Most remote flash systems use short bursts of flash light known as communication flashes to talk with the remote flashes. Because they use light, this means they have to be in line of sight of your flash. In some lighting situations, this is difficult or downright impossible. If this happens, consider using a radio-based controller.

To fire one of these flashes, you need a way to communicate between your camera and your remote strobes. There are three ways of doing this. Use a cable (known as a PC sync

lead) from your camera to your flashes or control them wirelessly. If you want to command your flashes wirelessly, you have two options. You can control them optically (i.e. infrared or via communication flashes) or via radio signals.

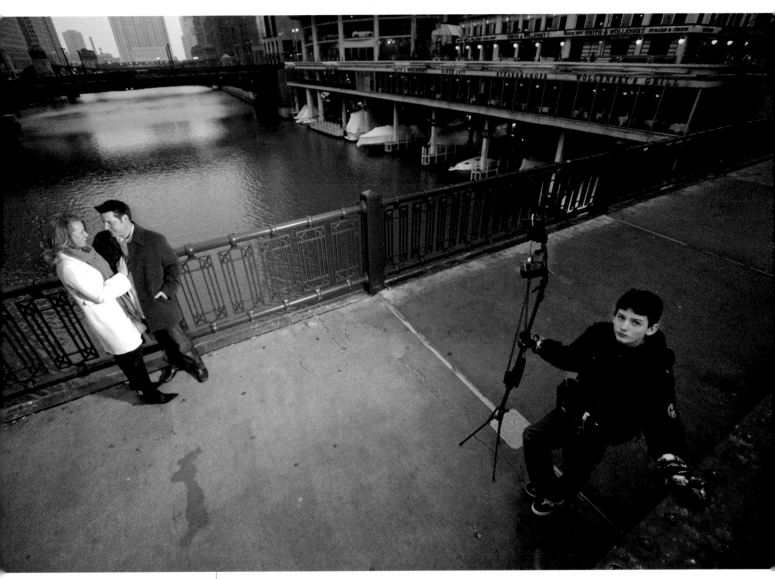

Figure 4-3: *Off-camera flashes are useful because instead of having the flash attached to your camera, you can place them anywhere you like, which helps you control where the light comes from.*

TIP:

Bizarrely, the 'PC' in PC Sync lead has nothing to do with computers. It stands for Prontor-Compur, the companies which first standardized this type of connector.

Figure 4-4: This is a Canon Speedlite Transmitter ST-E2. One of these can wirelessly trigger your Speedlites, but it doesn't have all the functionality of the newer Speedlites. The Canon 580EX II Speedlites flash, for example, has more groups and better range.

Most Speedlites have a slave mode, which enables them to be controlled wirelessly. To control these lights, however, you need a flash that has a master mode. To find out if your flash has a master mode, check the manual. In master mode, Speedlites can control other flashes that are set to 'slave' mode. Most camera manufacturers also market a 'remote flash controller' as shown in **Figure 4-4**, which is cheaper than a Speedlite, and designed only to control other flashes by that manufacturer.

Light only goes in a straight line from your flash head, so if you have flashes in all directions from where you are standing, getting the communication flash to all your Speedlites can turn out to be a real challenge. The solution is to use a radio controller instead. The reason why this works is that radio waves are omnidirectional. Radio triggers offer several advantages; the biggest of which is that you don't have to worry about being in a direct sight-line between you and your flashes, but you also get a bigger range and better reliability.

Finally, check your camera manual, because some cameras — the Canon EOS 7D, all Pentax cameras and Nikons from the D90 on up — can control slave flashes directly with the built-in flash. Often, the built-in flash isn't really powerful enough to control all the flashes. However, it may be just what you need to get started, or to save your skin in an emergency.

Wireless radio flash triggers

Whether or not I bother with radio triggers (see **Figure 4-5** to get an idea what they might look like) depends on many factors. If the lighting situation means I don't need them, obviously, I wouldn't bother. Then again, if I'm on a particularly critical shoot, where I have to be sure that every flash fires every time without fail, I might decide to use the radio triggers after all. It's better to use some extra batteries and equipment than to miss a vital shot, for obvious reasons.

So, wireless radio flash triggers are a vital part of my kit bag. There are lots of different versions available, all with their own advantages and weaknesses.

Figure 4-5: *Radio triggers use radio waves instead of light to communicate, which means that they are more reliable in many situations.*

RadioPopper

The RadioPopper brand, in my experience, offers the complete package. The company offers a product line that is reliable and allows you to seamlessly use every function and feature your Speedlite has to offer.

Think of a RadioPopper as an interpeter. The RadioPopper captures the optical communication from the master unit, instantaneously converts the information to a

radio signal sending it to the receiver, which decodes the instructions back to a light signal. Your flash reads this signal and fires without delay.

I have used the RadioPopper since its inception and they work with absolutely bullet-proof reliability. I would not go on assignment without them. Despite what my gushing endorsement might sound like, I'm not paid or sponsored by RadioPopper. I simply love their product.

Quantum FreeXWire

I have used the Quantum FreeXWire system; it's a good solid system. Quantum's current limitation is that you cannot get all the features and functions out of your Canon or Nikon creative lighting system using Quantum's FreeXWire system. They will trigger your Speedlites wirelessly, but only in manual mode, which means you don't get all the cool features your flash has to offer. If you were to use a complete Quantum strobe system and forego using Canon or Nikon then they offer a TTL wireless solution, but you're are limited to using the Q5dr-T or the Qflash Trio, which is a shame if you've already invested in the Canon or Nikon strobes.

Pocket Wizards Mini & Flex

I have used the Pocket Wizard systems, too. In my experience, the Flex and Mini were not reliable with my Canon 580EX II Speedlites. The Flex and Mini need other options to allow for reliable communication when using the Canon 580 Speedlites. Interestingly, I did not have issues with the Pocket Wizard system when using the less powerful Canon 430EX II Speedlite. It's a moot point. I only use 580's so they were not very useful for me.

If you are not looking to use the creative features and just want to wirelessly fire your Speedlites in manual mode, they work great. But I look at it this way. I'm paying extra for the cool toys that Canon and Nikon have built into their flash systems, and once I've put the money down, I want to be able to use every feature.

Figure 4-6: *If you're shooting in the studio, you can always re-take a shot. When you're shooting documentary-style on location, you really can't afford to miss a shot due to your flashes not recycling quickly enough. Don't miss the shot-- use good batteries! This photo was taken with a Canon EOS 1D Mark II, 70-200mm IS lens at 70mm, 1/100 sec, f/3.2 and ISO 400, in Program exposure mode. I used a Canon 580EX II Speedlite on my camera. The flash was fired through a Gary Fong Lightsphere with the dome in place for added diffusion. I was using a Canon CP-E4 battery pack to keep the recycle time short.*

Batteries, batteries, batteries

One of the things frequently overlooked is batteries. Remember that, when working with a Speedlite, several characteristics of the flash are affected by the status of the batteries.

It is possible to avoid switching your batteries until they are completely empty, but this is false economy. One of the most common flash exposure problems results from a lack of battery power during heavy use. If your flash does not recycle fast enough, for example, you will miss moments and have underexposed, motion-blurred images.

Of course, all Speedlites accept alkaline batteries (usually of the AA variety), which gives you some flexibility. You can use the cheap AAs from your corner shop, but they're not going to last very long.

Some photographers try to make a compromise by using rechargeable, high-capacity rechargeable AA NiMH batteries. There is something to this, as rechargeable batteries tend to keep full power for longer, especially the cutting edge 2700mAh MAHA batteries you can buy these days.

So, if you are using disposable AAs, stop immediately! If you find yourself in a situation where it is unavoidable, then keep looking for opportunities to refresh the batteries. If you know you have a lull before an intense set of shooting, say, between the ceremony and the reception of a wedding, switch your batteries.

A better solution than using individual AA batteries - especially if you're doing intensive photo shoots — is to consider using external battery packs. Canon sells a Canon CP-E4 pack which goes with their flashes. They are quite bulky, but the amount of power you have available is much higher. The battery pack holds eight AA batteries, but because each individual battery is under less strain, the number of photos increases four-fold.

There are several advantages to using external battery packs. Apart from the higher capacity we've already mentioned, they are much faster to swap. No matter how fast you are at refreshing AA batteries, I'm willing to take you on in a race. Instead of having to fiddle with four individual batteries, I can simply unplug the pack, and plug in another one; it takes three seconds at the most.

There's another, less obvious advantage, too. When plugged in, your Speedlite will only use the external battery pack. Use this knowledge to your advantage by creating a safety buffer for yourself. Ensure that your Speedlite has fresh AA batteries in its own battery compartment, and then shoot with the battery pack. If the pack fails or runs low, simply unplug it, and the batteries in the flash itself take over. Phew, another bullet dodged!

Studio lighting

If possible, I try to avoid using studio lighting. Perhaps it's a left-over from my background in editorial photography, but I dislike the idea of having to lug a ton of equipment around. Studio lights are significantly more powerful than the on-camera flashes we're using throughout most of this book, but my style of photography lends it to the credo of 'quality-over-quantity' and I rarely need the extra power offered by studio lights.

Studio strobes have advantages, of course, but in general, they are more fragile and heavier. Studio strobe also bulbs burn out much faster than the bulbs in portable equipment. Of course, then there is the issue of powering them. Most studio lighting systems do have portability kits, of course, but they are invariably heavy, bulky, and expensive.

Of course, there will be situations where you need more lighting, and powerful lighting equipment is required, but don't forget that nothing is stopping you from using several on-camera-flashes at the same time. When you use several of them from the same location or lighting stand, it's called creating a gang of flashes. This can give incredible results, while not sacrificing the portability of your equipment.

Learn more about using gangs of flashes in Chapter 7, "Getting Creative".

I also use the Quantum Q-Flash X5DR Digital, as shown in **Figure 4-9**, when I want extra power. The Q Flash gives me 150 watt-seconds of power (compared to the typical 50 w/s for regular Speedlites) with many of the same dedicated features that I'm accustomed to with my Canon strobes. Of course, the Q-flash also comes in a Nikon version. The extra boost in power is nice when you need more wattage in the cottage so to speak. I do love bigger, high-power studio strobes like the Pro Foto or Elinchrome ones, but I don't actually need

them. If you use the techniques in this book and endeavor a similar style of photography, neither will you!

Light modifiers

A light modifier, you'll be unsurprised to learn, is a device that modifies your light in one way or another. While it is possible to use the flashes as they are, of course, direct flash light is never particularly flattering, and can almost always be improved in one way or another.

Flash Diffusers

I modify light in a variety of ways, whether it is light from my flashes or available light. On my flashes, I always use some form of light modifier. Back in the 1980s, when I was working for a newspaper, we used to take plastic bottles with us. Joy liquid soap bottles used to be frosted. We'd cut the bottoms off and duct tape them on to our flash. Poof! You have a diffuser.

These days, you can still use plastic bottles or a paper plate, if you really want to. Naturally, the commercial products available are easier to slip on and off the flashes, and they look a tad more attractive, too. I don't know about you, but I don't really want to show up at a celebrity wedding with dish soap bottles gaffer-taped to the strobe!

Currently, there are many different on-flash diffusers on the market. I've tried many of them, but Gary Fong Lightspheres are my go-to solution for on-camera diffusers. They give a beautiful, soft light, and can be used in different ways to create lovely lighting for a variety of different situations.

Other Diffusers

A diffuser is a semi-transparent material, usually spanned over a flexible frame, and normally collapsible. They create the illusion of a light source being bigger than it really is, which helps create a lovely, soft feel to the light, with softer shadows. Compare, for

example, a day of direct sunlight (harsh shadows, bright light) with an overcast day (soft shadows, less bright, but much 'gentler' lighting). Diffusers come in lots of different sizes, from vinyl-record-sized ones used for macro photography, to ones that are big enough to light a whole car.

For more information about diffusers and how they work see Chapter 2, "Understanding Light".

Soft boxes

A soft box is a combination of a reflector and a diffuser. It is designed to take all the light from a flash, reflect it so it is directed in one direction, through a diffuser panel. The bigger the panel of diffusing material is, the 'softer' the light. Soft boxes are ideal for photographing people because they give gorgeous, soft light.

Chapter 6, "Controlling the light," provides examples of photography with soft boxes.

Snoots, Barn Doors and Honeycombs

There are a few more typical light modifiers for flash photography, and they all have their uses. Snoots, barn doors and honeycomb attachments are different ways of 'shaping' light, and making it more directional. They are often interchangeable, but it depends on what effects you are trying to achieve.

A snoot is a conical-shaped item that is placed at the front of a flash. It gives the effect of a spotlight, and can in be useful for highlighting someone's hair, for example.

Barn doors are another way of shaping flash light. They can be useful for ensuring that light doesn't fall on certain aspects of your scene. Using a barn door to block light from hitting the background, for example, is one use or making certain that you're not inadvertently drawing more attention to the ground or walls of a scene.

Honeycombs can be useful for creating extremely directional light. They are named for the six-sided, honeycomb-shaped grid in them, usually made of a light-absorbing material. The

effect is that all light which doesn't go directly in the direction of your subject is absorbed. Honeycombs are used to accentuate features on models, especially on men, but, as with the other light modifiers in this section. I rarely find that I need them.

Gels and filters

Colored pieces of plastic or polyester to be used in front of flashes to change their color qualities are known as gels. You can use lightly colored gels to correct the color of your flashes to match the surrounding light, so you can use a single white balance setting for your whole scene.

When you're working as an editorial photographer, for example, gels can give you an eye-catching edge in your photographic work. I recall once, back when I was still working for the *Chicago Sun Times*, where I was doing a shoot in a lab at University of Chicago. I put a put a purple gel on the beakers in the background, a yellow gel coming through the microscope, and just utilized an unaltered flash for his face. The photo turned out pretty cool, but it confused the hell out of the technician who was developing the photo. "Ah, geez I spent three hours trying to correct it", he said. Currently, the only time I use any gels is when I am working with tungsten lighting or for creative effect.

Both Chapters 6, "Controlling the light" and Chapter 7, "Getting extra creative" showcase uses of gels.

Basic lighting starter kit

When I run workshops, I'm faced with an interesting challenge; I have to put together a package which is advanced enough that people can practice the required techniques, but without overwhelming them with loads of advanced equipment. So not surprisingly, I've spent quite a bit of time thinking and putting together a good lighting kit for practicing and showing off the power of portable flash photography. As I was putting the kit together, it dawned on me that it's actually a pretty good starter kit for anyone reading this book as well. Don't get me wrong, it's not the cheapest shopping list out there, but I think it's a

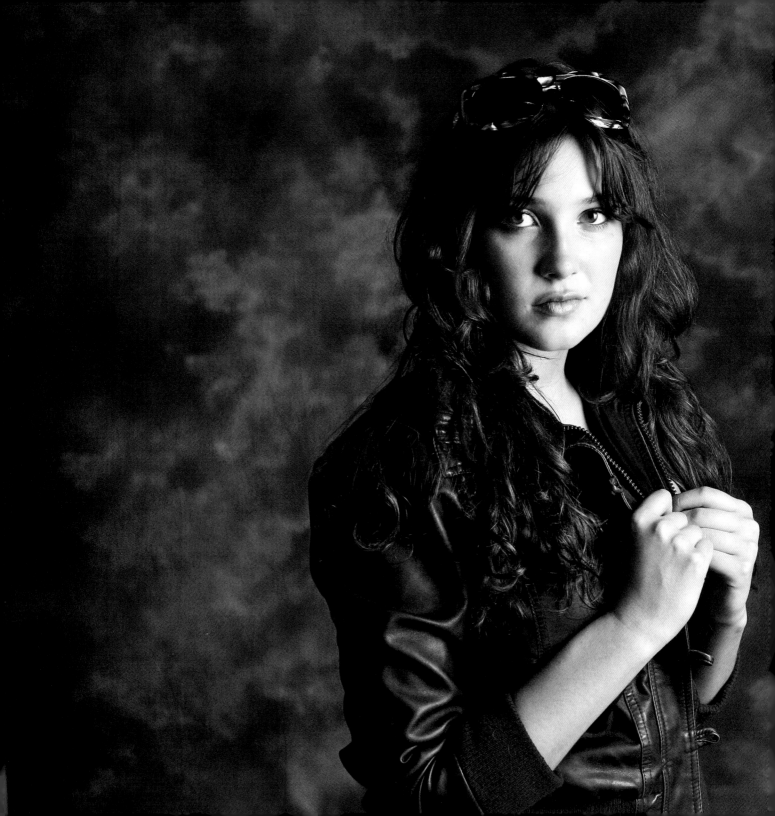

great creative starting point for building a good, versatile mobile lighting kit. It can (and probably should) be expanded.

Figure 4-7: Simple lighting can be powerful. This photo was taken with a Canon EOS 1D Mark III, 24-70mm lens at 43mm, 1/125 sec, f/8 and ISO 250, in Manual exposure mode.

Figure 4-7 was taken with a single Canon 580EX II Speedlite bounced into a Westcott 43 inch Optical White Satin with Removable Black Cover-Collapsible flash set to E-TTL II mode, triggered via Canon Speedlite Transmitter ST-E2 line of sight.

What you add to the kit next depends entirely on what your photography style is. The great thing is that you'll have a great start in the equipment listed below, and once you're using it to its full potential, you'll realize yourself which other pieces of equipment will complement what you already have.

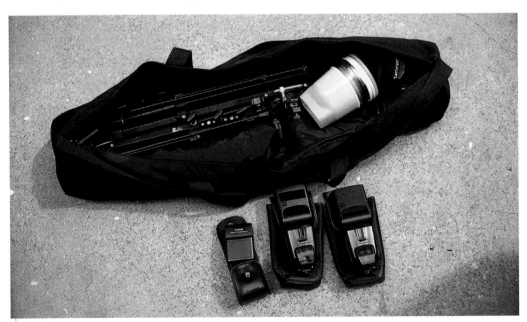

*In **Figure 4-8**, you can see my basic lighting kit consisting of two light stands, two Gary Fong Lightsphere light modifiers, a shoot-through umbrella, a couple of Canon 580 EX II Speedlites and a Canon Speedlite Transmitter ST-E2.*

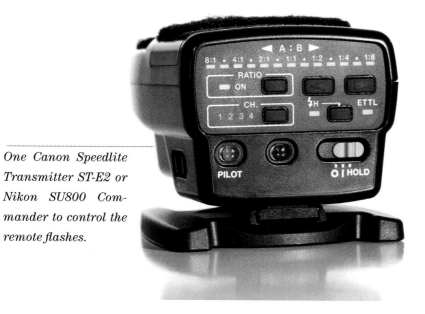

One Canon Speedlite Transmitter ST-E2 or Nikon SU800 Commander to control the remote flashes.

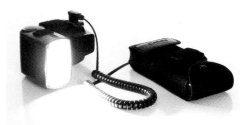

Canon 580EX II Speedlite with a CP-E4 battery pack

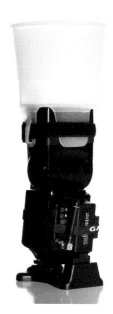

Gary Fong Lightsphere light modifier on a Canon 580EX II Speedlite with a RadioPopper receiver in the PX Receiver Replacement Canon Mounting Bracket/Base

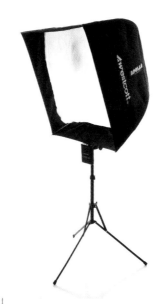

Bogen Manfrotto 001B Nano light stand with a FJ Westcott 28 inch with Recessed Front Apollo

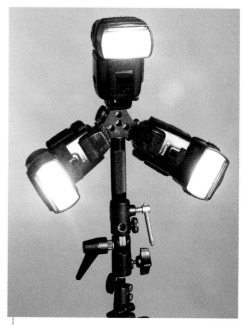

Bogen Manfrotto 2905 swivel umbrella adapter with an iDC Triple Threat Flash Bracket

With this kit, you have substantial flexibility to build a lighting mood. The two flashes can be used in many different ways to create different effects. The light stands are flexible enough to enable you to raise and lower your flashes to the position you would like, and the umbrella adapters make it possible to add further light modifiers to the stands. The light modifiers are a good start for creating beautiful lighting, but I'll explain how to get started with the full kit throughout the rest of this book.

My kit-bag

As I said, I'm a huge fan of using the right tool for the job. I do a lot of jobs, so clearly I need a heap of tools! I am often asked what I bring with me on a typical photo shoot. So here we go!

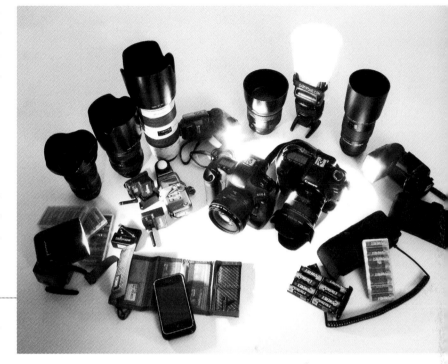

Figure 4-9: This is all the gear I take on a typical shoot, whether it's a wedding, documentary project, or corporate portraiture shoot.

List of gear

- Four Canon 580EX II Speedlites
- Two Canon CP-E4 battery packs
- 32 PowerX AA 2700 milliamp NiMH rechargeable batteries
- Two RadioPopper transmitters
- Four RadioPopper receivers
- Two Gary Fong Lightspheres
- A Sekonic L - 358 light meter
- Ten ProSpec 8GB CF cards in a ThinkTank Pixel Pocket
- One Canon EOS 1D Mark IV body

- One Canon EOS 5D Mark II body
- One 16-35mm f/2.8 L series wide angle zoom lens
- One 24 -70mm f/2.8 L series medium zoom lens
- One 70 – 200mm f/2.8 L series telephoto zoom lens
- One 80mm f/1.2 prime lens
- One 100mm f/2.8 macro lens
- One 24mm f/1.4 prime lens
- One 50mm f/1.2 prime lens

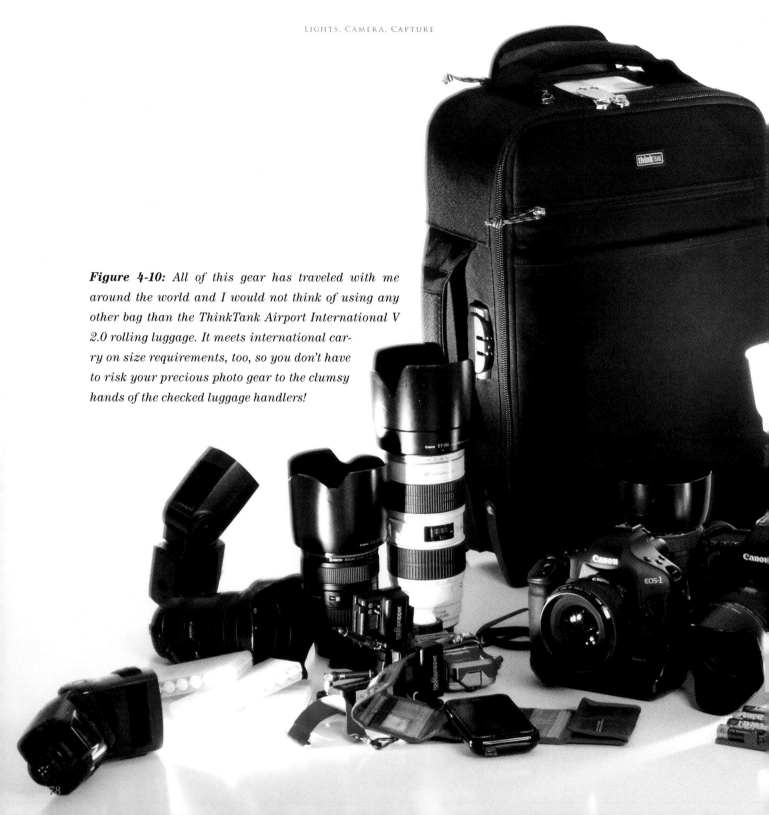

Figure 4-10: *All of this gear has traveled with me around the world and I would not think of using any other bag than the ThinkTank Airport International V 2.0 rolling luggage. It meets international carry on size requirements, too, so you don't have to risk your precious photo gear to the clumsy hands of the checked luggage handlers!*

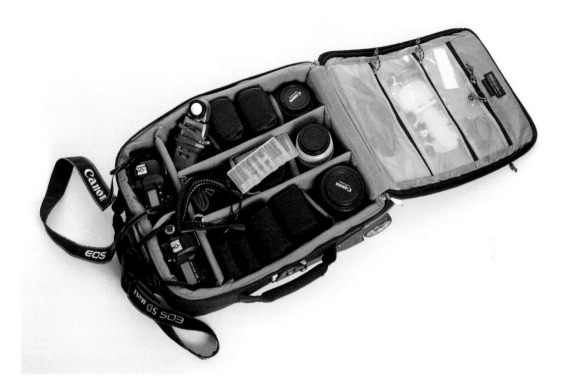

Figure 4-11: *Without more than an inch to spare, my camera bag is all packed and ready to go.*

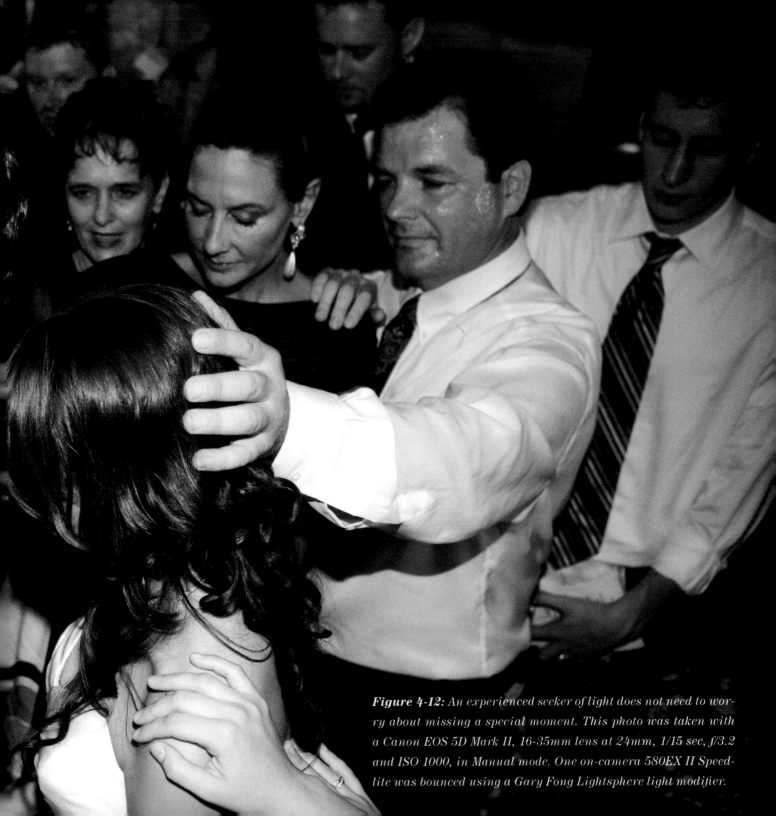

Figure 4-12: *An experienced seeker of light does not need to worry about missing a special moment. This photo was taken with a Canon EOS 5D Mark II, 16-35mm lens at 24mm, 1/15 sec, f/3.2 and ISO 1000, in Manual mode. One on-camera 580EX II Speedlite was bounced using a Gary Fong Lightsphere light modifier.*

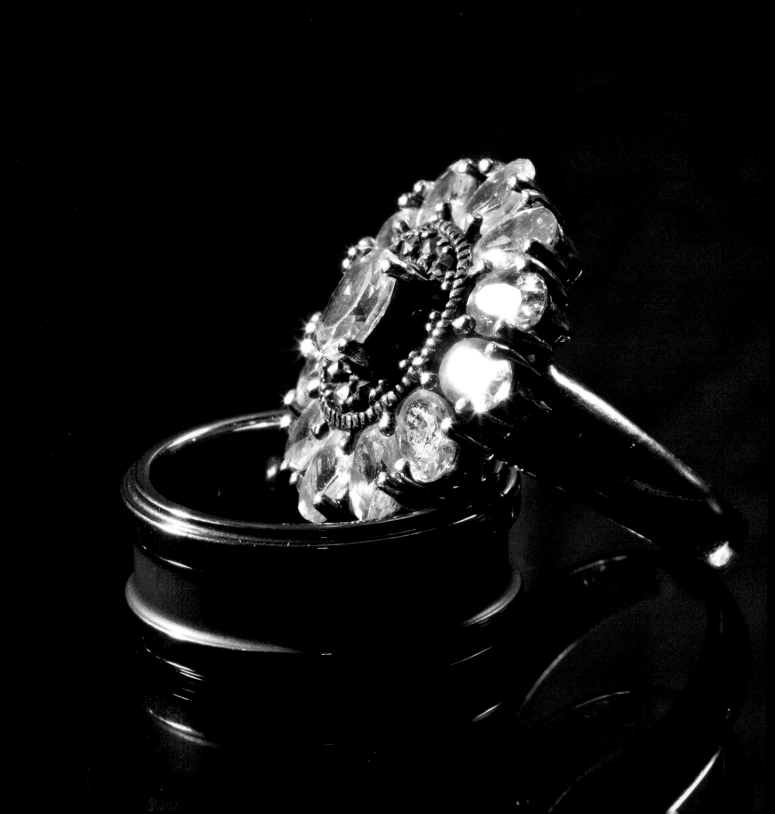

5

GETTING THE MOST FROM YOUR LIGHTING KIT

SO FAR IN THE BOOK, WE'VE COVERED THE BASICS YOU NEED IN ORDER TO BE ABLE TO TAKE FULL BENEFIT FROM THE NEXT FEW CHAPTERS. I hope you're ready because this is where the magic starts happening!

Figure 5-1: Lighting some photos will prove trickier than others, but the most important thing to remember is to work with your light and equipment. Photo was taken with a Canon EOS 50D, 100mm macro lens, 1/250 sec, f/16 and ISO 200, in Manual exposure mode.

Know your equipment

I know it's a weird note to start this chapter on, but I have been working with people on my workshops for many years, and it turns out that the first hurdle that gets some people — even people who tend to get very good results — is they don't know their equipment well enough.

Don't worry about it too much if you fit into this category. There's no need to be ashamed. To be able to understand the light and to find ways of manipulating it with your camera, flashes and accessories, you do need to know and understand your tools inside out. So this would be an excellent time to mark this page you're reading right now, dig out your camera and flash manuals, and read them!

Figure 5-1 was taken with two Canon 580EX II Speedlites off camera, flash set to E-TTL II mode. One was in group A, camera left, and one in group B back lighting the subject with a Gary Fong Lightsphere. The other flash utilized a HonlPhoto 8" Regular Speed Snoot,and was triggered via line of sight with a Canon Speedlite Transmitter ST-E2. The bulk of the flash power biased towards group A, using group B for fill.

Camera modes

I suspect that most of you know the camera modes on your camera and what they do, at least on a basic level. However, it's important to have a firm grasp of what each camera mode does and how to get the most from your flash in context of the topic of the book you're holding now.

Automatic mode (usually signified with a little green camera) puts all the control in the hands of your camera. In essence, you've just spent your hard-earned cash on a beautiful SLR, and then chosen the one setting which 'dumbs down' your camera back to the point-and-shoot Stone Age. You've made it to chapter five in a book about advanced lighting techniques, so don't ever let me catch you with your camera set to automatic!

Program mode (P) is automatic mode for serious photographers. Unlike automatic mode (the little green square, or "Auto"), Program mode enables you to take some creative control

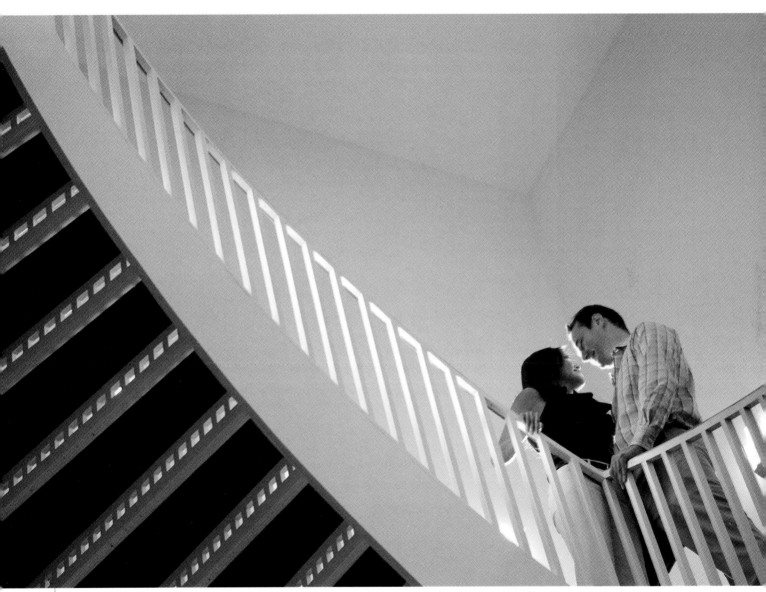

Figure 5-2: *Manual mode is your best option in complicated lighting situations. Use it when you need to be in full control of everything that's going on in a shot. In this photo, for example, I didn't trust the camera to get it right. The main subject is off to one side, plus there is substantial contrast and light sources. This photo was taken with a Canon EOS 1D Mark III, 24-70mm lens at 70mm, 1/200 sec, f/4 and ISO 640, in Manual exposure mode.*

and make some decisions yourself, like the ISO, and setting the bias of the exposure (see your camera manual for info about how to do this) towards a big aperture / fast shutter time or small aperture / slow shutter time. Program mode still won't let you go 'outside the boundaries' of a good exposure, so your photos will come out well most of the time.

Set to P, you can simply attach a flash to the hot shoe, and start taking photos. The camera and flash do all of the calculating. Program mode is nice for fill flash outside, for example, or for situations where you prefer to be left free to concentrate on 'capturing the moment' without worrying too much about the technical side of photography too much.

Manual mode (M) lets you control all aspects of your photo shoot yourself, and is your best option in complicated lighting situations. It gives the processors in your camera a vacation, and gives the big gray microprocessor between your ears a chance of a proper work-out. In manual mode, you select everything yourself. ISO, aperture, and shutter speed on the camera. For even more control, you can also manually set the flash output on the Speedlite — perfect for complicated lighting situations which might leave your camera (and strobes) confused – like **Figure 5-2**!

Figure 5-2 was taken with a Canon 580EX II flash set to E-TTL II mode, bare flash with no light modifier, triggered via a Canon Speedlite Transmitter ST-E2 with RadioPopper transmitter and receiver. The flash was placed low behind the couple to rim light them and separate them from the background.

Working with manual modes

Many people are startled when they start working with flashes connected to their camera because it can appear that the flash changes everything. It changes everything you thought you knew about photography upside down, right? Well, no, not really. This might come as a surprise, but even with a flash attached, it all makes perfect sense.

If you find yourself struggling, keep the following rule in mind. The shutter speed controls the ambient light. The aperture controls your flash output.

Say you want to photograph a scene with two dancers posing in a ballroom. The room is lit with hundreds and hundreds of gorgeous little candles, and you have a wide array of flash equipment at your disposal.

There are two extremes in the way you can photograph this scene. Leave all your flashes in their carrying bags, and take a high-ISO photo of the dancers lit by candle light. The background will look phenomenal, but good luck making the models look good. The other extreme is to light the models fully, and take the photo with the flashes at full blast. The dancers will come out beautifully, and you will barely see the candles in the background at all.

Figure 5-3: For photos like this, don't trust anything other than manual mode. You need the control to pull off the shots properly! This photo was taken with a Canon EOS 1D Mark III, 24mm, 1/4 sec, f/2.0 and ISO 1000, in Manual exposure mode, of course.

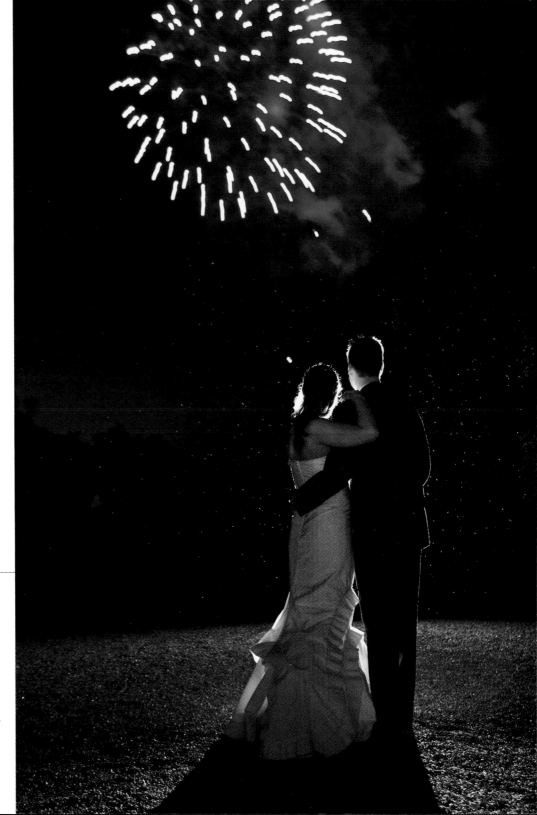

To get a happy medium, you could play with flash compensation, but let's do this properly. Go to manual mode and remember the rule. Shutter speed controls the ambient light — so if you have a slower shutter speed, you'll be able to see the room and the candles well. A faster shutter speed will make the ambient light (the candles) seem less bright.

Your aperture setting controls the flash output. If you have a wide aperture, you let significant light onto the imaging sensor, so the flashes don't have to work too hard. If you use a small aperture, the flashes have to pump out vast quantities of light to get the exposure right.

TIP:

> Write this down, and tape it to the back of your camera. Aperture = flash output. Shutter Speed = ambient light. It's the single most important thing to remember when working with flash photography!

Let's put what we know now together in one photograph; as shown in **Figure 5-3**. For this photo, the scene is obviously very dark indeed, but we do want to capture the fireworks and the happy couple well. Let's dial in ISO 1000 to start with, to capture some of the dusk scene. Now, let's get the flash output right. It's dark, so the flashes have to work quite hard anyway, so let's pick a relatively big aperture. F/2.0 or your largest aperture should do it. Now, we need to dial in the background as well. If you want most of it visible, select a slower shutter speed. If you want the background to appear 'dimmed' in comparison with your foreground, you can select a higher shutter speed. And, of course, if you want the background gone altogether, take the shutter speed as high as your flash sync will allow — usually 1/250 second (or faster - but more about high speed flash sync later in this chapter).

TIP:

> Your flashes are happiest when they don't have to work at full capacity. When you are shooting at a small aperture, your flashes have to work harder. Help them out by keeping your aperture under f/5.6 when working with small strobes. If you your flashes are struggling, use a bigger aperture or higher ISO!

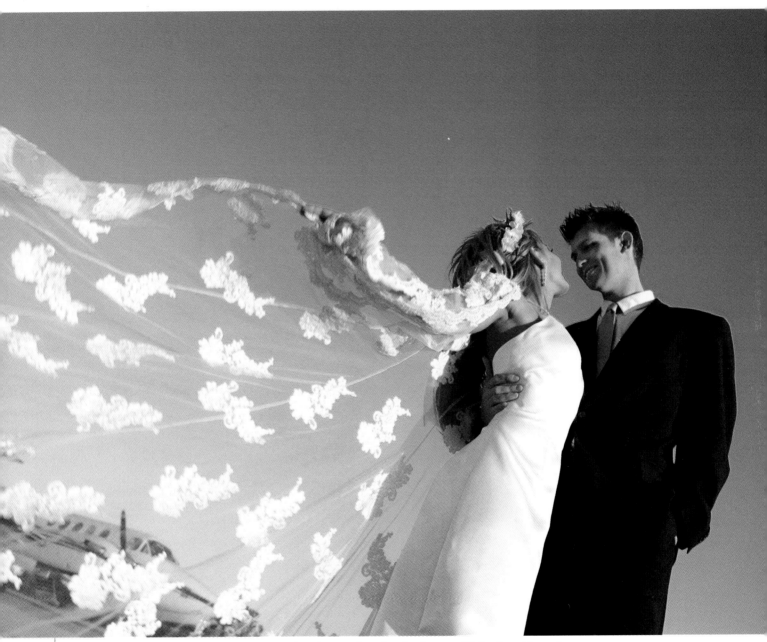

Figure 5-4: *Aperture priority is fantastic when using the flashes as fill-flash outdoors! The photo was taken with a 16-35mm lens at 28mm, 1/200 sec, f/7.1 and ISO 200, in Aperture Priority exposure mode.*

Aperture and Shutter priority modes

Now that you know how flash photography works in full manual, you might be left wondering, "Hey, what about the two semi-automatic modes? Aren't they useful at all?"

Of course they're useful, but you have to be comfortable using them. Many photographers choose to stick with program or manual mode, but I think it's important to understand what each mode does and how it works. When you're taking photos in a high-pressure situation, you don't want to have to change your manual settings every few shots, so it can often be a good idea to let the camera do some of the thinking for you.

Aperture priority (Av)

Aperture value (Av) mode enables you to select the aperture you want. The camera will select a shutter speed which it thinks will complement the aperture you've selected. Remember shutter speed is for ambient light, so what the camera is trying to do in aperture mode is to get the flash exposure spot-on, based on the aperture you've selected. It will then try to select a shutter speed so the ambient light is correctly exposed.

You'll often find that Av mode can be a little temperamental - especially if you're photographing in settings with low light. Your exposures will come out well, because your flash and aperture are taking care of business there. Then your camera will just sit there, in your hands, for what seems like ages, trying to get a decent exposure in the dark, which might take anywhere from an instant up to a few seconds. That's no way to get good photos. However, if you are just trying to get a hint of the background and not a perfect exposure, stick to manual mode.

TIP: ───────────────────────────────────

> In very low light, it is best to use Manual mode over (Av) mode.

If you're shooting in relatively well-lit situations or if you're working with mixed light sources, Av mode is your friend, as it gives you great control over your flashes, while your camera will look after the background and the available light for you. This enables you to concentrate on the foreground, to really make your photos pop.

Learn more about mixed light sources in Chapter 6, "Controlling the Light"

Shutter priority (Tv)

Shutter priority can also work very well when you're working with flash photography.

You should use shutter priority mode when you want to make absolutely sure that you have images without any motion blur. I might decide to use shutter priority mode during the processional and recessional at a wedding, for example.

To use this mode efficiently, I would choose the shutter speed that I know would cut down on the amount of ambient light in the image. In a relatively well-lit church, I might be shooting at ISO 800. I want to use flash, but I don't want to take a chance of motion blur occurring. I would choose a shutter speed of 1/125th of a second. The camera will choose the appropriate aperture.

You'll often find that the camera will open up the aperture as wide as possible to allow all the available light the lens will allow. If you are using a f/2.8 lens, that's what the camera would choose. From my experience in this situation, I have a good 'feel' for what the lighting is like. Don't worry if you're not there quite yet – this experience comes with time and practice.

TIP: ────────────────────────────────

> To fully 'learn' a new photography mode, try shooting only in that mode for a day. You might get frustrated at first, but you'll start getting a feel for in which lighting that particular mode is most useful—and in what situations it is best avoided.

I know that at 1/125th of a second at ISO 800 there is not enough ambient light to affect the photograph, so I can be confident that my pictures will be free of motion blur.

Shutter priority mode works well in brightly light scenes too, but remember to use higher shutter speeds, and turn on the high speed sync feature of your flash and camera. Choose the corresponding shutter speed that will give the desired result.

Having said all that, personally, I would use manual mode in both of the situations above, but it is important to know that flash photography works in all modes, with different

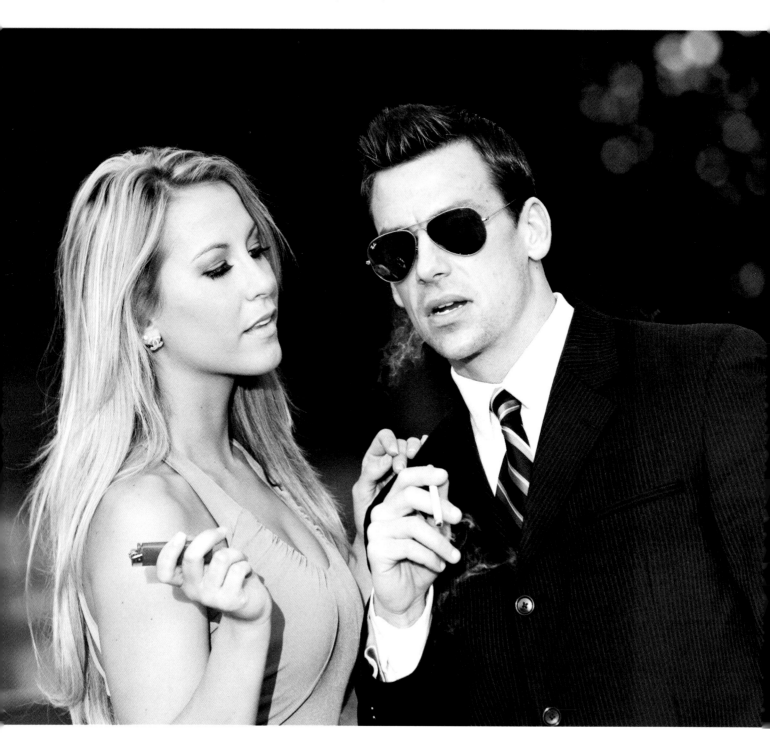

results from each mode. Before you discard a camera mode as 'not useful', I would suggest you experiment with it in a variety of settings, and learn which modes work best for you.

Flash modes

There is so much more to flash photography than the settings on your camera, of course. Flashes themselves are far more advanced than they used to be. No longer just dumb blinking lights, modern on-camera flashguns are stuffed full of electronics themselves. Thankfully they are all designed to make it easier and faster to get creative as a photographer.

Just like your camera, a flash has a series of different modes of operation.

E-TTL

Evaluative through the lens (or E-TTL) is the Rolls Royce of flash systems and truly incredible when you think about it. When set to E-TTL mode, all your flashes work together with your camera to calculate the correct exposure and flash output. When you press the shutter (or the exposure lock button), the camera sends a signal to your flashes to blink. This "blink" measures the light from where they sit, calculates how much flash output is needed, then sends a second signal to your flashes. This data also includes how powerful each flash needs to be. Of course this all happens before firing all the flashes and taking the photo. All of this would have been impressive enough if the camera was only communicating with the flash that's physically attached to your camera via the hotshoe, but it gets better. It all happens in a fraction of a fraction of a second, wirelessly. Wow!

Figure 5-5: E-TTL is pretty amazing technology which results in perfect exposures in most lighting situations. This photo was taken with a Canon EOS 1D Mark III, 70-200mm IS lens at 200mm, 1/160 sec, f/4 and ISO 320, in Aperture Priority exposure mode.

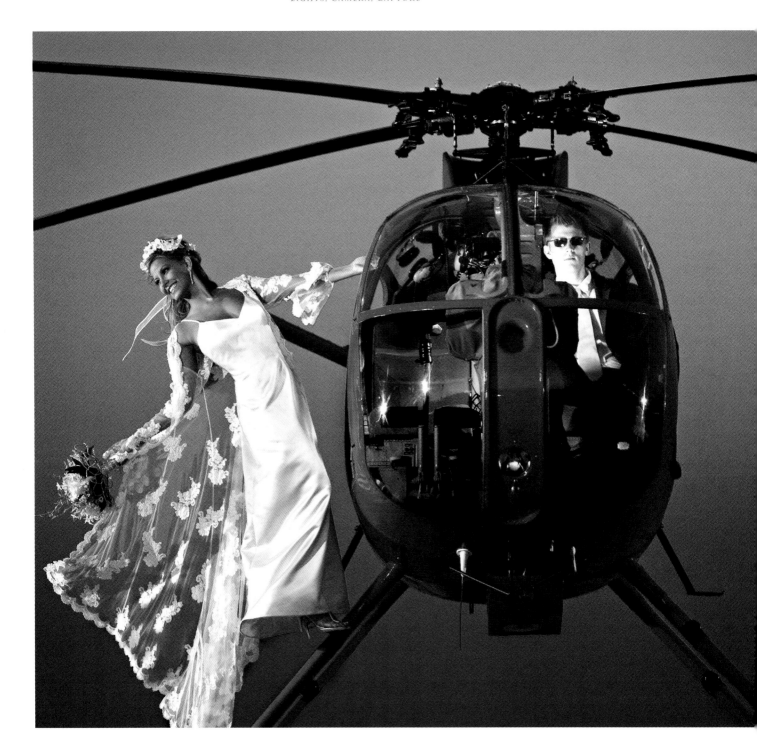

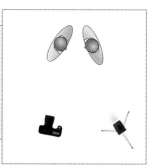

Figure 5-5 was taken with just a single flash - a Canon Speedlite 580EX II - set to E-TTL II mode to give the camera free reign in choosing the appropriate flash output for the lighting situation. The flash was triggered via a Canon Speedlite Transmitter ST-E2 with RadioPopper transmitter and receiver.

Figure 5-6: Once you've started 'seeing the light', all that stands between you and fantastic photos like this is a little bit of imagination – and the technical skills you're learning to match, of course. This photo was taken with a Canon EOS 1D Mark III, 70-200mm IS lens at 85mm, 1/160 sec, f/4 and ISO 200, in Manual exposure mode.

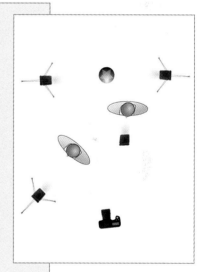

Figure 5-6 was not a simple shot as I had to use four strobes to create this photograph. All of the strobes were off camera. I used one Canon 580EX II inside the cockpit of the helicopter in group C, E-TTL II mode. Two Quantum Qflashes in group B, to light the sides of the red helicopter, E-TTL mode. One Canon 580EX II Speedlite was set high and to left of the model in group A, E-TTL II mode. All the flashes were triggered via a Canon 580EX II Speedlite on-camera set to be the master flash, but only as a trigger and not contributing light to the scene. Flashes were triggered using RadioPopper transmitter and receivers. Therefore, all flash out put was controlled from camera.

The next time you press the camera shutter, think about everything that happens and the consistency of your results. I've used it for many years now, but whenever I stop to think how it all works, I'm amazed. Using E-TTL is nothing short of astonishing, and the technology involved is one of the things that make working with flashes so exciting.

Fixing half closed eyes

Do you have a friend who always seems to have their eyes half closed in photographs? There's a scientific explanation for this. Put simply, that person has a very fast reaction time. In normal E-TTL mode, your flash fires a pre-flash to calculate the exposure. Some people react to this pre-flash and start to blink their eyes involuntarily, so when the full-strength flash fires, their eyes are already half-closed.

You can fire the pre-flash ahead of time by using the exposure lock button on your camera. Exposure Lock (EL) ensures that the light measuring is done ahead of time, so the pre-flash is over and done with. Nobody can react quickly enough to blink their eyes to the normal flash. Now your problem is solved!

Automatic

Automatic is a less advanced mode compared to the more modern measuring methods which we'll get to in just a minute. Automatic mode has been around for many years, and it is showing its age. When you use Automatic mode, you set the distance to the subject on the flash, and then the flash determines its own flash output. If you're using multiple flashes, they all do their light measuring at the same time. If you introduce more flashes, they do consider each other in the process, but the amount of control you have over the process diminishes significantly. If you use different brands or types of flashes, they might be ever so slightly mismatched. Unfortunately, it might be just enough to throw your exposure off. The solution is usually to switch to manual mode or to use one of the more advanced flash metering modes, like E-TTL.

Manual

In manual mode, the flash goes back to being a 'dumb flashing brick'. You have to choose each individual setting yourself, usually expressed as a fraction of full output power.

When you have a flash set to manual mode, you select its output as a fraction of the maximum output. If you have a set of identical flashes, they will be roughly comparable, so an output of 1/8th from both flashes will result in equivalent output from each flash.

TIP: ───────────────────────────────

> Do not use the LCD screen on your camera as an indication of whether the exposure is correct: Use the camera's histogram mode instead, as we talked about in Chapter 3, "Getting the Basics Right".

Do bear in mind that if you have more powerful flashes mixed in with others, the fractions will be different, which makes setting up the flashes a little bit more complicated. This is where you can use the LCD screen on the back of your camera to good use. Keep taking test shots to balance the strength of the flash outputs to create the effect you want.

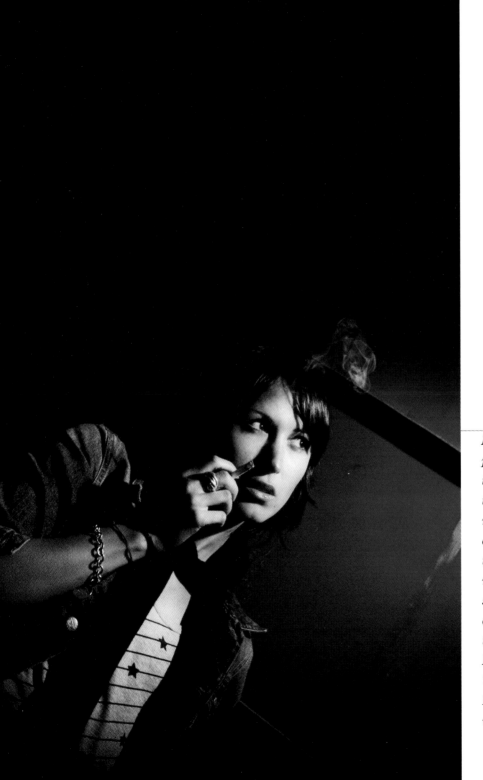

Figure 5-7: *When taking pictures in a studio setting, there's no point in making the camera measure and re-measure the lighting every shot. Nothing is going to change anyway, so you may as well guarantee consistency by setting the flash output manually. Photo was taken with a Canon EOS 1D Mark II 70-200mm IS lens at 75mm, 1/200 sec, f/2.8 and ISO 200, in Manual exposure mode.*

Figure 5-7 was taken with one Canon 580EX Speedlite in E-TTL mode, held high to camera right by a Voice Activated Human Light stand, in other words the person who was available to hold the flash for me. The flash head was manually zoomed to 105mm to vignette beam of light emitting from the flash. No light modifiers were used. The flash was triggered via the Canon Speedlite Transmitter ST-E2.

A deeper understanding: How a flash works

We talk in more detail about the advantages of high-speed flash sync and rear curtain sync in Chapter 7, "Getting Creative".

In normal modes, your flash can sync with your camera up to a certain shutter speed. Back in the day, this used to be 1/60 second as standard on most cameras. These days, standard flash sync is 1/200th or 1/250th of a second for most cameras.

To understand why you might need high-speed flash synchronization, you need to understand how a flash is triggered by a camera.

Inside your camera, there are two curtains (also known as 'curtain shutters' or just 'shutters') that move across the sensor. Think of your sensor as a window that has two curtains that are both able to cover the window completely. When you press the shutter button on your camera, one curtain is pulled from left to right, which leaves the window exposed. At the end of the exposure, the second curtain is pulled across to cover the window again. Once the exposure is complete, both curtains are moved back to the left, ready for the next exposure.

Forgive the history lesson, but you might be interested to know that on film-based cameras with a manual advance lever, these curtains would be on springs. When you were flicking the lever to forward to the next frame on your roll of film, you were, unbeknownst to you, pulling the two curtains back in preparation for the next exposure. The flash was triggered mechanically, by creating an electrical connection when the shutters were fully opened. This mechanical connection (and the limitations of the springs used in old cameras) is the reason why early cameras could only 'sync' to 1/60th of a second.

High speed flash sync (FP)

Most cameras have a Focal Plane (FP) or High Speed flash synchronization mode. It changes the way your flash works, allowing you to take photos at much higher shutter speeds.

When your flash is in normal mode, the following happens: You press the shutter, the first curtain of the shutter opens fully, the camera sends a signal to the flashes, and the flashes fire. At the end of the exposure (whether the exposure is short or long), the second curtain is pulled across to finish the exposure.

When you start talking about very fast exposures — like the 1/8000 second exposure offered by cutting-edge SLR cameras (or even at lesser shutter speeds, like the 1/400th of a second shutter speed used in **Figure 5-8**) something interesting happens.

Because the shutter has to be open for such a brief period of time, the closing shutter actually starts moving before the opening shutter has finished moving. The effect is that the whole imaging chip does get the same amount of light, but the chip might never be exposed all at the same time.

If you're shooting in natural light, this isn't a problem at all. But if you want to add a flash to the mix, it becomes tricky. If the shutter is never fully open, when do you fire the flashes? Flash manufacturers, realizing that people still wanted to use flash even at high shutter speeds, came up with a solution. High speed sync mode. When the flash is set to high-speed mode, it works differently. Instead of a single flash once the shutter opens, the flash actually sends lots of tiny flash pulses. This ensures that the subject is evenly lit for the duration of the exposure as the shutter curtains move across the sensor.

In high speed sync mode, your flashes do take significantly more power, so you drain the batteries much faster. Of course, if you need it, use it. The effects can be incredible, and it gives you even greater flexibility in your photographic work.

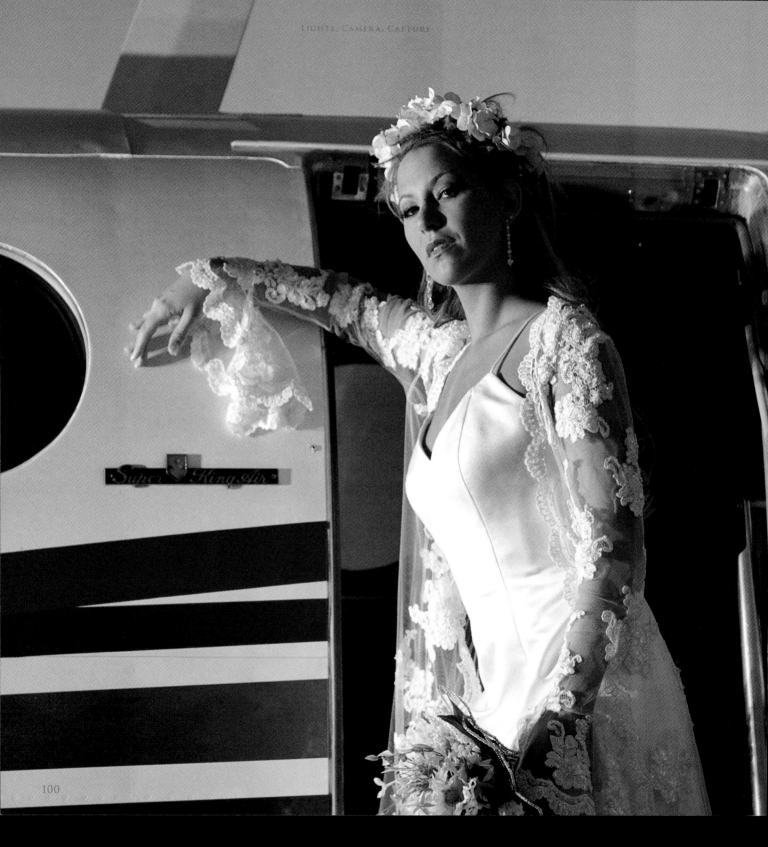

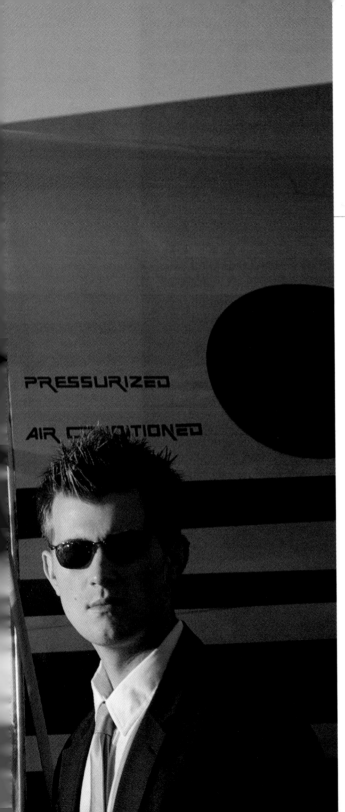

***Figure* 5-8:** *This photo is a double whammy. I've used high-speed flash sync and aperture Priority mode, but it also shows a lovely example of the kind of light you can expect in the Golden Hour. This photo was taken with a Canon EOS 1D Mark III, 70-200mm lens at 100mm, 1/500 sec, f/4 and ISO 200, in Manual exposure mode.*

Figure 5-8 was taken with a Canon 580EX II Speedlite with a ¼ CTO gel to warm up the flash to resemble sunset light. The flash was set to E-TTL II mode and triggered via a Canon Speedlite Transmitter ST-E2 with RadioPopper transmitter and receiver.

Rear curtain sync

As I explained earlier in this chapter, in normal flash mode, the flash usually fires when the first curtain is fully opened. This works well for most photography, but you may want a creative effect. Say you're out photographing at dusk and you want to photograph a moving car with a flash. You want to make it seem as if the car is moving. So, you set up your camera on a tripod, get your lights set up, and get someone to drive the car past from right to left. As it drives into your field of view, you click the shutter. The flashes fire, the shutter stays open for 1/20th of a second, and then closes.

Answer quick: What would this photo look like? If you're advanced in the art of seeking light, it should be easy. The car will be well lit, in the left end of the frame. Then, the car's headlights continue off to the right of the frame. When you look back at the photo, it looks as if the car is driving backwards at full speed. After all, the lights extend from the front of the car. That wasn't the effect we wanted!

This is where rear-curtain sync comes in. When you set the camera and flash to fire the flashes in rear-curtain sync, it will send the signal to the flashes just before the shutter closes, instead of just after it has opened. If you were to repeat the above photo with rear-curtain sync, you would get a set of streaks of lights, and the car well lit to the right of the photo. Because of the way our brains work, the light streaks to the rear of the car makes it look as if it is racing along at high speed. Much better!

Everything we've spoken about in this chapter goes back to one of the things I said right at the beginning of the book: Know your equipment. Not everything discussed here will be in your camera or flash manual, but knowing and understanding how your camera and flash work will help you realize the photos you are creating in your mind's eye.

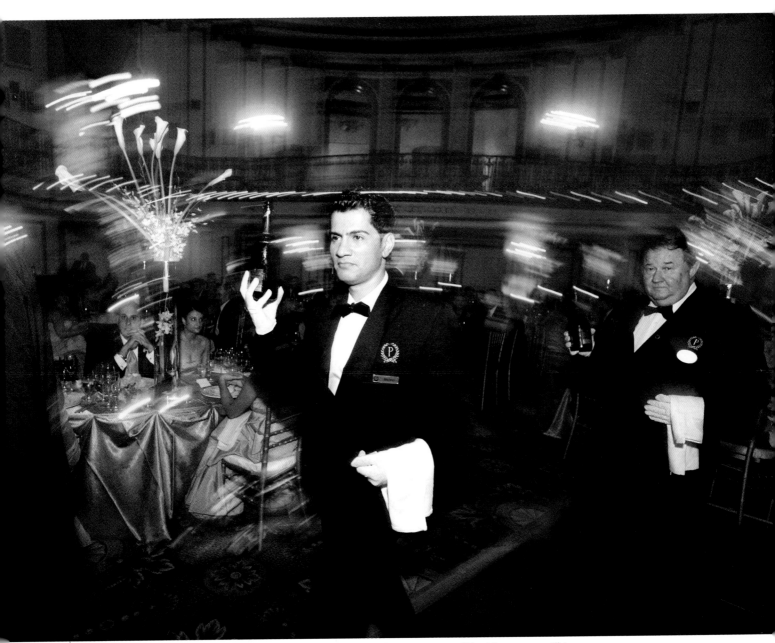

Figure 5-9: *By using rear-curtain sync you get a much more compelling "movement" to a photograph because the motion blur elicits a felling of speed. This photo was taken with a Canon EOS 5D 16-35mm lens at 17mm, 1/15 sec, f/3.5 and ISO 800, in Manual exposure mode with rear-curtain sync.*

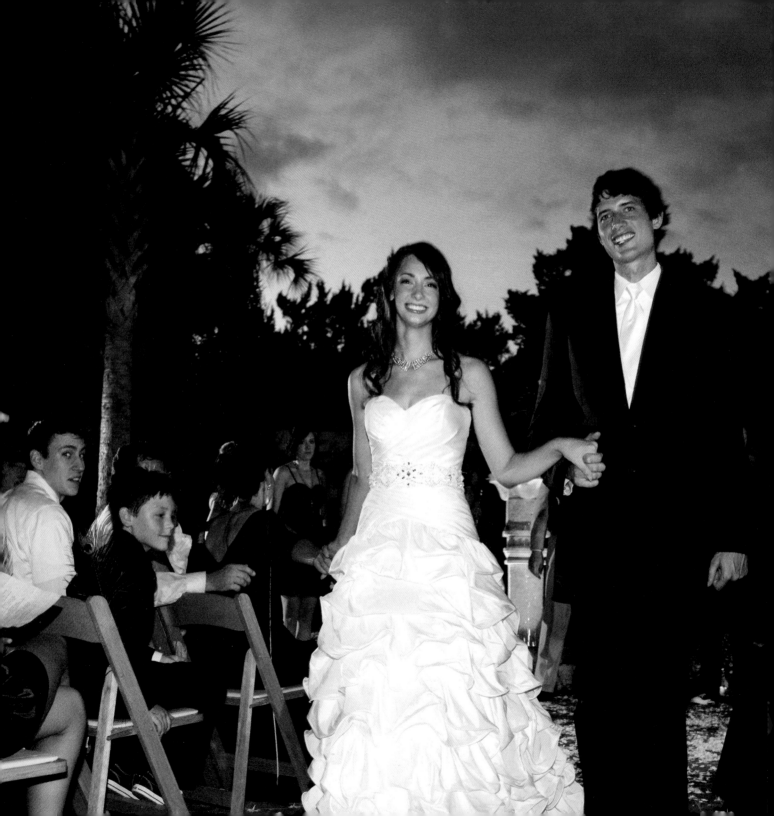

Figure 5-10: *An ounce of planning is worth a pound of cure: By setting up the lights in advance, I was ready to take this shot once the happy couple walks back up the aisle. This photo was taken with a Canon EOS 5D Mark II, 24-70mm lens at 24mm, 1/30 sec, f/2.8 and ISO 1000, in Manual mode. One on-camera 580EX II Speedlite was bounced using a Light-sphere in E-TTL II mode as the master and two off-camera 580EX II Speedlites triggered via the master using RadioPop-per transmitter and receivers.*

6

CONTROLLING THE LIGHT

STROBES GIVE YOU AN INCREDIBLE SENSE OF FLEXIBILITY IN YOUR APPROACH TO LIGHT, LARGELY DUE TO THE MANY DIFFERENT WAYS YOU CAN MANIPULATE AND ADJUST THEIR OUTPUT.

Figure 6-1: Who would have thought it's possible to take awesome photos without even lighting the foreground. This photo was taken with a Canon EOS 5D Mark II, 50mm f/1.2 lens, 1/60 sec, f/4.5 at ISO 400 in manual mode. Backlighting was created using a Canon 580EX II Speedlite, Canon ST-E2 Speedlite Transmitter controlled by a RadioPopper transmitter and receiver.

Your flexibility increases significantly if you are able to move the flash away from the camera's hotshoe because you can position it exactly where you would like it, independent of where and how you position your camera. Add more than one flash to the mix, and you're straying even further into creative territory. Create the light you want anywhere.

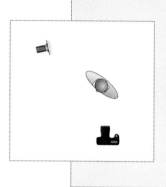

Figure 6-1 was taken with two Canon 580EX II Speedlites, in E-TTL II mode, triggered using the Canon Speedlite Transmitter ST-E2. The foreground light on the model was modified using a Westcott Bruce Dorn Select Asymmetrical Stripbank and the hair light is a bare 580EX II Speedlite with the flash head zoomed to 105mm to focus the light onto the back of her head. The Speedlites were in two different groups to control the light output from each Speedlite independently. The foreground Speedlite was in group B and the hair light was in group A. I wanted a kiss of light from the hair light to create some separation from the background. With the 'hair light' set to group A, I dialed the power up to group B, the foreground Speedlite in the strip light soft box.

As we've hinted at throughout this book, there's so much more to using flashes than where you place them and which way they are pointing. In this chapter, we're going to stand proud, say "Let there be light," and empower you to control the light in any situation.

If controlling the light sounds like hard work then I'm afraid I'll have to agree with you. Yet, in my opinion, really taking control of your lights – whether its available light or that added to a scene with strobes – is one of the most fun and creative aspects of digital photography.

Before we get too entrenched in the techniques themselves, I'd just like to say this: There is no 'right' way or 'wrong' way to use flash. There are hundreds of different ways to use your flash and the purpose of any lighting exercise is to use the flash effectively. By effectively, I mean that the flash accents the images for the best overall quality possible. There are three ways to fulfill that goal: Practice, practice and practice.

Simple techniques with a single strobe

Before we get into discussing lighting techniques using a single strobe, I should disclaim that I never travel with less than two Speedlites. The more Speedlites you have at your

Figure 6-2: Sometimes, less is more: The subtle lighting of this model really sets the mood for this shot – imagine what it would look like if we had used direct flash! This photo was taken with a Canon EOS 1D Mark IIN, 70-200mm at 70mm, 1/200 sec, f/2.8 and ISO 200, in Manual exposure mode.

disposal the greater your creative potential. One of my mantras is always be prepared, and in my experience two Speedlites is the bare minimum that allows me to get the shots that I want. Regardless of whether I'm expecting to simply shoot candids of my family or go on a serious shoot, I always carry at least two Speedlites.

Figure 6-2 was lit using a Canon 580EX II flash in E-TTL II mode controlled from camera, triggered using a Canon Speedlite Transmitter ST-E2 with RadioPopper PX transmitter attached to the ST-E2 and the receiver attached to the Speedlite. The 580EX II had a full CTO gel (color temperature orange) over the flash head to create a dramatic colorful silhouette in an otherwise uninteresting environment.

Of course, if you find yourself out with only one strobe, it doesn't mean that all hope is gone of catching a good photo. **Figure 6-1**, for example, is taken with simple lighting using a single strobe. This chapter collects a series of techniques and ideas to help you along. If you're not too familiar working with a flash, it would certainly be worth trying the single-lightsource techniques out before you start out with multi-flash set-ups. Best of all, the effect of these one-flash techniques all work exactly the same whether you have a single strobe attached to your camera, or if the strobe you're working with is one of five you've set up around the room to get an awesome capture.

Direct flash

The simplest way of using a flash is to simply attach it to your camera, point it at what you're trying to take a photo of, and press the shutter button. It isn't hard to use direct flash, but it isn't pretty either. Most of the time, direct flash will produce an image where the main subject is very bright and the background is very dark. Additionally, if you're close to a wall, there'll be a harsh shadow behind your subject.

If you are shooting with direct flash on a camera, it'll light the subject, and the photos will probably be exposed decently, but because the light comes from the same direction of the camera, you'll get very flat light. Direct flash is the curse of compact cameras because its users have no choice. The flash is built into the camera body, right next to the lens, but it's possible to get similarly horrendous results with a high-end strobe

attached to a digital SLR – just see my less-than-attractive example in **Figure 6-3**.

Figure 6-3: Direct flash rarely gives a good result, and this is no exception. Considering how easy it is to light photos like this so they look much better, I can barely stand to look at this image! This photo was taken using a Canon EOS 5D Mark II, 24-105mm f/4.0 IS lens at 105mm, Program mode, on-camera Canon 580EX II Speedlite, E-TTL II mode, 1/60th sec with f/4.0, ISO 400.

The light from a direct flash is unflattering. If you've come along far enough to acquire a proper strobe, there's no excuse of making that mistake anymore!

Bounce flash

From direct flash, you can make a really easy adjustment which will give your images a huge lift in quality: Bounce your flash.

Light from your flash will reflect off surfaces. You can use this to your advantage by tilting or rotating your flash head to point towards a suitable surface. If you have a white ceiling, for example, you can point your flash upwards to reflect (or 'bounce') the light. The result is staggeringly different from using direct flash. The harsh shadows are eliminated, your subject will be lit much more evenly, and the light looks much more natural.

Figure 6-4: Don't underestimate the impact and power of a simple bounced flash. Just look at the impact and the moving story contained in this simple photo! This photo was taken with a Canon EOS 5D 16-35mm lens at 35mm, 130 sec, f/2.8 and ISO 400, in Manual exposure mode. The lighting was down with a Canon 580EX II Speedlite in E-TTL mode, with +1/3 flash exposure compensation, bounced off the ceiling with a white reflector card to push some light forward.

TIP:

> Amaze your friends by bouncing the light on a compact camera some time: Use a white business card to reflect the flash light upwards to a white ceiling. The difference is stunning. It is scarcely believable how much better a picture can look!

When you bounce your flash, remember that the light has to travel much further than usual, and you will 'lose' brightness of light in the process. Your Speedlite is more powerful than the flash that might be built-in to some SLR camera bodies (and certainly more powerful than the ones built into compact cameras).

From a lighting perspective, when you point your flash towards the ceiling, you are turning the white surface above your head into an enormous light source. This is what makes the light in your image so much softer and more appealing!

Figure 6-5: *Without fill flash, this self portrait isn't worth much. This photo was taken with a Canon EOS 1Ds Mark III, 16-35mm f/2.8 zoom lens at 16mm, 1/800 sec, f/8 and ISO 100, in Manual exposure mode, no flash.*

When you are taking photos with a bounced flash, your flash might not be up to the job of lighting the whole scene anymore. If your photos are coming out darker than planned, consider using a larger aperture or a higher ISO value on your camera.

There are many ways you can bounce flash light, but before you read on, I'd recommend you experiment a little to see the various results. Point your flash directly upward and compare the resulting photo with a shot where you point the flash 45 degree upwards. Try to bounce your light sideways, off a wall. Bounce it off the floor. Can you see how the different types of light make a difference?

Another thing that could be interesting to try out is to reflect your flash light off colored surfaces. What happens if you try to bounce light via a green curtain, a blue wall, or a red book case? Try it, and take a note of what happens. You never know when these effects will come in handy on a shoot at some point in the future!

Figure 6-6: *Much better! I mounted a camera onto my mountain bike and fired two strobes and the camera remotely. I used my Pocket Wizard to fire the camera and the RadioPoppers to fire the strobes. This photo was taken with a Canon EOS 1Ds Mark III, 16–35mm lens at 16mm, 1/25 sec, f/22 and ISO 50, in Shutter Priority exposure mode, using two Canon 580EX II Speedlites.*

Fill flash

Remember earlier in this chapter, where I said that direct flash should always be avoided? I lied. There is an exception. If you're outside, photographing on a bright and sunny day, you can use a 'fill flash' to make your photos pop.

You've probably taken photos in direct sunshine before and you'll have seen what happens. The sun is bright and shadows on your model's face are very harsh – see **Figure 6-5** for an excellent example of what not to do. In some situations, you could try to use a reflector to 'lift' the shadows a little, but I dare you to try and ride ahead of me in this situation with a reflector and catch a decent photograph!

Luckily, the problem can be remedied with a flash. The idea is to add enough light to the scene to 'fill' the shadows, hence the term 'fill flash'. How much flash light you need for an

image depends on how far away you are from the model, how bright the sun is, and how much of the shadow you want to remove. Often, you need just the slightest kiss of light to make the image come out beautifully. If you're photographing straight into the sun, you're going to need a bit more oomph to get a good shot.

In **Figure 6-6**, I was photographing straight into the sunlight, which demands some funky lighting. The camera was mounted to my bike using a Bogen Manfrotto Super Clamp and variable friction magic arm with camera bracket. The camera was fired using a hard-wired Pocket Wizard, the on-camera Canon 580EX II Speedlite was the master in group A, wirelessly firing the remote slave Speedlite in group B. I used RadioPoppers to communicate between master and slave Speedlites. Group A Speedlite being the main and group B Speedlite being the fill on the side.

I used shutter priority mode on camera in **Figure 6-6** so I could control the shutter speed. I wanted to create the feeling motion and speed, so I chose a slow shutter speed. The flash froze the action on me in the foreground and adding enough fill flash to bring out the details in my face while being back-lit by the sun. The Speedlites were in E-TTL II mode, allowing the camera and Speedlite to do the heavy lifting at calculating proper flash exposure on the fly.

To get more control of the way photos look when I'm working with fill flash, I prefer to use aperture priority mode. When you're using aperture priority mode, I suggest experimenting to get the effect you desire. Point the flash directly at your subject, without using a diffuser, and experiment with the flash output to get the photo just right.

As an exercise, think about this for a minute: Why is it suddenly okay to use direct flash light outside in bright sunshine?

In bright sunshine, you need substantial light to overpower the sun. It is doable (and we'll look at how to do it in chapter 7 "Getting extra creative"), but you're probably not going to pull it off with a single strobe. As such, the sun is your main light source. Imagine the sun is up and to the right, for example. That's perfect lighting to give your model definition and three-dimensionality to your photo. Your direct Speedlite, which would have been unflattering and amateurish in an indoor setting, is a complementary light in this situation-perfect!

Taking the flash off-camera

You've got a healthy taste for how you can use a single flash in your camera's hot shoe, but that's only the beginning. We have talked about why it's a problem to use direct flash; the light is typically incredibly unflattering.

Figure 6-7: By simply moving the flash off the camera, up, and to the left, you dramatically change the way the light looks and can end up with something as lovely as this! This photo was taken with a Canon EOS 1D Mark III, 70-200mm IS lens at 120mm, 1/640 sec, f/4 and ISO 200, in Manual exposure mode

Figure 6-7 was taken with a Canon 580EX II Speedlite off-camera to the left in E-TTL II mode fired wirelessly using a Canon Speedlite Transmitter ST-E2 with RadioPopper transmitter and receiver.

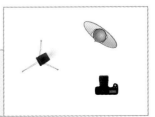

As we saw in **Figure 6-3**, direct flash can be flat, bright, and horrible. Predominately the viewer of a photograph taken with direct flash will think that the lighting appears unnatural. Why? Well, think about it: when do you look at something where the light source comes from the same angle as you, the viewer? The sun is overhead. Lights in your house hang from the ceiling or sit off to the side on tables, which is exactly why a direct on-camera flash usually looks unnatural.

Figure 6-8: Move the light around for even more creative effects. In this case, backlighting the subjects created a rim light effect to separate them from the background. This photo was taken with a Canon EOS 5D Mark II, 70-200mm IS lens at 110mm, 1/30 sec, f/2.8 and ISO 800, in Manual exposure mode.

Figure 6-8 was taken using a remote slave Canon 580EX II Speedlite triggered with a Canon Speedlite Transmitter ST-E2 with RadioPopper transmitter and receiver in E-TTL II mode with + 1 stop of flash exposure compensation. The city lights were actually the lights of Las Vegas, but the location was quite dark, so I had to use a high ISO. Placing the strobe behind the subjects separated them from the background, which effectively draws your eyes to the subject's eyes.

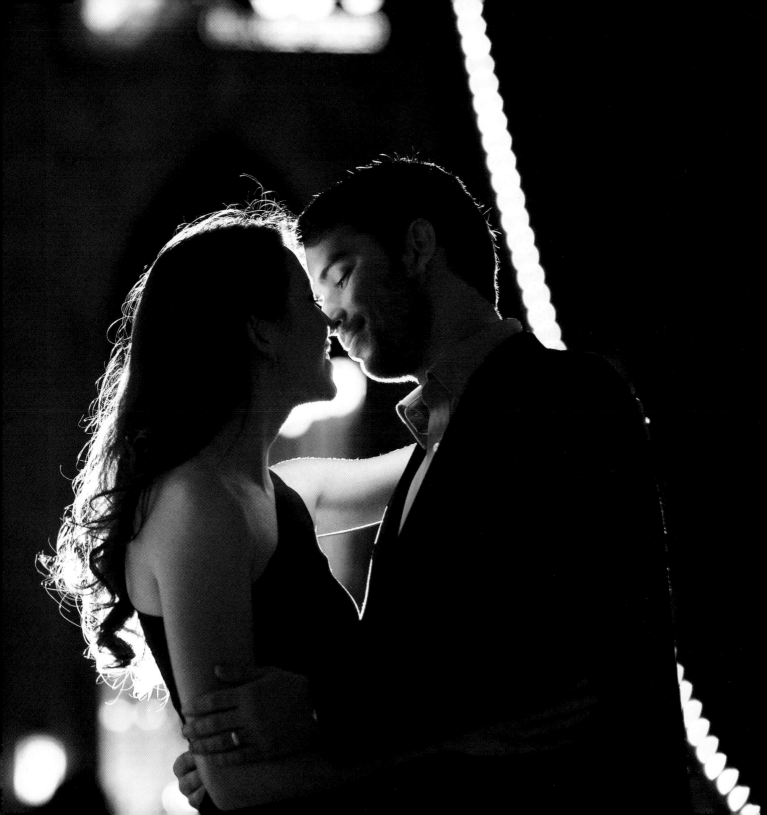

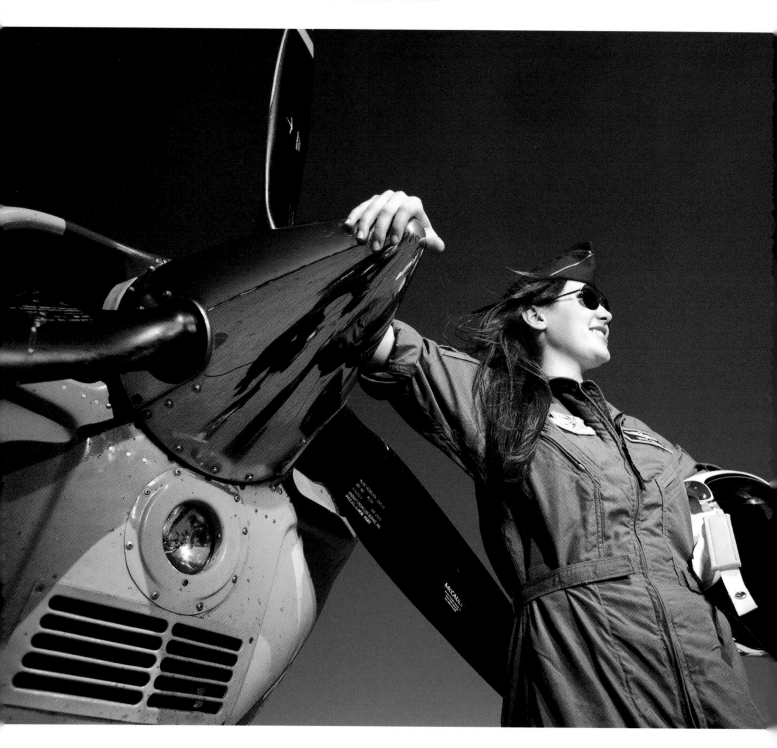

Even if we continue working with one flash, we can improve the way it looks massively by simply taking it off the camera, and moving it to another location. Get it high above the camera and off to the left (like in **Figure 6-7**) or right, for example, and you get a drastic change in the way the light looks. Or move it further still, and get a creative effect – like in **Figure 6-8.**

By moving the light off to one side, hints of a shadows starts appearing on a person's face, which adds a sense of depth. Overall, this is always a much better look. As photographers, we work in a two dimensional media, and yet, light creates depth giving you space and dimension. Direct on-camera flash tends to flatten your images, so get that flash off-camera and create the light you want-- anywhere, anytime!

Of course, nothing is stopping you from combining the various techniques. You can combine off-camera techniques with the idea of a flash to lighten up dark shadows covered by the sun, for example.

I've gone into the pros and cons of the various ways of controlling your flashes off-camera in chapter 4 "Lighting Equipment." The method you choose to take flashes off the camera doesn't make that much of a difference. The important thing is simply setting your flashes to fire when you want them to.

Controlling multiple flashes

So, we now know the power of a single flash, but naturally, we're not stopping there. While bouncing a single flash is a huge improvement and taking it off the camera is another step in the right direction, we're not fully in command of the light until we start adding more light sources.

Figure 6-9: Take a closer look at this photo – doesn't it look magnificent? It's the result of two flashes in perfect harmony. A gorgeous model and a retro airplane help too, naturally! This photo was taken with a Canon EOS 5D Mark II, 16-35mm lens at 23mm, 1/2700 sec, f/4.0 and ISO 100, in Manual exposure mode.

In a way, you're already familiar with multiple light sources. When you're working with fill flash, you're working with at least two light sources: your fill and the sun. We will build upon this idea when we start working with multiple flashes.

TIP: ───

> Did you spot that **Figure 6-9** was taken at 1/2700th of a second? That's only possible with a flash set to high-speed (or 'FP') mode. Learn more about high-speed flash work in chapter 5 "Working with your flashes"

Figure 6-9 was taken with two Canon 580EX II Speedlites ganged together on a light stand with using a Bruce Dorn iDC Triple Threat, which allows you to mount three flash heads together on one light stand. Canon 580EX II Speedlites were in E-TTL II mode controlled from camera using a Canon 580EX II Speedlite as the master, but set to function as just a trigger and not contribute light to the scene and RadioPopper transmitter and receivers to communicate with the remote strobes.

When you're photographing with multiple lights, you're opening a whole new world of possibilities, but it doesn't have to be much more complicated than working with a single flash. If you're struggling to mentally compose a multi-light-source photo, start simply. And don't worry, it will come more naturally after some practice. For now, take your time to 'build' your light. Start with one strobe and see where your photo could benefit from improvement.

The great thing about working with multiple flashes is that, among other things, you can control the brightness, direction, color, softness, and position of your light sources-all of which makes a difference to the final result of your photos.

Positioning multiple flashes

How much you are able to vary the positioning of your flashes depends on the method you've chosen for remote controlling them.

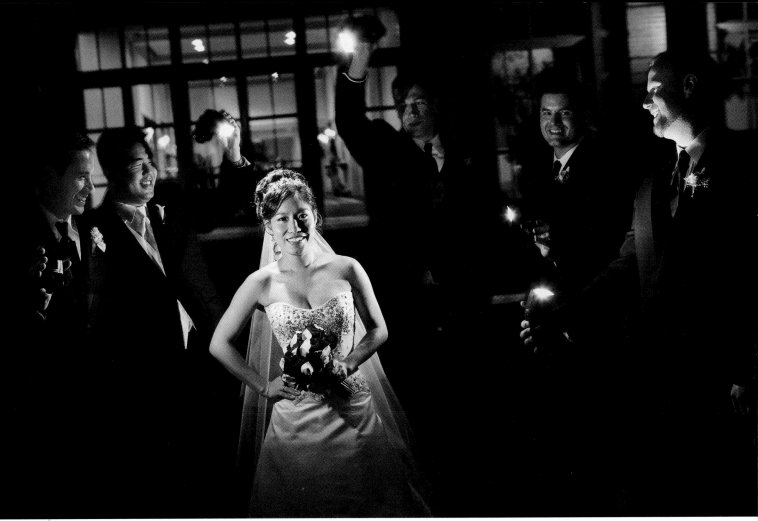

Figure 6-10: You don't have to go completely crazy with the number of flashes you're using, but if the photo demands it, keep on adding them until you have the effect you want. This photo was taken with a Canon EOS 5D, 24-70mm lens at 45mm, 1/1.7th sec, almost 2 seconds, f/5.0 and ISO 200, in Manual exposure mode.

Figure 6-10 was taken with six Canon Speedlites. They were 550, 580EX, and 580EX II model flashes. All flashes were set to manual mode at ¼ power, with no flash modifiers, triggered via a Canon 580EX Speedlite set as the master, but not contributing to the scene. All were fired via the optical sensor in the Canon Speedlite, line of sight. This photo is also a great example of a piece of lighting equipment which is often forgotten about in books like this: The Voice-Activated Human Light Stand. Five of them are visible –and well dressed!

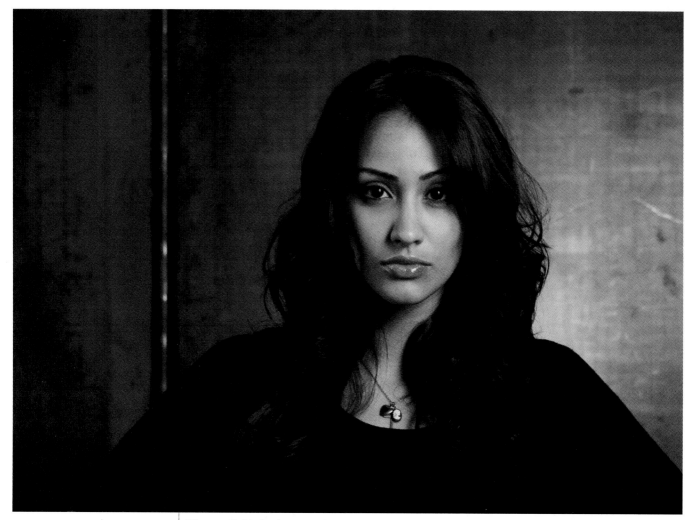

Figure 6-11: *Let's start simple with two lights and one model. This photo was taken with a Canon EOS 50D, 24-70mm lens at 70mm, 1/160 sec, f/7.0 and ISO 200, in Manual exposure mode.*

Find out more about the different ways of controlling a flash off–camera in Chapter 4, "Lighting Equipment".

You have a lot of freedom when you're working with multiple flashes, but getting their positions right can be tricky at times. It can be tempting to add more lights until it looks good — with **Figure 6-10** being an excellent example — but that isn't always useful. More

lights can add up to more headaches. Start simple and work your way through the shot. My style is to use lighting to compliment the scene, add light where I need it. Remember: you're looking for quality of light. You can get stunning results with simple set-ups. Two to three lights can give exquisite effects, but you've got to set them up so they pull their weight.

Figure 6-11 was taken with three Canon 580EX II Speedlites flash set to E-TTL II mode, with one 580EX II on-camera in group A as the master, but only set as a trigger not contributing any light to the scene. The master flash still fires, but it's a communication flash at such a low light level it does not affect the scene. All of the wireless commands are communicated in that pre-flash. The other two 580EX II Speedlites were in group A for the left flash and group B for the right flash, flash ratio was set at 1:1 or equal exposure value from each group, using two Westcott 36x48 inch Shallow Soft boxes.

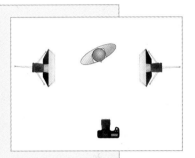

Let me talk you through a series of lighting set-ups, to try and help you get your head around the possibilities with some simple, well-placed flashes. By using a couple of lights with soft boxes on them — one on each side of the camera, like in **Figure 6-11**, you get a beautiful soft light.

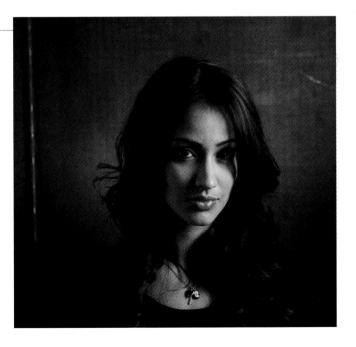

Figure 6-12: I'm feeling creative — let's add a touch of color to the scene by lighting the background with a third flash, fired through a colored gel. This photo was taken with a Canon EOS 50D, 24-70mm lens at 60mm, 1/200 sec, f/7.0 and ISO 200, in Manual exposure mode. Let's stop and think for a second, why use such a high shutter speed? The camera syncs at 1/200th of a second. Remember the rule I mentioned earlier, shutter = ambient light and aperture = flash output. For these pictures I do not want any light pollution from any ambient light in the room. This scene is lit entirely by the Speedlites.

TIP:
With Canon Speedlites, the Master flash is group A by default and cannot be changed.

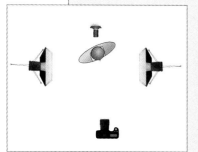

Figure 6-12 was taken with four Canon 580EX II Speedlites in three groups; flashes were all set to manual mode, with two Westcott 36x48 inch Shallow Softboxes, triggered via line of sight using the Canon 580EX II Speedlite in the camera hotshoe. Everything was controlled from camera using the master flash. Let's break down the flash settings. First, the master on-camera flash is in group A. The master flash was set up as a trigger and not contributing light to the scene. The left flash was in group A as well and set to ½ power. The right flash was in group B set to full power. The background flash was in group C set to 1/8th power and had a red gel attached. All commands were dialed in on the back of the master flash. I'm using manual mode instead of E-TTL II because I want consistent light output from my Speedlites. I'm not moving. My subject is not going anywhere. My lights are fixed. So why not dial everything in to where I want the light level to be? Sometimes E-TTL can give you varied exposures and reflective values change. In this situation I want frame to frame consistency; therefore, manual all the way.

Of course, lighting the foreground is important, but don't forget about the background. If you don't have a particularly interesting setting, then it's up to you to make it look more interesting. You could, of course, get someone to paint the wall behind your model, but that's going to take most of an afternoon. Wouldn't it be easier if you could do it yourself, in a fraction of a second? This is where the colored gels we spoke about in chapter 4: "Lighting equipment" come in. Add one to the front of a flash that's tucked away behind the model somewhere and you're in business. Just look how much better **Figure 6-12** looks than **Figure 6-11**!

Controlling brightness

In **Figure 6-11**, you can see how the right side of her face is slightly brighter than the left side. There are two easy ways of achieving this: change your distance from the model or change the intensity of the flash.

Moving light sources have other effects as well as changing the brightness, of course. There's

a complicated mathematical formula for calculating how bright light will be when seen from a certain distance. If you're curious about the science bit, Google "Inverse Square Law". However, for our use, its best summarized as "the closer a light subject is to the subject, the more light it will provide, while the further away a light source is, the less light it provides."

The other way to control the brightness of the flashes is to change the power of one of the flashes. Imagine they're both set to half power, for example. If you change the left flash to full power, that side will be twice as bright. If this scenario results in a too brightly lit scene, you could adjust the power to ½ power (left) and ¼ power (right) for a similar effect with less intensity. As always we're looking for quality of light, not quantity.

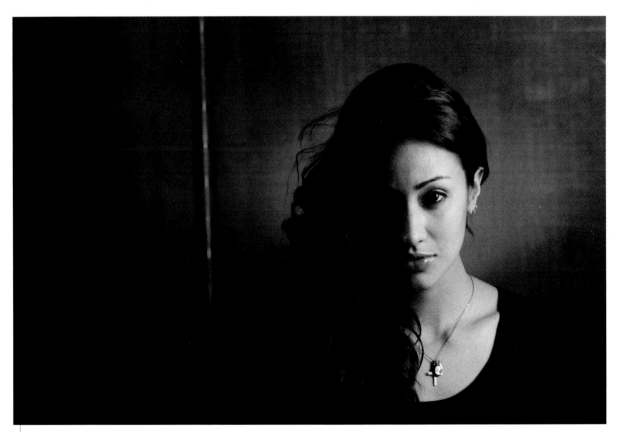

Figure 6-13: Changing the bias to the flash on the right side of the model's face creates a very different look. This photo was taken with exactly the same settings as in Figure 6-12 — only the bias of the light has been changed.

If you are using an advanced flash remote system, you can change the settings of the flashes from the remote connected to your flash, by grouping your flashes into groups, and then introducing a bias to one group. How many groups you can split the flashes into depends on the system you are using, but two or three is common. If the flash on the left is in group A and the other one is in group B, you can control their relative brightness by changing their ratio. In **Figure 6-13**, for example, I've biased the light heavily to the right-hand side of the scene, which gives a dramatic look.

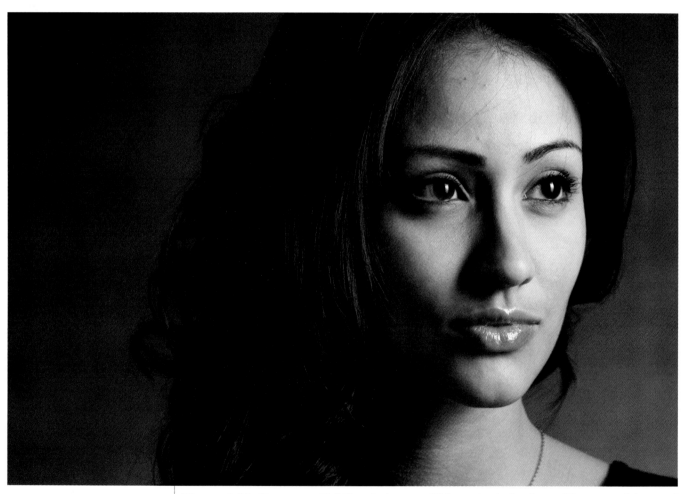

Figure 6-14: *Once your lighting is to your liking, start playing with composition and framing. In this case, all the settings are still the same as in the previous two shots; I just zoomed in further!*

I'm a strong believer of working smarter instead of harder. Instead of spending your whole photo shoot sending your lighting assistant to the flashes to tweak them or (even worse) wandering back and forth all the time yourself, spend your time taking photos. To make the change from **Figure 6-12** to **Figure 6-13**, I didn't have to go anywhere near the flashes to make this change. A couple of button presses on the back of the master flash in my camera's hot-shoe was all it took!

Modifying your flashes

As I've mentioned elsewhere in the book, I very rarely use unmodified flashes anymore. I could, of course, but I know from experience that I achieve much better results if I simply use a flash modifier.

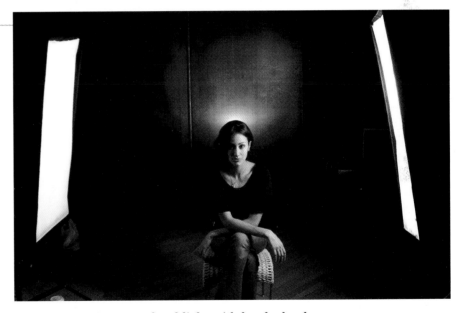

*Figure 6-15: This was the set-up for **Figure 6-11** through **6-14**. Very simple, but incredibly effective! This photo was taken with a Canon EOS 50D, 24-70mm lens at 24mm, 1/200 sec, f/6.4 and ISO 200, in Manual exposure mode.*

There are numerous ways you can modify your flash light, but for photographing people, you'll generally want soft light. When we're talking about soft light, we are talking about the size of the light source. A bare bulb hanging from a ceiling gives very hard light with hard, clearly defined shadows. Put a nice, large lampshade on it, and the light source appears bigger. Using a bigger, more diffused light source equals softer shadows.

Take a second look at **Figure 6-14**. Beautiful, soft lighting brings out the beauty in the model's face. The secret lies in the large soft-boxes I've used, visible in **Figure 6-15**.

The importance of light modifiers

Light modifiers are an extremely important tool in flash photography. I estimate that I use one about 90% of the time and I think that when you see their effects, you will, too!

When you're taking your strobe off the camera, you're going through the hassle of setting up on light stands to hold your strobes anyhow. It doesn't take much additional time to set up a light modifier at the same time, and the results are well-worth the small amount of time required to set them up. Quite often, you'll want to do the same even if the flash is still attached to the camera.

Look at the lovely light in **Figure 6-16**, for example, despite the couple being lit from behind by the sun! This shot was made possible by using a light diffuser. There are many different flash diffusers on the market, and I've tried quite a few, but I keep going back to Gary Fong's Lightsphere and other products in his arsenal.

For more detail about which types of light modifications are available and examples of them – check out Chapter 4, "Lighting Equipment".

Figure 6-16: Especially in situations where you have to move around a lot, adding a light modifier to your flash can make a world of difference. This photo was taken with a Canon EOS 1Ds Mark III, 24-70mm, lens at 27mm, 1/320 sec, f/4 and ISO 200, in Aperture Priority exposure mode. A Canon 580EX II Speedlite in E-TTL II mode with high speed flash sync activated to allow me to cross the native flash sync threshold of 1/250th sec. The flash was shot directly through the Gary Fong Lightsphere with the dome in place to soften and diffuse the light.

Dealing with mixed light sources

When we're talking about 'mixed light sources', we're usually about to start discussing a problem dealing with white balance. How can you best deal with these white balance challenges? The important thing to remember is that your camera can only deal with one white balance at the time.

Learn more about why mixed light sources and white balance can be a challenge in Chapter 1, "Understanding Light."

Figure 6-17: When working in daylight, you're in luck. Flash light is balanced to be similar to the standard daylight color temperature. This photo was taken with a Canon EOS 5D Mark II, 24-105 mm lens at 105mm, 1/320 sec, f/6.3 and ISO 320, in Manual exposure mode.

Figure 6-17 was taken with a Canon 580EX II flash set to E-TTL II mode; high speed sync was active with a Gary Fong Lightsphere, triggered via a Canon Speedlite Transmitter ST-E2 with RadioPopper transmitter and receiver. Notice the near umbrella quality of light outside on the street. I increased the shutter speed to underexpose the ambient light to create the dark look of the image.

If you're out photographing in daylight, like in **Figure 6-17**, for example, you can expect a white balance of around 6000 kelvin. If you want to add flashes to this, you're in luck, because the color temperature of most flashes is around 5500-6000 kelvin, which isn't that far removed from the color temperature of sunshine.

For a refresher on the Kelvin scale and what it means to your photography, turn to Chapter 3, "Getting the basics right".

Take your flash indoors to a Tungsten-lit setting, and you're suddenly in a completely different situation. Tungsten incandescent light bulbs are roughly 3000 kelvin (but this varies greatly from manufacturer to manufacturer, and bulb to bulb), but your flashes will still be operating at around 5500-6000 kelvin. Now, you have a few options. You can turn off the lights in the location and continue just with your flashes. This, in effect, turns the

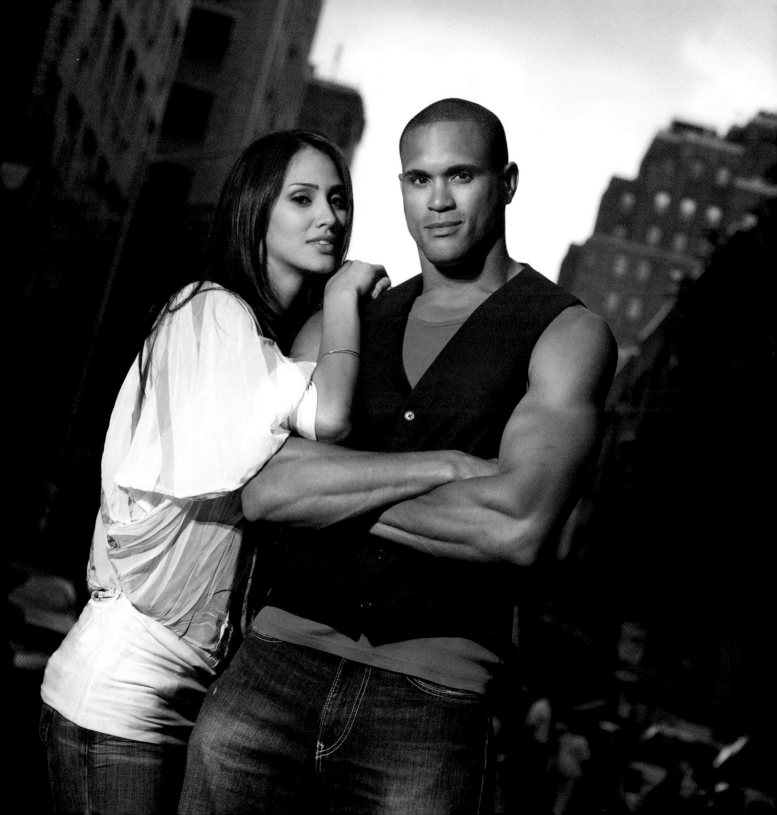

venue into an ad-hoc photo studio, where you take control of all the lights. This isn't always possible (like in **Figure 6-18**), and isn't a particularly elegant solution, either.

Figure 6-18 was taken with a Canon 580EX II Speedlite flash set to E-TTL II mode, with a Gary Fong Lightsphere, triggered via a Canon Speedlite Transmitter ST-E2 with RadioPopper transmitter and receiver. The couple is backlit using one Speedlite to separate them from the cityscape background and at f/2.8. I only needed a kiss of light to make this image sing.

The other thing you can do is to use very high-powered flashes (or a great number of lower-powered ones) to overpower the available light. If most of the light available is flash light, you can expose for the flashes, and any other light available is effectively 'drowned out', giving a result much like **Figure 6-2**.

Figure 6-18: If I had wanted this background to be dark, I would have faced a rather awkward conversation with the building manager about dimming the lights of the building in the background. This photo was taken with a Canon EOS 1D Mark III, 24-70mm lens at 70mm, 1/20 sec, f/2.8 and ISO 640, in Manual exposure mode.

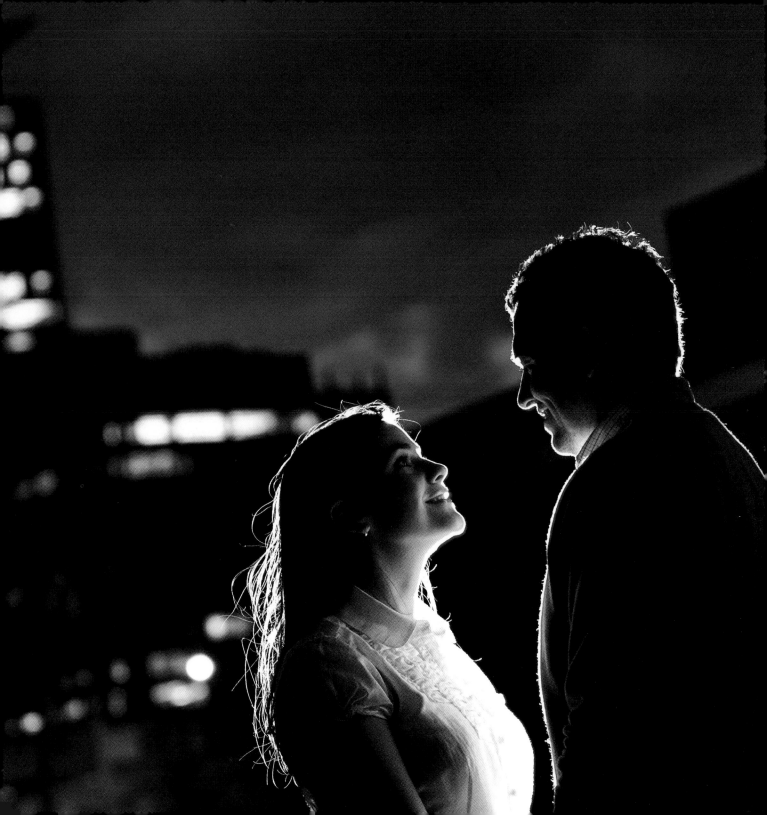

Figure 6-19: In this photo, the flash light is quite close to drowning out the background. If I wanted the background to fade further into obscurity, I could have added a little more power on the flash or used a faster shutter speed. This photo was taken with a Canon EOS 1D Mark III, 70-200mm lens at 200mm, 1/13 sec, f/3.5 and ISO 500, in Manual exposure mode.

Figure 6-19 was taken with two Canon 580EX II Speedlites off-camera set to E-TTL II mode. Each Speedlite was modified using a Westcott 43 inch Optical White Satin with Removable Black Cover-Collapsible umbrella. I shot through the umbrellas with the black cover removed, triggered via a Canon Speedlite Transmitter ST-E2 with RadioPopper transmitter and receiver. Each Speedlite was in a different group. The low fill light was in group A and the high main light was in group B. I set the ratio to bias the bulk of the light to the main in group B. All Speedlites were controlled wirelessly from camera. Gorgeous light anywhere anytime.

Take a look at **Figure 6-19**. It would have been trivial to drown out the background altogether. I could have used a shutter speed of 1/30 to halve the brightness of the background, 1/60 to halve it again, or 1/120 to reduce it to an eighth of the original brightness, rendering it practically invisible. Don't forget, however, that there's often a reason why you're at a particular location. If you're at a wedding reception, for example, the happy couple probably would like the location to be featured in the photographs!

We've talked about all the ways of dealing with multiple light sources. But what is the elegant solution? The best thing to do is to temperature-balance your flashes to available light.

Temperature-balancing your flashes

Let's say you are photographing a wedding, for example. Most venues utilize Tungsten light. The challenge is that the house lights are around 3000-3200 K and your Speedlites are close to daylight 5200 K. As you have no control over the color temperature of the house lights, the solution is to balance your Speedlites to match the house lights.

Attaching a Full CTO (color temperature orange) gel, pre-cut to fit over your flash head, will allow you to quickly and easily match your flash to the house lights. Now remember to set you camera's white balance to the Tungsten preset or kelvin. With the kelvin setting you can dial in the exact color temperature you want the image to be. Its okay if there are a few degrees difference between your Speedlites and the house lights. If you're in the ball park, your pictures should look great.

Figure 6-20: By using CTO (Color Temperature Orange) filters, I was able to match the color of the flash light to the color of the ambient light. Figure 6-20 was taken with a Canon EOS 1Ds Mark III, 24-70mm lens at 70mm, 1/50th sec. f/5.0, ISO 800, Manual exposure mode, 3000K white balance.

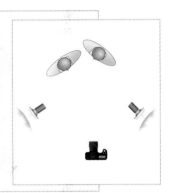

Figure 6-20 was taken with one Canon 580EX II Speedlight as the master. Two Quantum Qflash T5d-R flashes with QNexus modules allowed for wireless communication with Canon Speedlites, triggered via the Canon 580EX II master with RadioPopper transmitter and receivers. In this case, I chose to use Qflashes because when I like the extra power available to me: Each Qflash has about three times the power of a standard Speedlite. The Qflashes were filtered with Full CTO gels and bounced into Westcott 43 inch Optical White Satin umbrellas with Removable Black Cover-Collapsible. Nothing fancy here just nice soft light, so both lights were set to 1:1 or even power.

Good photography stores will sell you pre-balanced color temperature gels to match your flash light to certain light sources. A particular orange gel, for example, 'warms' the flash down a little, lowering it's color temperature from 5200K to 3200K, and might help it match a warmer light source. Once your flashes are balanced to your environment, you're left with a single color temperature! Set your camera to the coordinating white balance and you're good to go. Check out **Figure 6-20** for an example.

What if there are three light sources?

There are situations where it's fiercely difficult — perhaps even impossible — to get the scene balanced. If you're facing a lighting situation where you already have two different

temperature light sources, you're facing a serious challenge. You could try to balance your flashes to one of the sources, but then you're still left to deal with the other color temperature.

To be honest, there isn't that much you can do. You can try to use one of the techniques above to overcome the stray light source (i.e. get it turned off, block it, or drown it out), but it may well be that you're out of luck. You could try to overcome the issue by turning the image into a black-and-white photograph. But luckily, as seers and creators of light, we've got a final ace up our sleeves. If you can't beat the light, join it! Sounds good, but how? By using it creatively!

Mismatched color temperatures? Use them creatively!

Generally for the best portraits, it's a good idea to try to get the color balances all matched up. After all, you'll want your photo to look as natural as possible, right? As with everything else in this book, that's not a hard, fast rule. Color temperatures can be a great chance to get your creative juices flowing.

Figure 6-21: This photo has three light sources with different color temperatures in it. In the photo, you can see early evening daylight, tungsten from the house lights, and flash from my lights – and still it looks awesome! This photo was taken with a Canon EOS 5D lens 24-70mm at 24mm, 1/15 sec, f/4.0 and ISO 400, in Manual exposure mode.

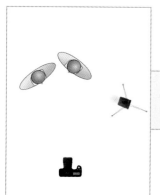

Figure 6-21 was taken with a Canon 580EX Speedlite set to E-TTL mode, with a Gary Fong Lightsphere, triggered via line of sight using a Canon Speedlite Transmitter ST-E2.

The image shown at **Figure 6-21** (and, to a lesser degree, **Figure 6-10** and **Figure 6-20**), is an excellent example of what I mean when I say 'creative' use of color temperatures. It would probably have been possible to warm the flash to match the light in the building in **Figure 6-21**, but I saw a different opportunity.

In this photo, the flash light is unadjusted, and so is roughly the same color temperature of daylight. The building in the background is lit brightly with Tungsten lighting – which

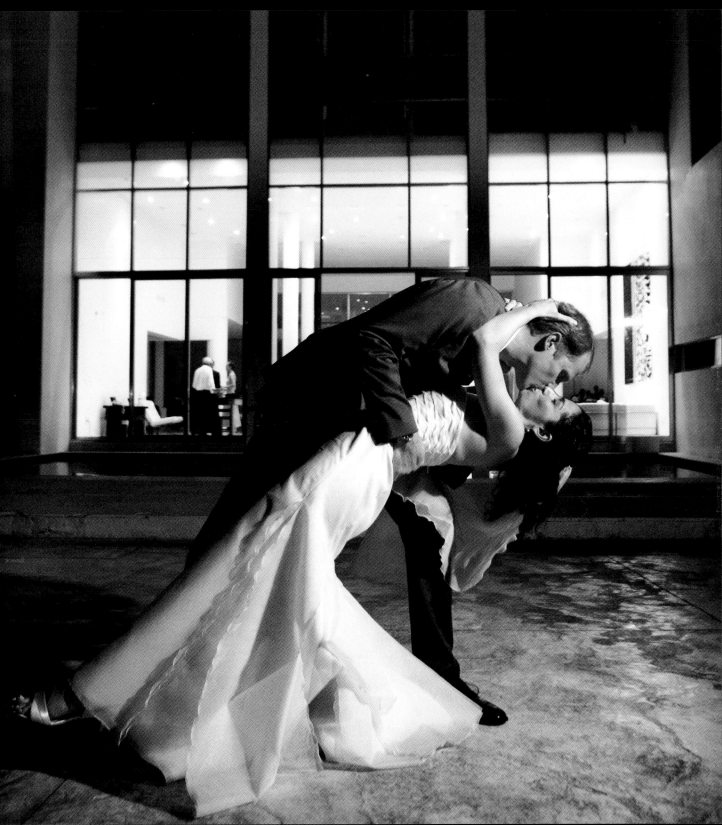

makes it appear vastly warmer than the foreground. Beyond that, we have the sky where the last rays of sunlight are fading, which has a very cold light temperature again. Between the three light sources, you end up with a very appealing and unusual photograph. And, needless to say, a very happy couple!

Make the backgrounds work for you!

Nobody is going to argue: your subjects are by far the most important part of the photo. Interestingly, this is where people just starting out with their first camera often go wrong. They've learned to take the lens cap off and to not cover the lens with their fingers and are starting to get some decent shots of people, but the backgrounds are letting their photos down.

I would love to say that this is exclusive to amateurs, but even photographers who are getting quite advanced and technically skilled are occasionally guilty of not paying enough attention to the background. I like to think of the background as another person in my photograph: They, too, have to be shown full of character, from their best side.

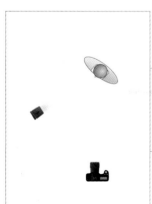

Figure 6-22: It's often possible to remove the background from a photo – but do you retain the 'feel' you're trying to achieve? This photo was taken with a Canon EOS 5D Mark II, lens 70 -200mm at 75mm, 1/60 sec, f/4.5 and ISO 400, in Manual exposure mode.

Figure 6-22 was taken with a Canon 580EX II Speedlite flash set to E-TTL II mode, with no flash modifier, triggered via a Canon Speedlite Transmitter ST-E2. Notice the long shadows produced by placing the flash low and aiming up at the subject creating those dramatic long shadows.

With the power of creative lighting, you have considerable influence over what the background looks like. Go back a few pages and compare **Figure 6-1** with **Figure 6-22**. The two photos are taken within minutes of each other, but the difference between them is absolutely staggering. The contrast between these two images shows how dramatic a difference a focus shift can make. In **Figure 6-1**, all you can see is the background. The

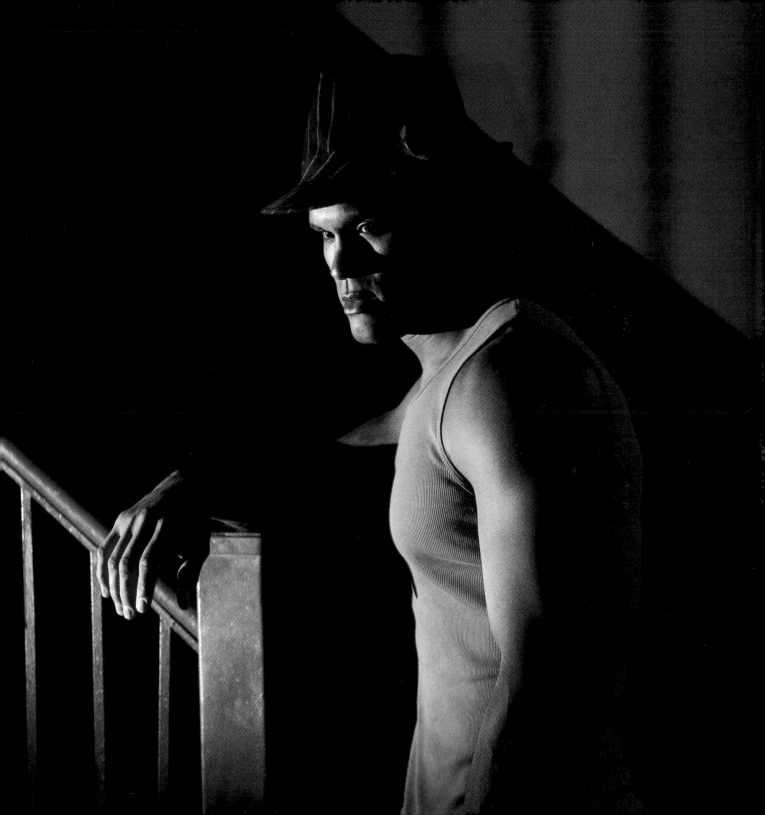

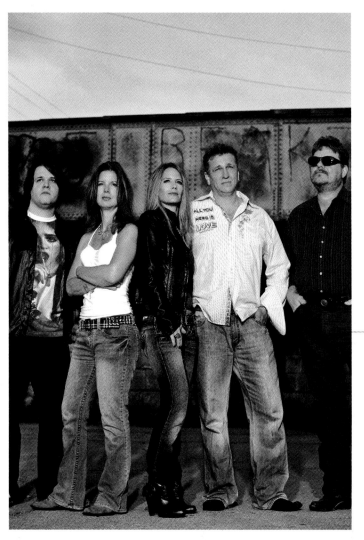

model in the photo is only visible because he is 'the absence of background'. **Figure 6-22** is the direct opposite.

These two photos are interesting as illustrations, as they show opposite ends of the scale. What I really wanted to show you, though, is how you can pull the background and the foreground together into one photo. Hopefully, resulting in an image that is better than both of these examples combined.

*Compare **Figure 6-23** and **Figure 6-24**. They are taken in the same location using practically the same camera settings, but **Figure 6-24** looks much better due to paying more careful attention to the background. This photo was taken with a Canon EOS 1D Mark III, 50mm, 1/250 sec, f/4.5 and ISO 50, in Manual exposure mode.*

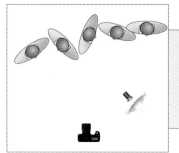

Figures 6-23 and **6-24** were taken with one Canon 580EX II Speedlite as the master. One Quantum Qflash T5d-R flash with QNexus module triggered via the Speedlite master with RadioPopper transmitter and receivers. The light was bounced into Westcott 43 inch Optical White Satin with Removable Black Cover-Collapsible Umbrella.

A messy background is rarely recommended, and can often be avoided by simply paying a little bit of extra attention. When I was out photographing the band in **Figures 6-23** and **6-24**, for example, we chose the location by the railway bridge because it looked gritty and cool, but the sky and the power-lines were ruining my shot. Simply re-thinking and re-framing the shot resulted in a far better photo.

Figure 6-25: By introducing colored gels, the background takes on a much more attractive quality. But now, the background gets all the attention! This photo was taken with a Canon EOS 5D Mark II, 24-70mm lens at 70mm, 1/60 sec, f/4.5 and ISO 400, in Manual exposure mode, daylight white balance to exaggerate the colors.

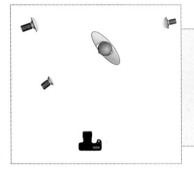

Figure 6-25 was taken with three Canon 580EX II Speedlites flash set to manual mode, in three different groups. The bare flash without a gel is in group A. The flash with the full CTO gel is in group B. The flash with the green gel is in group C. I adjusted the power levels to bring out the best color in each gel, triggered via Canon Speedlite Transmitter ST-E2 with RadioPopper transmitter and receivers.

As we mentioned before in connection with **Figure 6-12**, adding a dash of color can be an effective way to make your backgrounds work harder for you. One of the reasons why this works well is if you light the background to be darker than your foreground, it can look a little odd and unnatural. I know it sounds counterintuitive, but adding a touch of color fools the eye into thinking it looks normal, even though you've in fact made the scene look less natural. I don't get it either, but it trust me, it works. Try it some time!

For **Figure 6-25**, I decided to add a touch of color to the scene: A touch of orangey-red covering the stairway to the front of the model, and a green gel on the background behind the model. It certainly adds a lot of depth to the scene, but I wasn't really feeling it, to be honest. The fiber board, bricks and planks of wood on the right of the model and the diagonal line running through the model's head, combined with the barrage of colors draw your attention away from the man. It is as if I'm begging you to look at the background, which certainly isn't my intention.

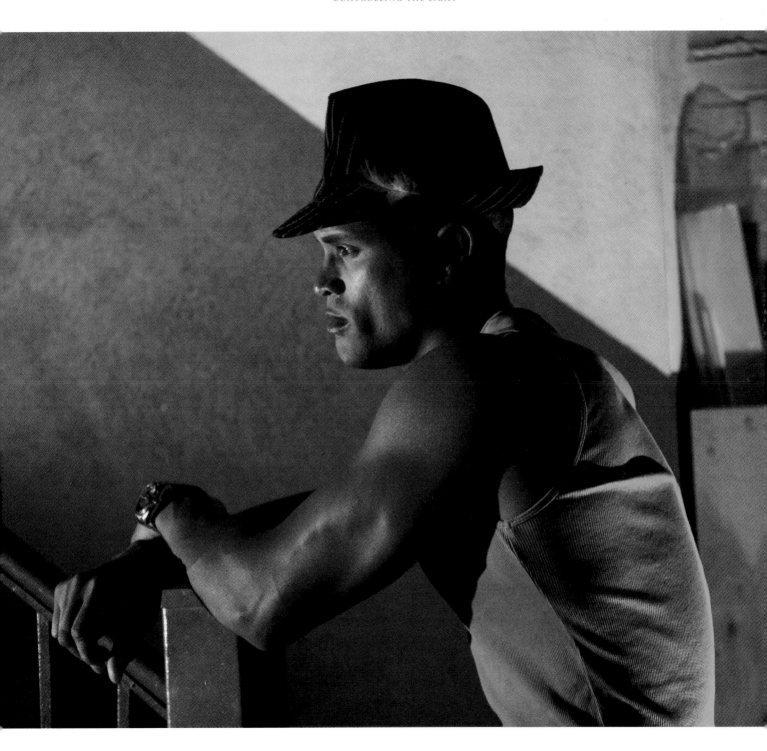

Figure 6-26: Ah! Now we're getting somewhere! The background improves the photo on the whole without drawing the attention away from the model. Much better! This photo was taken with a Canon EOS 5D Mark II, 70-200mm lens at 73mm, 1/60 sec, f/4.5 and ISO 500, in Manual exposure mode, daylight white balance to exaggerate the colors.

We've seen this photo with an unfocused background (**Figure 6-22**), showing only the background (**Figure 6-1**), and a combination of the two effects, which wasn't quite right (**Figure 6-25**).

I took a long, hard look at the scene, and thought about which parts of the photo I did like. The model is good-looking and moody, and there's something cool about that stairway.

In the end, I decided to simplify the scene. By having the model lean forward, his head is no longer 'cut off' by the diagonal line, and we get the additional benefit of moving him away from the messy background at the bottom of the stairs. The slight touch of green hitting the back of his arm adds a touch of color and mystery to the picture, and the contrast light hitting him from the front adds to the moody feeling of the photo. It may not be perfect, but I'm sure you'll agree it's much better than the other photos taken on this location!

Photographing Groups

When photographing groups, you have to step up and get heard. Nothing is worse than a big group of people who are continuing conversations when you're trying to put a photograph together. Take charge. Get your subject's attention; request they focus on you.

I always tell my groups, "If you can't see my *lens* I can't see you." This usually helps. They'll be looking for the lens, which means that at least they're looking in the right direction.

It's important to watch your composition too. I try to never stack people's heads on top of one another in an image, as they will look like bowling balls lined up in a row. Instead, I work with the group to stagger them so none of their heads are blocking anyone, nor set up atop of one another. Keep positive and have good energy and your subjects will cooperate to accomplish the formal group shots. Now that you have everyone's attention and they're in place- make some pictures!

How many times are you in a situation where there just isn't any good light? Who wants to lug around power packs and search for electrical outlets to power everything up or for that matter, the cables? No thanks, I try to work smarter, not harder.

For my group formals I take a simple approach: Three lights, nothing fancy, just nice clean even, good light. Here's my three light set up: three Canon 580EX II Speedlites and two six foot light stands with umbrella adapters. Simply use the hot shoe foot that comes with your flash to mount the flash onto the light stand. I use Gary Fong Lightspheres on the strobes and RadioPopper transmitter and receivers to ensure the flashes go off properly. You can do without the RadioPoppers and control your Speedlites optically via the built in line of sight communication, but if you want to make sure your strobes fire every time, no matter where you're shooting from, then the RadioPoppers are the way to go.

Positioning your lights correctly is crucial. You don't want to create shadows that fall across your subjects. For formal shots, I keep all the Speedlites in the same group, no need to ratio the power. I place the strobes at a 45 degree angle to the camera, 1 left, 1 right, and 1 on camera. I point all the flash heads up at a 90 degree angle and shoot away. Most of the time, I shoot the formals in manual flash mode for consistent results. This set up gives me beautiful consistent results whether I'm shooting in a church or outside.

*Figure 6-27: I often opt to use the Quantum Qflash in situations where I'm going to need more flash output or when I am shooting tons of group formals because the additional light gives me the opportunity for greater creativity. For **Figure 6-27** I was shooting formals for about an hour with varying size groups. This photo was taken with a Canon EOS 1Ds Mark III, and a 24-70mm lens at 50mm, 1/50 sec, f/5.6 and ISO 800, in Manual exposure mode. I was using tungsten white balance to match the house lights. This photo was taken with one Canon 580EX II as the master and two Qflashes. All flashes were set to manual mode, at ½ power, and bounced into Westcott 43 inch Optical White Satin with Removable Black Cover-Collapsible Umbrellas, triggered via the Canon master and RadioPopper transmitter and receivers. All strobes were filtered with Full CTO gels to match the house lights.*

Figure 6-28: *This was a group shot of all the groomsmen just before the ceremony. I wanted a dramatic shot of the groom and his boys. My vision was a black and white picture with strong lighting. I saw the setting, had a shot in mind, and executed it. This photo was taken with a Canon EOS 1Ds Mark III, 16-35mm lens at 17mm, 1/60 sec, f/4 and ISO 320, in Manual exposure mode, auto white balance due to the mixed light sources — the daylight from the window, the overhead house lights and the flashes. The photo was taken with two Canon 580EX II Speedlites, flashes were in two groups with the foreground light in group A in E-TTL II mode, and the back light in group B Manual mode. I chose Manual mode for group B to give continuous light output at full power for the strong back light effect. Light A used a Gary Fong Lightsphere, while light B was unmodified, triggered via Canon Speedlite Transmitter ST-E2 with RadioPopper transmitter and receivers.*

Smaller groups

I often find that weddings take on a life of their own. This particular wedding ran late, very late, almost three hours late. The bride chose this location for the beautiful gardens and wanted their formals taken outside. The only challenge was that we were supposed to be shooting the formals at sunset! No problem! Be prepared and never let them see you sweat.

Figure 6-29: Bridal party outside on the roof of a building with storm clouds rolling in fast. The goal was to accomplish some fun formals before the rain came. I accomplished this by using the Canon Speedlites and Gary Fong Lightspheres. I'm always amazed at the quality of light you can get from these light modifiers, quick and simple set up. I used two Canon 580EX II Speedlites on light stands with Lightspheres and even 1:1 lighting, E-TTL II mode on the strobes and manual mode on camera. The lights were positioned at a 45 degree angle to the camera, triggered optically via line of sight by a Canon 580EX set as the master, but not contributing to the scene. Great light fast, anywhere anytime.

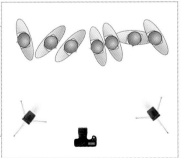

In **Figure 6-29,** I used a simple on-camera flash bounced, using a Lightsphere. I aimed the flash head upward and to the left to compliment the direction of the window light, which was lighting the ladies in the background holding the veil. The bride and little girls were lit from the on-camera bounced flash. Simple lighting worked with all the available light to result in a natural look.

Figure 6-30: Be ready for spontaneous moments when they occur. These little girls ran up as their aunt was waiting to walk down the aisle.

It was dark, pitch-black night, and the only ambient light was coming from a few landscape lights. I didn't want my pictures to be big black holes of darkness, and I knew I would need to shoot at high ISO and slow shutter speeds to capture some depth to the background. Because the happy couple was running late, the bride and groom only wanted to give me a few minutes to capture their group shots, but they were happy with the results!

Figure 6-31: It can be difficult to take photos in very low light. If there is not enough going on in the background, it might look as if they are standing in a void! To avoid this, I had to ramp up the ISO and use a very long shutter time. This photo was taken with a Canon EOS 1D Mark III, 24-70mm lens at 32mm, 1/2.5 sec, f/4.5, ISO 1000, in Manual exposure mode, using tungsten white balance. Figure 6-30 was taken with three Canon 580EX II Speedlites, in E-TTL II mode. All strobes were modified using the Gary Fong Lightsphere, triggered optically line of sight via Canon 580EX II on camera set as the Master.

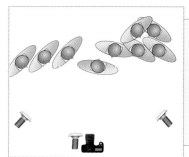

In **Figure 6-31**, I used three Canon Speedlites, Gary Fong Lightspheres, and the power of ISO to pull it off. I had to use a slow shutter speed — a whopping 2.5 seconds — to record what little ambient light there was. This captured some motion in the image as the subjects were moving around having fun. While the flash froze most of the action, there is just enough ambient light to allow for motion blur.

Alternately, if I had wanted a completely frozen moment in time I could have increased the shutter speed. The trade off is that there would have been less ambient light, and in this dark setting, I needed all the light I could get. The lights were placed in a simple three-flash set-up. There were two off-camera flashes one to the left and one to the right at 45-degree angles to the camera and one on-camera flash. All lights were pointed up at a 90-degree angle spilling soft light onto the subjects.

With a bag full of flashes and a brain full of ideas, you can make nearly any photo concept come to life. I hope you like the photos in this chapter, but while it would be flattering, I urge you to resist the temptation of just copying the setups. Use them as springboards to make your own creativity flourish and create some beautiful, unique photos!

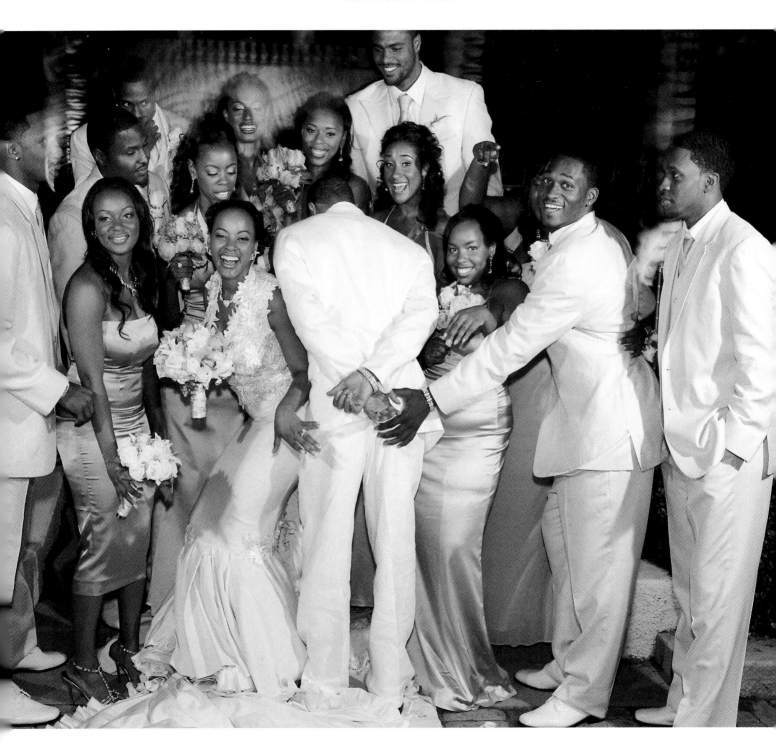

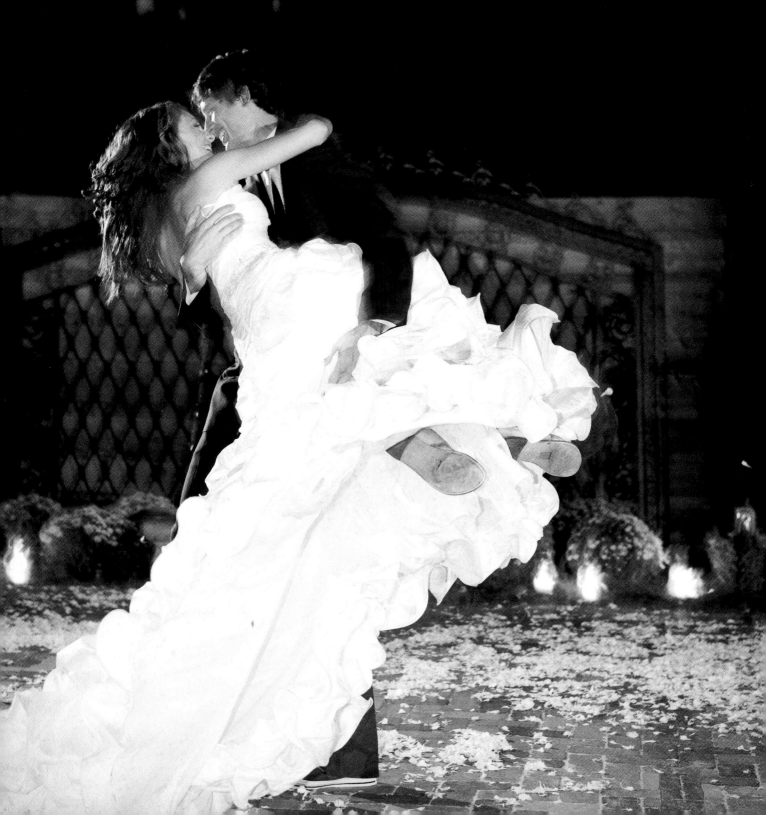

7

CREATIVE LIGHTING

DEPENDING ON YOUR PHOTOGRAPHY STYLE, YOU MIGHT FIND THAT YOU SPEND A GREAT DEAL OF YOUR TIME TRYING TO MAKE YOUR PHOTOGRAPHY LOOK AS NATURAL AS POSSIBLE. Other times, however, you're going to want to make your photos stand out in various ways. A simple touch of color can make your images sizzle. Illustrating movement in a photograph can be eye catching as well. Anything is possible. All you need to do is to visualize what you want to try and apply what you've learned about seeing the light to your lighting techniques.

Figure 7-1: When photographing in low light, don't be shy about really cranking up the ISO. Capturing this image required a whopping ISO of 1600! Only a few years ago, that would have been completely unthinkable. This photo was taken with a Canon EOS 5D Mark II, 24-70mm lens at 52mm, 1/18 sec, f/3.2 and ISO 1600, in Manual exposure mode. Two off-camera Canon 580EX II Speedlites lit the couple as they danced.

Colored Light

Colored light can be used effectively to build a mood in a photograph. The great thing about the flexibility of colored light is that you can paint a wall in a fraction of a second. Is the white wall behind your subject too boring? Make it red, blue, green, or, well, any number of colors by pointing one of your Speedlites at it. Simply add a colored gel and you're on your way!

TIP:
> If you're going to spend a few hours trying out different gels, you don't have to hire a model. Teddy bears are more patient — and cheaper, too.

Different colored gels give significantly different effects: A blue background tends to be dark and moody, whilst a red background gives you a feeling of urgency. Green can look a little hospital-like, but if your model has dark hair, can look absolutely astonishing as a way to frame their silhouette. The best way to get a feel for what works well is to experiment.

Figures 7-1 and **7-2** were taken with two Canon Speedlites. One Speedlite 580EX II was in a large Westcott soft box camera right in group A. The second, a gelled background light, was in group C. It was bare flash no light modifier, with its power at – 1 EV, flash set to E-TTL II mode, triggered via Canon Speedlite Transmitter ST-E2.

The light surrounding a model, whether it is the background or simply a portion of the scene, can drastically impact how one perceives the scene. In **Figure 7-1**, the contrast between the cool tone of the green background and the nice, warm quality of the model's face makes her look fantastic.

In **Figure 7-2**, the model is lit exactly the same way, but the background has warm glow to it. As you can see, this gives a different impression of the background, but it also means that the model stands out less dramatically because the color tones of her skin are similar to that of the background.

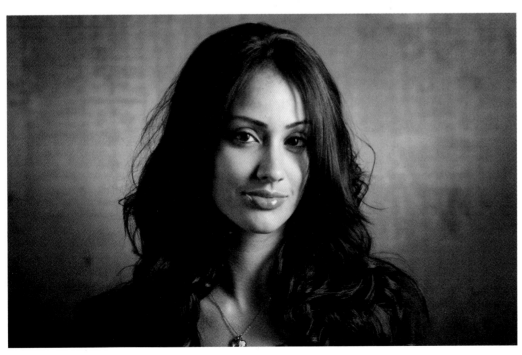

Figures 7-1 and 7-2: These two photos were taken within seconds of each other. The only difference was the gel on the Speedlite behind the model was changed. Both photos were taken with a Canon EOS 50D, 70-200mm f/2.8 IS lens at 144mm, 1/200 sec, f/6.3 and ISO 200, in Manual exposure mode.

Figure 7-3: In this photo, I made the car stand out by adding a red glow underneath it. I simply put a Speedlite with a red gel on it underneath the car, lying on its side! Photo was taken with a Canon EOS 5D Mark II, 24-70mm f/2.8 lens at 48mm, 1/40 sec, f/3.2 and ISO 500, in Manual exposure mode.

Figure 7-3 took some time to prepare, which was a bit tricky since we were holding up traffic and I was working under pressure! This image was lit using three strobes in three groups. The main light on the model, camera left, was a Canon 580EX II Speedlite in group A with the power biased towards group A, inside a Westcott medium soft box, in E-TTL II mode. The second strobe was a Quantum Qflash in group B with a red gel, no light modifier, in E-TTL mode. The third strobe was a Canon 580EX II in group C with the power set to -2 1/3 EV, bare flash in E-TTL II mode for a kiss of light to separate the Cadillac from the background. All the strobes were fired using a Canon 580EX as the master, but not contributing any light to the scene. Speedlites were triggered via the master 580EX with RadioPopper transmitter and receivers.

Of course, you don't have to limit your flash use to the background – you can make it an important feature of the foreground as well (as we saw with the stairway photos in Chapter 6), or you can use it to add flair to another portion of the image. In **Figure 7-3**, for example, I decided that the car looked a little bit too dull and lifeless, so I added a light source underneath. I found that adding a white strobe was too overpowering for the effect I was trying to achieve, so I decided to think in a different direction instead: By adding a red gel to the Speedlite, the light takes on a completely different quality – it looks much better that way!

To get the best possible effect out of your gelled Speedlites, it is a good idea to reduce their power output a little bit. You get the purest color from gelled strobes at lower strobe power, but this depends on how powerful your flashes are, and the quality of your gels.

When you reduce the power of your gelled strobes, remember that you may have to reduce the output of the rest of your strobes, too, to keep the scene lit well. You can compensate for the light you lose in the process by adjusting your shutter time, aperture, or ISO.

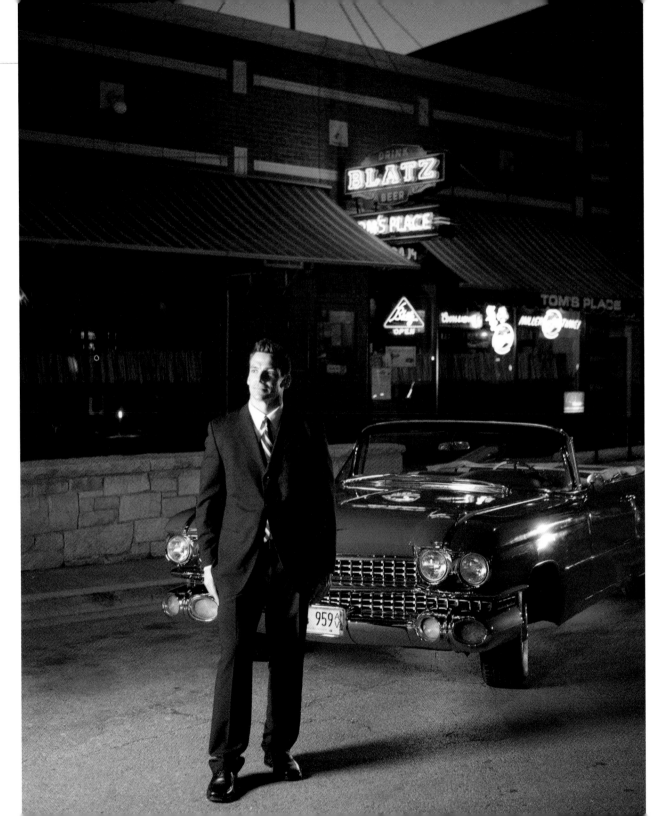

163

Long exposures and flash

The benefit of flash photography is that you can 'freeze' the motion in an image well. The benefit of long exposures is the creative motion blur effect you get, but if it is dark, your subjects will come out dark as well. You can combine both benefits by using both a longer shutter time to get a feeling of speed and a flash to freeze the motion.

As we discussed in Chapter 3, "Getting the Basics Right," you can use the shutter speed to decide how much available light you would like to capture, and the aperture to regulate the flash output.

You can combine these two to completely overpower the available light with a powerful burst of flash light and a fast shutter speed. Alternatively, you can use the available light to your advantage by using a slower shutter speed. You may have noted how **Figure 7-3** has a relatively slow shutter speed of 1/40th of a second. This is so the lights of the background will show up properly in the picture. You can take this even further for greater creative effect.

Figure 7-4: The happy couple at the center provided this picture with a dynamic feel and smiles all around. This effect was achieved by zooming in while taking the photo. The faster shutter speed combined with the flash gives this distinctive effect. The photo was taken with a Canon EOS 20D, 16-35mm f/2.8 lens at 16mm, 1/13 sec, f/3.5 and ISO 800, in Manual exposure mode.

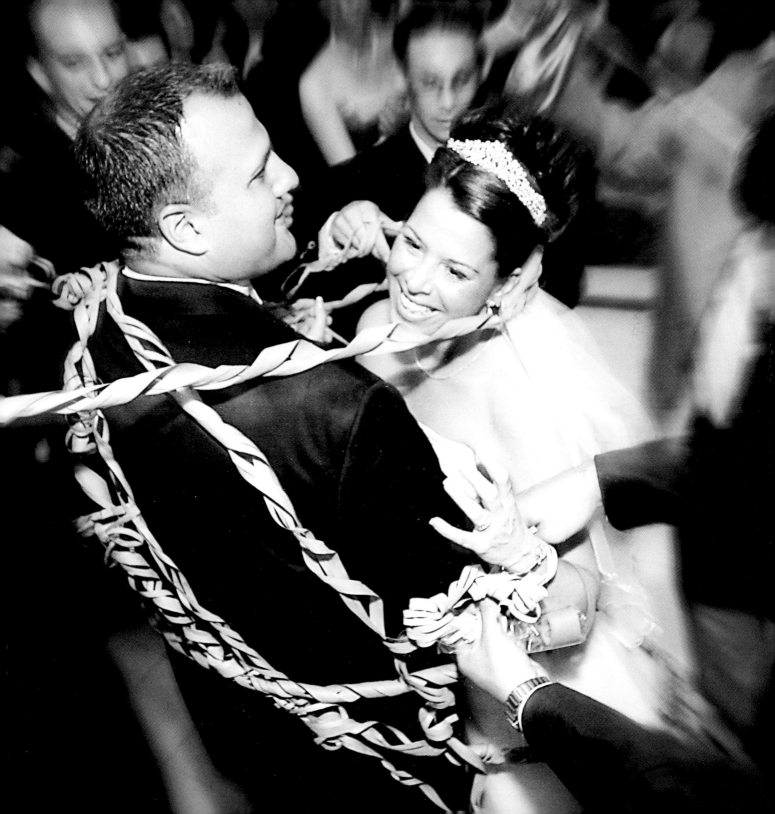

The flash will freeze the motion, but the slower shutter speed will add a sense of speed and a dynamic feel to anything which might be moving in the image. If nothing is moving fast enough for your liking, you can always introduce some artificial movement, by moving your whole camera, or by zooming your lens while you take the photo. **Figure 7-4**, for example, was taken by zooming in as I pressed the shutter button. The 1/13th of a second shutter speed means that you get the Star Wars-style 'warp speed' effect in the photo, and the flash helps punctuate the movement by adding a sharp image, too.

Figure 7-4 was taken with a single Canon 580EX flash set to E-TTL mode, with a Gary Fong Lightsphere. The power of E-TTL in this setting means that the exposure was perfect, and the Lightsphere helped me getting a beautiful, even light.

Rear Curtain Sync

We've talked about how Rear Curtain sync works from a technical point of view in Chapter 5 and now it's time to put the theory into practice.

As you know, rear curtain sync works by triggering the flash at the end of an exposure — this means that any motion blur appears to move "backward" from the image frozen by the flash. We can use this to our advantage to capture the feeling of motion when people are dancing, for example. The light trails are created by the ambient light. This conveys the energy of the moment while the flash freezes the expression of your subjects.

Figure 7-5: The goal of this picture was to capture the feeling of celebration and excitement. I want my pictures to put the viewer right there in the moment, and in this photo, it really works: You can almost hear the music. In this shot, I was panning (moving my camera from side to side) and zooming my lens in while I took the photo. As this photo was taken at sunset, there was enough ambient light to add a touch of motion blur. This photo was taken with a Canon EOS 5D, 16-35mm f/2.8 lens at 16mm, 1/50 sec, f/5.6 and ISO 200, in Aperture Priority exposure mode using + 1/3rd exposure compensation for the bright white room. I used one on-camera Canon 580EX flash, head straight up, in E-TTL mode with a Gary Fong Lightsphere.

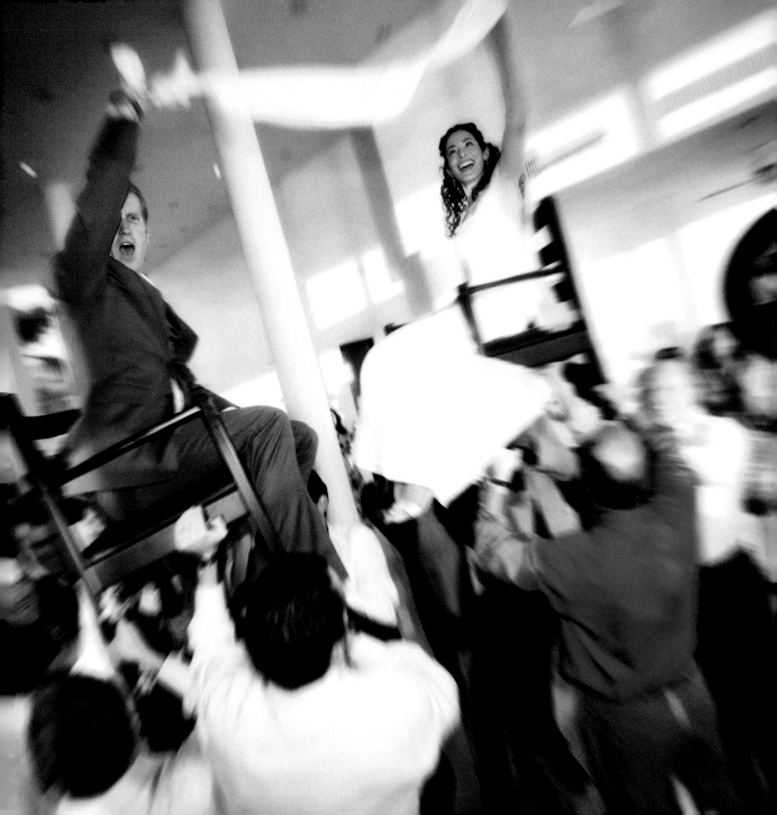

The settings I recommend to start off are somewhere in the vicinity of ISO 400 to ISO 800 with around 1/15th to 1/4th of a second shutter speed, and an aperture f/3.5 to f/4.5. As for the flash, I typically bounce the flash using the Gary Fong Lightsphere, usually with the flash in E-TTL mode.

TIP: ──

> I choose E-TTL mode 90% of the time because it usually just works well.

Usually I shoot very close to my subjects, which means I'll be on the dance floor – no problem! Dancing along with your subjects as you take your photos can further increase the feeling for the viewer of what it felt like to be there. This is a great technique that is useful in many situations.

Ganging strobes

We've spoken about how you can use multiple light sources to build a compelling scene, lighting-wise, but I've also mentioned that for some applications, Speedlites aren't powerful enough. You might want to enhance the quality of the lighting in a scene in broad sunlight, for example, but you may have noticed that the sun is rather bright. So as a photographer, how do you deal with that?

One answer to enhancing bright sunlight might be to break out more powerful lighting equipment, but before you do, perhaps there is another solution… Sure, each individual Speedlite has only about 50 watt second worth of power, but why not put two next to each other? Or four? That would give you 100 (or 200, if you use four of them) watt seconds, with all the benefits of the Speedlites: High speed flash sync, perfect remote-controllability, and using the equipment you're most familiar with anyway!

Figure 7-6: If you need more light, you can gang your flashes together. If you need several flashes together in one place, using a IDC Triple Threat Flash Bracket can help you add more Speedlites to the same light stand.

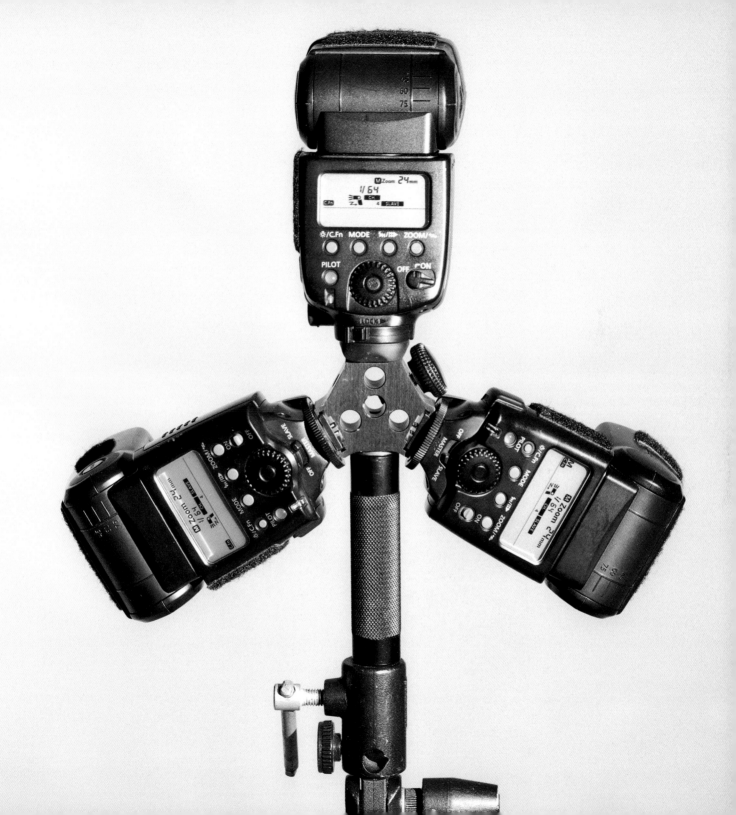

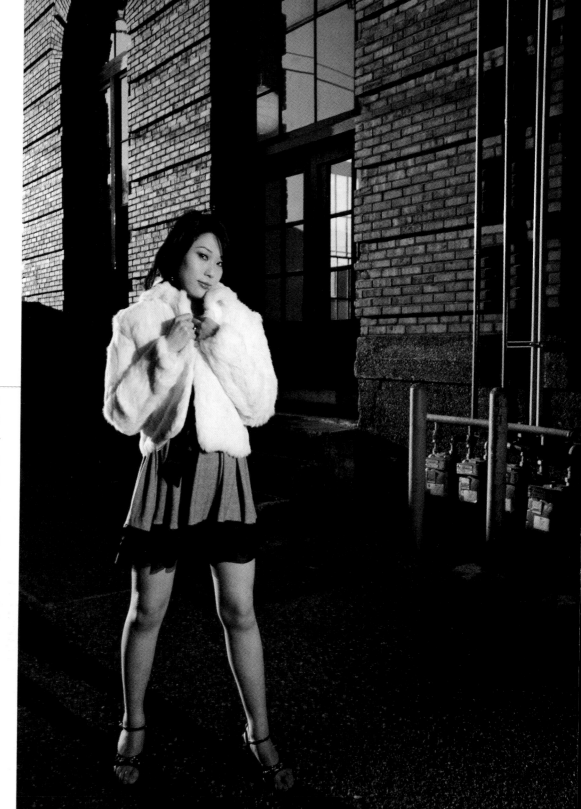

Figure 7-7: *If this photo had been taken without flash, the shadows under her chin would have been very dark and it would have been difficult to recognize her. By combining high-speed flash sync and Aperture Priority, this was averted! This photo was taken with a Canon EOS 5D Mark II, 24-105 IS lens at 32mm, 1/400 sec, f/4 and ISO 100, with -2 exposure compensation to darken the ambient exposure in Aperture Priority exposure mode.*

Using your strobes like this is called 'ganging' the Speedlites, and it works like a dream: You continue shooting photos like you always would, without having to change your workflow or think about bringing extra equipment. All you need is a couple of extra Speedlites!

High speed sync

When photographing outside on a bright sunny day, your subjects may have dark shadows under their eyes and nose as a result of the direct sunlight. As you know, you can control available light with your shutter speed – but if your flashes can't sync with your camera, you have a problem. Luckily, there is a solution. High-speed sync or FP ('Focal Plane sync') gives you the ability to take control and choose an aperture that will be effective for outdoor fill flash.

Figure 7-7 was taken with three Canon 580EX II Speedlites ganged together acting as one flash set to E-TTL II mode, using High Speed Sync, bare flash with no modifiers, triggered via Speedlite Transmitter ST-E2 with RadioPopper transmitter and receivers.

For a reminder on how High-Speed sync works, and why you might need it, turn back to Chapter 6, "Controlling the Light"!

High-speed flash sync allows you to choose a smaller aperture. In **Figure 7-7**, for example, I decided to use f/4, and setting the flash to High-Speed sync mode. The camera does the rest; it chooses the appropriate shutter speed. In this case, that was 1/400th of a second.

This ensures that the flash works within its effective range to fill in those shadows. It works like magic, and has the added benefit of adding little catch lights (a reflection of the flash – which makes eyes look more alive) to your subject's eyes, and to create the look I was striving for.

While shooting outside, high-speed sync has the benefit of providing you with greater control over your backgrounds. I find this very useful, as I always look for a clean, uncluttered background.

Creating light patterns

Most of the time, my shooting style is complementary. I like to add light that looks as if it fits in with the lighting and environment as-is. I rarely light a scene for flair, but tend to go for good-quality, aesthetically pleasing light.

Figure 7-8: Some times, you can get cool, creative effects by shooting your flash through something, to throw interesting shadows. In this case, the water glass and the model's hand are affecting the shape and pattern of the light, giving an interesting effect! This image was created using a Canon EOS 50D with a 24-70mm lens at 43mm at ISO 200, 1/200 of a sec. f/8 camera in Manual mode.

This photo was taken using two Canon 580EX II Speedlites in E-TTL II mode triggered with a Speedlite Transmitter ST-E2. One Speedlite was from camera left with a yellow gel. The light was aimed to shine through her fingers creating the shadow pattern on her face in group A and a second Speedlite was covered with a blue gel behind her in group B, with the ratio biased towards group A.

Having said that, sometimes the situation calls for more creative lighting, and it's possible to shape the light in unconventional ways to get a creative effect. You'll probably have seen photographs where light falls through a set of French blinds, for example, which gives a stark, striped light/shadow pattern.

If that is an esthetic you enjoy, don't stop at the time-worn flash-through-blinds cliché, however. The back of an ornate chair or a wicker basket can throw interesting patterns. Simply look around you and chances are you can find something to use to shape your light further!

Of course, nothing is stopping you from combining your knowledge of light to use several light shaping techniques at the same time. A softbox combined with a set of blinds gives a softer pattern, and a snoot combined with a second light shaper like the aforementioned wicker basket gives an entirely different pattern.

Remember that you don't have to limit yourself to just blocking light. A crystal chandelier

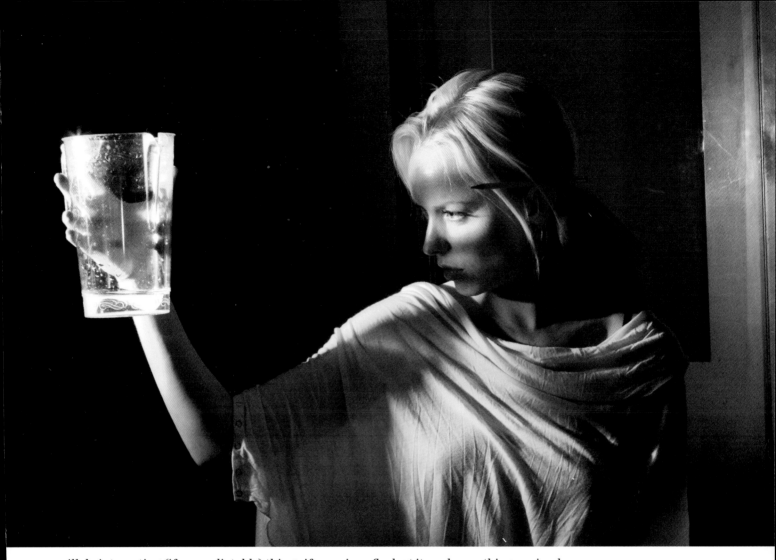

will do interesting (if unpredictable) things if you aim a flash at it, and something as simple as a hand holding a glass of water, as seen in **Figure 7-8**, can give equally ethereal results.

Once we have pulled out all the stops and are using everything we've learned about lighting, new creative techniques will start coming to you. This is the instinct we talked about would develop in Chapter 1. I often find myself walking into a room, and immediately start spotting ideas. I might think, "What if I point a flash at the cool architectural feature in the corner of the room?" I start composing the scene and the light in my mind the minute I am unpacking my lighting and photography gear. The trick is to think about the message you want to convey with a photograph. Once you know that, the lighting will fall into place.

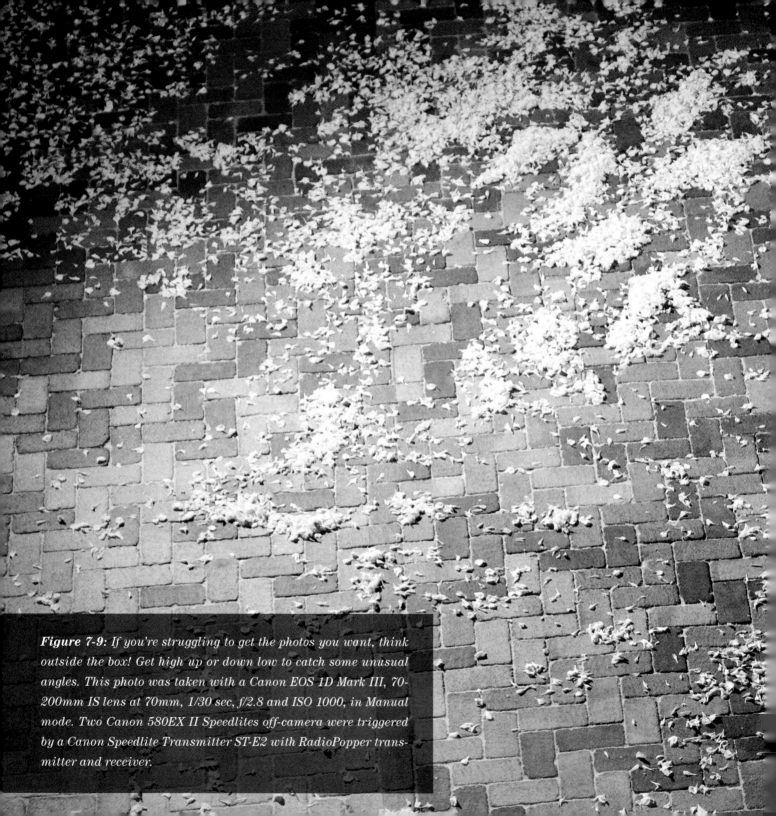

Figure 7-9: *If you're struggling to get the photos you want, think outside the box! Get high up or down low to catch some unusual angles. This photo was taken with a Canon EOS 1D Mark III, 70-200mm IS lens at 70mm, 1/30 sec, f/2.8 and ISO 1000, in Manual mode. Two Canon 580EX II Speedlites off-camera were triggered by a Canon Speedlite Transmitter ST-E2 with RadioPopper transmitter and receiver.*

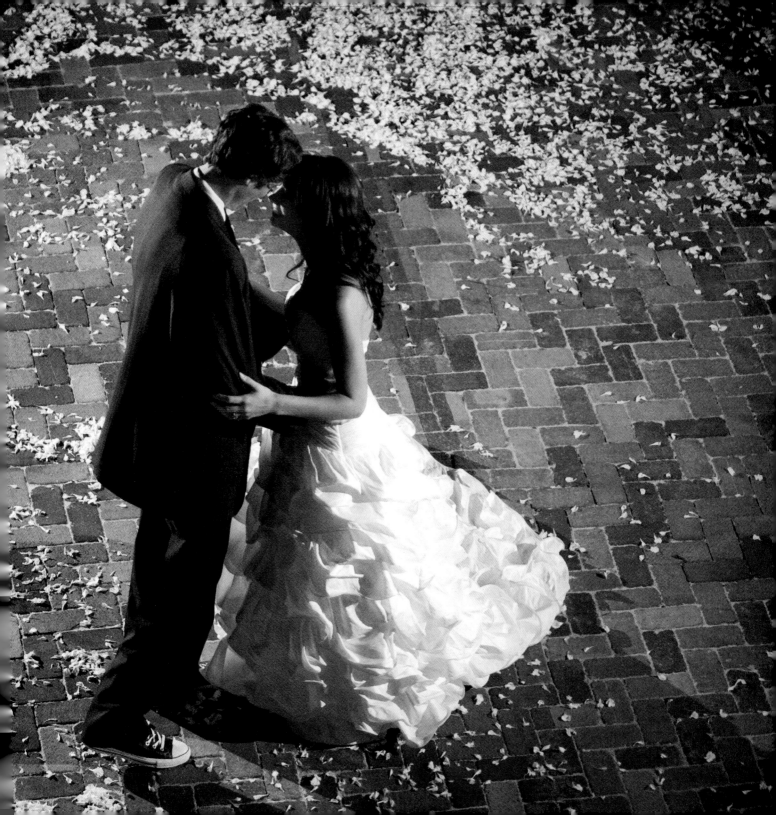

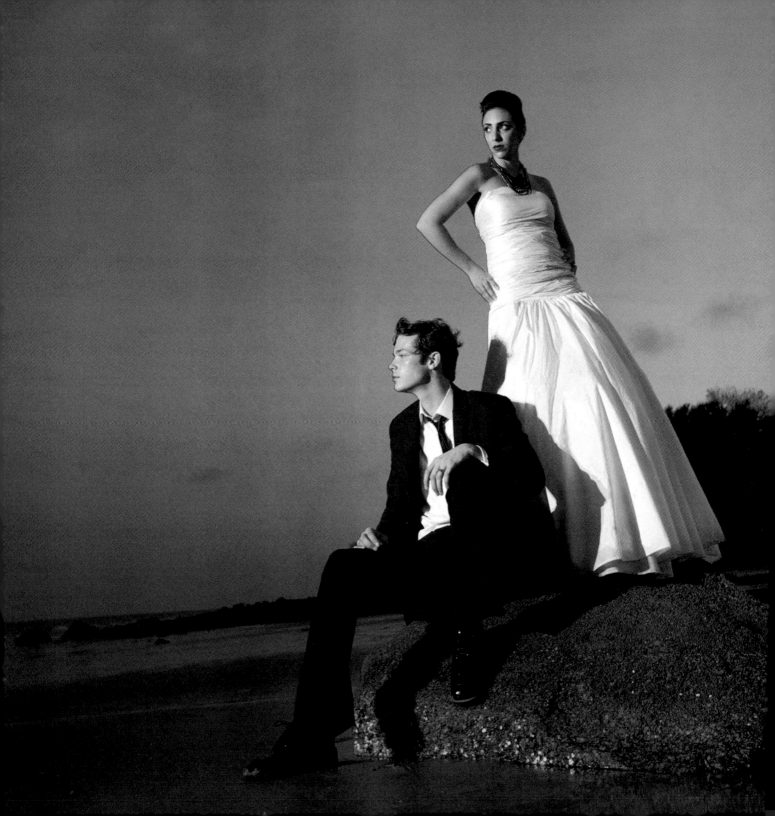

8

TRAVELING LIGHT

THE NATURE OF MY STYLE OF PHOTOG-
RAPHY MEANS THAT I AM CARRYING LESS
EQUIPMENT WITH ME THAN TRADITIONAL
STUDIO PHOTOGRAPHERS. One doesn't need the
huge batteries, lighting setups, or endless extension cords.
Working with Speedlites makes your luggage lighter and
smaller, but there are always opportunities for travelling
lighter still.

Figure 8-1: Taken just after sunset, this photo shows how you can really make the most of the mood offered by available light. This picture was taken with a Canon EOS 1D Mark III, 24-70mm lens at 24mm, 1/40 sec, f/4 and ISO 200, in Manual mode using one off-camera bare flash.

In this chapter, I'm looking at what you can do with a bare-bones setup that will fit in your hand-luggage while travelling. Finally, we will take a look at how you can use what you have at hand to become the MacGyver of lighting – it is incredible what you can achieve with a bit of ingenuity!

What's in your bag?

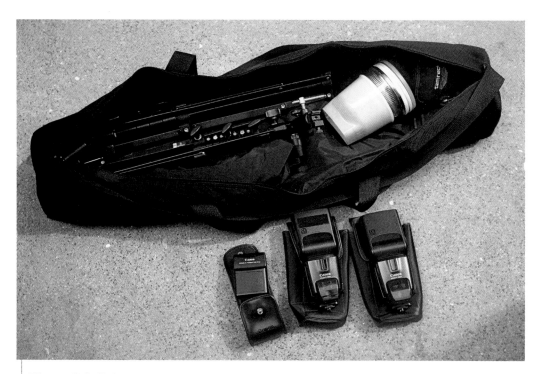

Figure 8-2: *This is a photo of my stripped-down lighting kit that goes with me just about everywhere. Even if I'm just headed to a family party with my Canon PowerShot G10, taking this simple bag still allows me the ability to shoot creatively.*

Even if the purpose of my travels isn't photography, I travel with a small set of photography equipment without exception. A camera, of course, always comes with me, but not always my SLR. I have been known to go to a family party with a point-and-shoot camera. It goes to show that with good lighting, it doesn't matter that much which camera you're shooting with.

I keep my small lighting kit in a tripod sling bag. Its contents are two Bogen Nano 001B (or 5001B) 6' Retractable Light Stands and two Manfrotto Swivel Umbrella Adapters with cold shoes. Alternatively, you could use the flash shoe that comes with your Canon or Nikon Speedlite with a ¼" nut in the bottom allowing it to be mounted on an umbrella adapter, a tripod, or light stand.

In addition, I bring with me a 43" collapsible optical white satin umbrella with removable black cover and a couple of Gary Fong Lightspheres. Of course, I need some flashes, so I bring along two Canon 580EX II Speedlites, and a Canon Speedlite Transmitter ST-E2 wireless transmitter. Invisible, but safely tucked into the bag, is a Manfrotto Spring Grip Clamp with attached flash shoe (often referred to as a Bogen 175F Justin Spring Clamp), which is basically a huge metal clothes peg with a shoe where you can attach a flash. It attaches nearly anywhere and works phenomenally well.

When I was on staff at the *Chicago Sun-Times Newspaper* this was my go-to everywhere lighting kit and it served me well.

Picking your equipment

The trick is to remember that most of the lighting equipment we're using in this book isn't bulky in itself. The items that take up the majority of space are the lighting stands, reflectors, umbrellas, and soft-boxes.

Instead of bringing your full light stands with you, you can use various ways of attaching your flashes to objects in your surrounding. It's easier, for example, to clamp a Speedlite to a tree on location with a bungee ball-cord, rather than having to carry a four pound lighting stand. So, you're going to need whatever technology you're comfortable with for the purpose of affixing your Speedlites to things. Mini tripods (like the Joby Gorillapod) can be lifesavers, but don't overlook simpler solutions. In remote locations, the Voice Activated Human Light-Stand (i.e. asking or paying someone to help you out for an afternoon) can prove valuable (and can lighten your packing load!). As previously mentioned, another great tool that I travel with is the 175F Justin clamp. It can be attached almost anywhere!

So, for your "traveling light lighting bag", pack a load of extra batteries. I recommend a high capacity MAHA / Powerex AA 2700mAh NiMH Rechargeable Batteries and a world charger that has dual voltage so it can be used anywhere in the world.

Get creative with your lighting accessories

It's worth remembering that most high-end portable strobes come with their own little feet. If you haven't found them yet, take a closer look in the pouch your Speedlites came in — there will be a little pouch by the rear flap, which contains a little foot.

I'll grant you, the little plastic foot doesn't look like much, but you'd be surprised how versatile those little feet can be. Slide your Speedlite into the plastic foot and suddenly you have a relatively sturdy base. Your Speedlite can swivel, tilt, and be used in all sorts of creative ways.

If you take a closer look, you'll see that the bottom of the flash foot has a screw thread in it. Does the size look familiar? Of course it does – it's the same size as the tripod thread at the bottom of your camera, which means you can attach your Speedlite to any tripod or camera accessory with a tripod thread. Armed with this knowledge, you've suddenly got a whole range of new possibilities for ad-hoc lighting opportunities.

There are hundreds of different solutions out there for fixing cameras in obscure places. You can buy clamps, large suction cups, mini-tripods, and flexible tripods (like the Joby Gorillapod), all of which fold down to relatively small sizes.

I'm also fond of bungee ball cords mentioned previously. They are like regular bungee cords, but instead of hooks, they have a small ball at the end of them. This makes it easy to secure the cord to things or to itself. You can hook several of them together if needed. I've even bungeed a couple of Speedlites together to get more flash output. Bring a few short ones with you; a few of them can be hooked together if you need longer ones. Plus they are perfect for attaching lighting to fixed objects. A tree, a fence-post, a car or the side of a building can instantly be turned into a lighting stand. If you can't find anything suitable on the location, pick up a few loose sticks, truss them together in the shape of a tripod, and hang your Speedlite off that. Your only limitation is your own imagination!

Duct tape also comes in handy here. Besides being remarkably useful for making emergency repairs to a Toyota Land Cruiser (or just about anything, really) in the middle of nowhere, it can be used for creating light stands, putting up ad-hoc reflectors, fashioning simple light-shapers (barn doors, etc) or even taping up your Speedlites for short periods of time. The keyword is creativity. As a Seeker of Light, you know where you need your light sources and which way they need to point. Whether you do this the easy way (through using commercial light stands) or the hard way (through a bit of clever engineering) is up to you. Always be prepared for the unexpected and no great image will ever be missed!

Of course, the same goes for light modifiers too. Many times I've used a paper plate or a folded piece of paper as a bounce card attached to my flash head with tape or a rubber band. There are tons of DIY solutions, but keep in mind that it is important to use the right tool for the right job. One particular situation that springs to my mind is when I was being especially creative on a location shoot, taping a Speedlite to the outside of a 6th floor window, to create the illusion of warm afternoon light. After two frames I noticed the flash was not firing. "Peculiar", I thought, and went to inspect the flash. Turns out that duct tape doesn't stick very well to cold steel, and my expensive strobe had plummeted six floors down.

TIP:
> Remember to fasten your camera and lighting equipment securely. Repairing or re-placing equipment is pricey. Hospital bills are even worse, so do be careful!

Getting the best from unknown locations

Now and then, you don't have the opportunity to take a look at a location ahead of time, but of course, you still want to capture great photos.

If I were on location and had to make a portrait with the bare-bones minimum equipment I would start off by ensuring I'm using all the light available to me to full effect. I would use my two Speedlites to accent my subject and I would employ whatever I had available as light modifiers.

Let's say I wanted to spotlight the subject's face. A toilet paper tube makes for a great directional light modifier, or 'snoot'. Place the paper tube over the flash head, tape it in place and block out all of the flash head that is not covered by the paper tube. It's not pretty, that's for sure, but nobody can see your camera in the picture anyway If it works, and the photos come out well, then that is all that matters.

Figure 8-3: The lighting really sets the mood for this shot, and it's quite incredible to think about that it was done with just two flashes!

Figure 8-3 was created with one Canon 580EX II Speedlite left of the camera with a Honl Photo snoot lighting his face in group A. One Canon 580EX II Speedlite on-camera right, in group C, with the – 3EV exposure value just adding some fill. Both flashes were in E-TTL II mode. The photo was taken with a Canon EOS 5D Mark II, 24-105mm f/4 IS lens at 82mm, 1/60 sec, f/4.5 and ISO 400, in Manual exposure mode.

With the main light in place, I would use my second flash as a large fill light. In a pinch a large manila envelope would work great, just remember your light will pick up the warmth from the color of the manila envelope. I would use a line of sight transmitter such as the Canon Speedlite Transmitter ST-E2 or Nikon SU 800 commander to fire my remote Speedlites via the built-in line of sight wireless communication feature.

Become the MacGyver of lighting. The final image might look something like **Figure 8-3**!

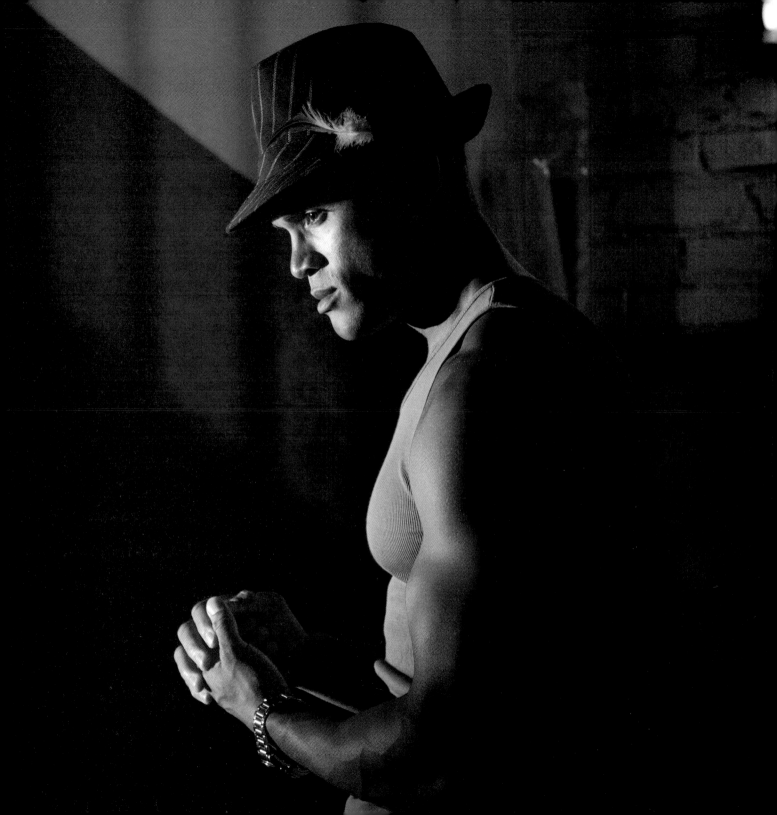

Preparing for the unexpected

One of my life rules is *"always be prepared."* I may not always have my full bag of lighting tricks, but I never leave home without the bare minimum to create the light I want.

In addition to my camera, memory cards, the traveling light bag mentioned previously, and a small assortment of lenses, here is the lighting equipment I always take with me when going to an unknown location to shoot:

- 16 high-capacity rechargeable batteries (I want a spare set of batteries ready to go and each flash takes four AA batteries)
- A battery charger
- A Honl Photo 7" Speed Snoot with Speed Strap, which has the additional bonus that you can use it as a bounce card
- A couple of bungee ball cords
- A roll of duct tape
- The flash shoe that comes with my flashes
- Plastic bags/covers for equipment
- Please end list format here
- With this simple set up I can create or compliment the light in any environment.

Dealing with the elements

Rain? Wind? A bit of snow? Many years as an editorial photographer has meant that postponing or cancelling shoots has been difficult or impossible. Then again, you shouldn't need to regardless of the weather. There is never a bad time to make good pictures, and I feel that weather adds to the drama of a photograph.

For a quick refresher on how radio triggers work in conjunction with your flashes, turn to Chapter 4, "Lighting Equipment".

Use common sense and protect your camera gear from the elements. There are rain covers on the market that will protect your camera and on-camera flash. Canon has done a very good job of weather proofing their pro-series camera bodies and the 580EX II Speedlites have rubber gasket around the hot shoe to protect it from the elements.

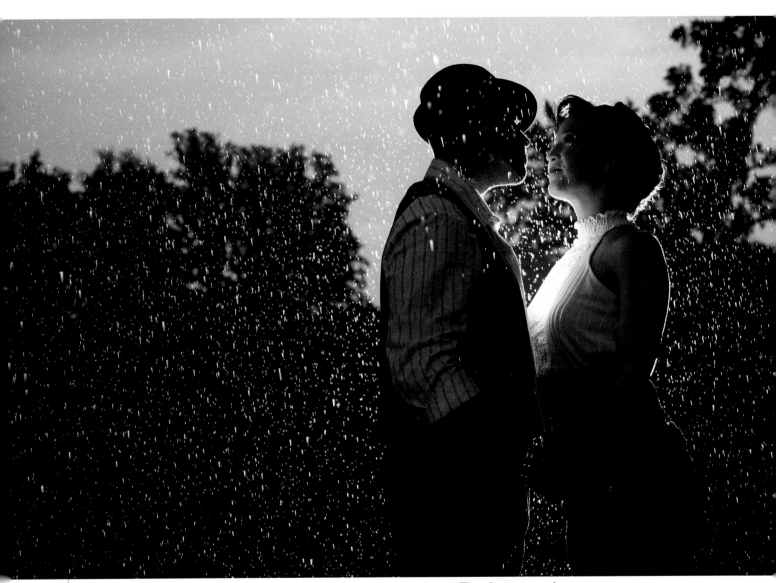

Figure 8-4: *This was a quick shoot as the rain began to pour down. The photo was taken with a Canon EOS 1D Mark III, 50mm lens, 1/250 sec, f/5 and ISO 320, in Manual exposure mode. I used a single Canon 580EX II bare flash, without light modifier. The flash was in E-TTL II mode, fired from an on-camera Canon 580EX II set as master. The flash was just used as trigger, and I used a RadioPopper transmitter and receiver to ensure the flashes triggered correctly. Line of sight would not work well in this setting for three reasons: the flash was behind the subjects, it's raining and it was bright daylight.*

For **Figure 8-4**, I placed plastic bags around my Speedlites using rubber bands to protect them from the rain. When you are taking pictures with your flashes in bags, you will probably need to use a radio trigger such as RadioPopper, as the bags can interfere with the communication signal. It's also worth noting that radio triggers are not waterproof, so make sure they are well protected.

Figure 8-5: Bad weather is not an excuse to stay indoors. You may even be able to use the weather to your advantage, just look at the drama in this photo!. This photo was taken with a Canon EOS 1D Mark IV, 70-200mm lens, lens at 125mm, 1/60 sec, f/3.2 and ISO 8000, in Manual exposure mode.

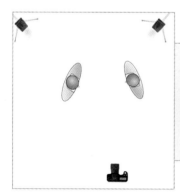

Figure 8-5 was taken with two Canon 580EX II flashes set to E-TTL II mode, triggered via a Canon Speedlite Transmitter ST-E2 with RadioPopper transmitter and receivers.

I love the back–lighting I used to make my subjects pop in **Figures 8-4** and **8-5**. In these two weather-related pictures, I chose to back light them both to highlight the falling rain in one and snow at night in the other.

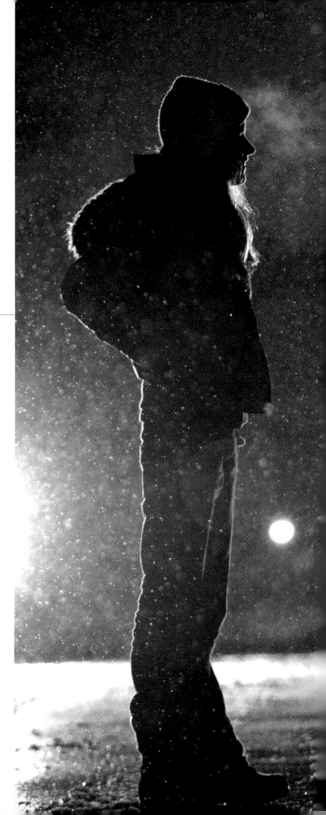

Figure 8-6: This photo was taken just as a huge storm was about to start. My assistant had to hang off the softbox to keep it aimed in the right direction. The photo was taken with a Canon EOS 5D Mark II, 85mm lens, 1/15 sec, f/5.6 and ISO 200, in Manual exposure mode.

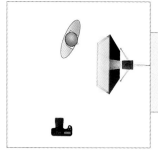

Figure 8-6 is taken with 1 – Quantum Qflash T5d-R with a QNexus module flash set to Canon E-TTL mode, triggered via a Canon Speedlite Transmitter ST-E2 line of sight.

Wind is a big factor when you are on location and you are using a large light modifier such as big reflector or softbox. I remember one fateful shoot where I had to use sand bags to hold down the light stand and an assistant to keep the softbox from taking flight. The problem is that huge lighting equipment is relatively light-weight, so essentially it is like a big sail catching the wind blowing across a sea. Even the mildest breeze can take your entire lighting rig for a ride like Auntie Em's house in the *Wizard of Oz*. For **Figure 8-6**, my assistant kept the softbox in place while I shot fast.

When travelling light, don't forget to pack your common sense – it has saved me many times from my own creative lighting ideas. Make sure you live to take another picture. Safety always comes first, so I will not be shooting with a softbox in a storm, nor will I be shooting if there is lightning! I like my photo shoots to be exciting, but getting hit by lightning might be a little bit on the extreme side, even for me.

When you are a photographer, it is all about creativity coupled with technical skills. Don't be shy about either of them – if you need to invent something on the spot to get the photos you want, break out the Leatherman tool and the gaffer tape. Don't let anything get between you and a great photo. Good luck!

Figure 8-7: This photo was taken with a Canon EOS 1Ds Mark III, 24-70mm lens at 54mm, 1/140 sec, f/4 and ISO 1600, in Manual mode. Three Canon Speedlites, one on-camera as the master and two at the altar, all in E-TTL II mode, were triggered via the master flash using RadioPopper transmitter and receivers.

APPENDIX A

GLOSSARY

Figure A-1: *Seek the ambient light and then add your own to not miss the shot. This photo was taken with a Canon EOS 1D Mark III, 70-200mm IS lens at 70mm, 1/30 sec, f/2.8 and ISO 1000, in Manual mode. Two Canon 580EX II Speedlites off-camera were triggered with a Canon Speedlite Transmitter ST-E2 with RadioPopper transmitter and receiver.*

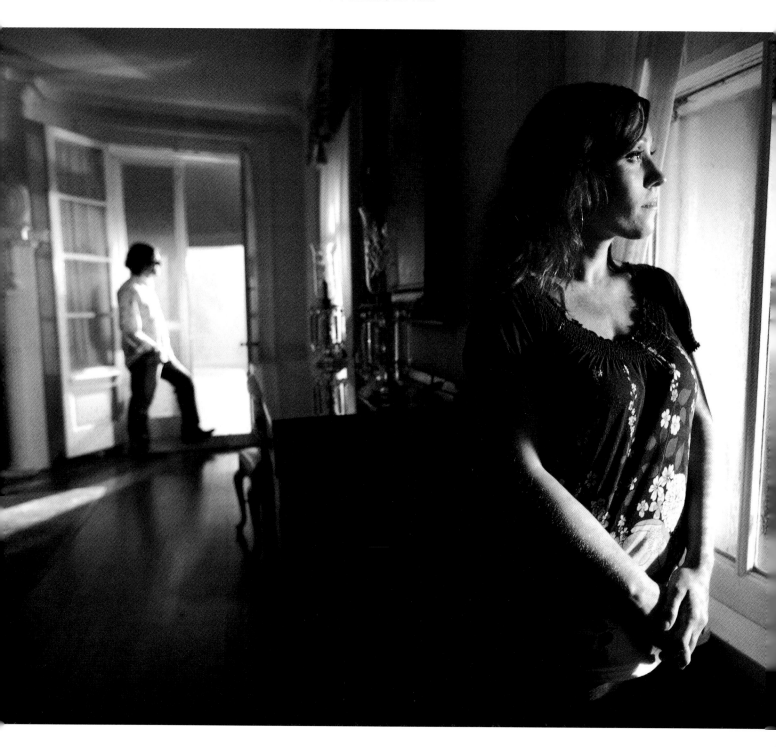

Figure A-1: If there is no light, don't fret. Make your own! This photo was taken with a Canon EOS 5D Mark II, 16-35mm f/2.8 lens at 23mm, 1/13 sec, f/4 and ISO 400, in Manual exposure mode.

Figure A-1 was created using two Canon 580EX II Speedlite One flash was in group A with the bulk of the power biased towards the A flash. While shooting, I zoomed in the flash head to 105mm to narrow the focus of light creating the long hard shadow. I placed the second flash outside the window of the girl in the foreground; this flash was in group B. All Speedlites had a ¼ CTO gel to warm them up like afternoon sunlight and all were in E-TTL II mode, without modifiers. The lights were triggered via a Canon STE-2 wireless transmitter and RadioPopper transmitter and receivers.

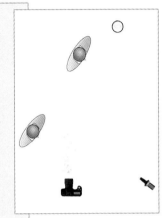

When life gives you lemons, make lemonade. That's as true for life in general as for photography. I recently did a shoot where it began to rain like cats and dogs and the light quickly faded into near darkness. "You can't publish an excuse," I thought, and decided to create my own afternoon sunset light. A couple of Speedlites later, and **Figure 9-1** was a reality. I placed one flash outside in the rear of the frame to light the man in the doorway and a second Speedlite to light the woman in the foreground. There was no natural light coming into this scene; it's all from my Speedlites.

GLOSSARY

AEB – common abbreviation for auto exposure bracketing

Adobe – a software company whose products include Adobe Photoshop, a popular image editing suite, and Adobe Photoshop Lightroom, software aimed at photographers wishing to improve their workflow

Apple Aperture – a piece of software designed by Apple, aimed at photographers wishing to improve their workflow

auto exposure – letting the light-meter in the camera determine which shutter speed and aperture should be used for a given scene

auto exposure bracketing – when using AEB, the camera will take multiple photos in succession with slightly different exposure settings, in an effort to hedge the photographer's bets against the camera's internal light meter measuring the lighting conditions wrong

auto focus – when using automatic focus, the subject in front of the camera lens is brought into focus by letting the camera determine when the subject is sharpest; achieved by electrical motors in the camera or lens

back lighting – lighting a subject from the back

bayonet fitting – a quick-release fitting to attach a lens to a camera, common on all current SLR cameras; the alternative, a screw fitting, is no longer used in modern cameras

bokeh – the shape and quality of the out-of-focus highlights in an image, usually in the background

camera RAW – a lossless file format like TIFF; unlike other file formats, camera RAW saves all the data available to the imaging chip, which means you have more unprocessed photo data to work with in your digital darkroom

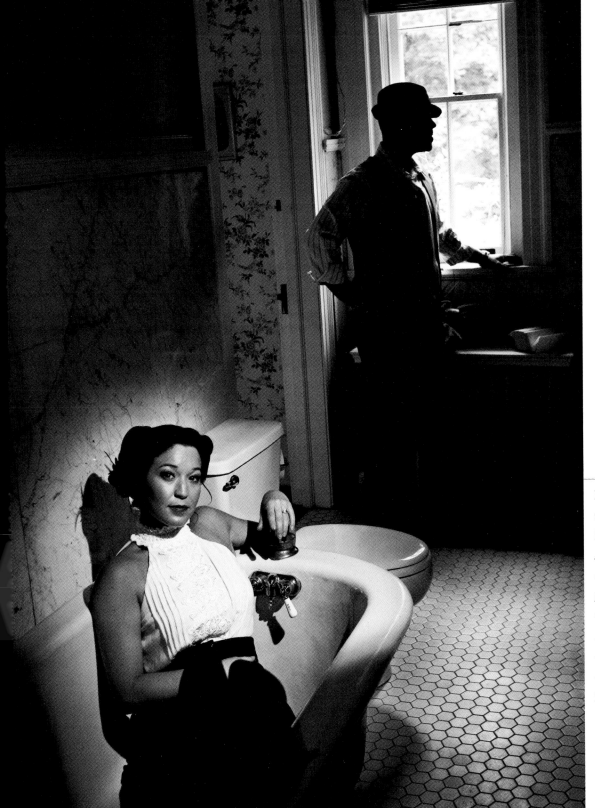

Figure A-2: *If there is no useful light, you just have to make your own. All the light in this photo comes from flashes. This photo was taken with a Canon EOS 1D Mark III, 16-35mm f/2 8 lens at 34mm, 1/50 sec, f/4 and ISO 400, in Manual exposure mode.*

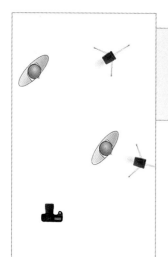

Figure A-2 used just one Speedlite and the available light entering through the window. One Canon 580EX II Speedlite was equipped with a Honl Photo Speed Snoot, 5" shorty high positioned camera right. The flash was triggered via the Canon ST-E2 wireless transmitter and RadioPopper transmitter and receiver.

catchlight – a small dot of white in somebody's eye; gives your model a 'glint' in the eye that, while not being natural, often makes a photo look more natural than if omitted

CCD chip – "charged coupling device;" an imaging chip used in many digital cameras; records the light that comes through the lens and replaces film; other imaging chips can be CMOS

contrast – an image with distinct difference between its brightest and its darkest point has high contrast

CMOS chip – "complementary metal–oxide semiconductor;" an imaging chip used in many digital cameras; records the light that comes through the lens and replaces film; other imaging chips can be CCD

CR2 – a camera RAW file

continuous lighting – the opposite of flash lighting; desk lamps, flood lights, and the sun are examples of continuous lighting

crop factor – because imaging chips in cameras are generally smaller than 35mm film, lenses used on dSLR cameras take on different characteristics when mated with a dSLR camera; a Canon EOS Digital Rebel Xti, for example, has an imaging chip which is 22.2 x 14.8mm in size; this is the equivalent of a 1.6x crop factor, so a 50mm lens on this camera would be the equivalent of an 80mm lens on a 35mm camera

depth of field – the amount of an image that is in focus is known as DOF; shallow depth of field means little of the image is in focus; deep DOF means more of the image is in focus

diffuser – a photography prop used to make light appear less harsh; when light shines through a diffuser, the light source appear bigger, and hence 'softer'

digital camera – a camera that uses an imaging chip instead of film to capture a photograph

digital darkroom – a term referring to the act of using digital image manipulation software to retouch, adjust, and manipulate images; much like you would do in the darkroom of times gone by

directional light – light that comes from a particular direction — like direct sunlight, or flash light — is known as directional; if light comes from many directions at once, such as sunlight diffused through clouds, it's known as omni directional

display – refers to the small LCD monitor on the back which allows you to preview your images

dSLR – digital SLR camera — see SLR

dynamic range – the range of shades an imaging chip or film can capture between perfect black and pristine white; to fully utilize the full dynamic range of a camera, shoot in RAW mode, as a JPEG file cannot save the full set of colors captured by a camera

E-TTL – "evaluative through the lens"; a way of measuring flash lighting; uses a pre-flash which measures how light is reflected off your subject, which is used to calculate how powerful the flash needs to be in order to get a good exposure

exposure – the combined settings of aperture, shutter speed, and ISO setting used when taking a photograph is the exposure of that photograph

exposure bracketing – see auto exposure bracketing

fill flash – a technique used primarily outdoors and in other brightly-lit areas, where you use the flash to reduce heavy shadows, making your subject stand out more compared to the background

filter – term used in two different ways: typically refers to glass items that screw into the front of a lens and change the quality of the light; can also apply filters in a software package, such as Photoshop

fixed focus lens – a lens that cannot change focal length; see prime lens

flash – a single-strobe light used in photography

flash gun – a highly portable flash system, often designed to attach to the hot shoe of a camera

focal distance – see focal length

focal length – the distance light has to travel between the front lens element and the film or imaging chip, measured in millimeter

focal plane – an imagined plane where all points are in focus with a given lens When working with macro photography, if you wish, say, a leaf to be in focus, it has to be in parallel with your imaging chip or film in the camera, along the focal plane; see chapter 5 for more information

focus – focusing a lens means that it is adjusted in order to concentrate light to give a sharp image on the imaging chip or film of a camera

gel – a piece of colored plastic or polyester used in front of a light source to change its color; A 'warming gel', for example, can add more red tones to the light

golden hour – the hour just after sunrise or just before sunset, so named after the warm quality of the sunlight

gray card – a piece of plastic or cardboard that is calibrated to an exact, 18% neutral gray It allows you to do light measurements and white balance measurements

histogram – a function present on many cameras, giving a graph representing the gray-values of a photograph; useful for trouble-shooting exposure problems

honeycomb filter – a studio flash attachment for creating directional light named for its shape

hot-shoe – the metal connector on top of all SLR and some digital compact cameras that allows you to connect an external flashgun or remote trigger

incandescent light – light from light bulbs

imaging chip – a light-sensitive chip that converts light into electrical signals Used instead of film in digital cameras; see CCD and CMOS

JPEG – a Joint Photographic Experts Group file is a 'lossy' image file format; smaller than TIFF and camera raw files, but due to its compression algorithms, subsequent open-edit-save procedures degrade the image quality; most digital cameras can save images in JPEG format, as it is seen as a good trade-off between quality and file size

JPG – a shortened version of JPEG, usually used as a file extension .jpg

LCD display – a liquid crystal display is often found on the back of digital cameras for framing and previewing images

manual focus – manually adjusting a lens by adjusting a focusing ring in order to bring your subject into focus; also see automatic focus

memory card – a card that holds the images you photograph; available in different sizes from 64MB to 16GB; replace the storage element of film in digital cameras

noise – "digital noise" in an image manifests itself as specks of brightness throughout an image; especially prevalent at higher ISO settings and at slow shutter speeds

optical zoom – zoom achieved by the use of optical elements in a zoom lens; distinction exists because of the inclusion of digital zoom on many digital compact cameras

PC connector – a PC Sync connector is a way to connect a system camera to an external flash system, often used in studio flash setup; it looks like two small concentric circles

Photoshop – the industry-standard professional digital image manipulation package; currently in version CS4 ; an easier-to-use and vastly cheaper consumer version is called Photoshop Elements

pixel – a single dot of color and brightness information; camera resolutions are often measured in megapixels (mpx), which is an increment of 1,000 pixels

post production – everything that happens to a photograph after it the shutter has closed: in-camera processing, digital darkroom and printing work

prime lens – lenses that have only a single focal length; generally provide high quality and low price, compared to their zoom lens counterparts; most common focal lengths are 28mm, 50mm, 85mm and 100mm; also known as a fixed focal lens

reflector – a photography prop used to reflect light

RAW – a RAW file is a camera raw file

RGB – common abbreviation for red, green, and blue, three normal color channels used in digital image manipulation; the other oft-used acronym is CMYK, which is used for print work

shutter speed – The amount of time that a shutter is open during an exposure

SLR – Single Lens Reflex camera; a type of system camera that uses a single lens connected to a camera body; focusing and framing is done via the lens, during which you look through a prism and a mirror; currently, most SLR cameras on sale are digital SLR cameras, known as dSLR

snoot – a cone-shaped attachment with a hole in the end, used for aiming light from studio flash light sources

specular highlight – a small dot of bright white on a subject, such as a catchlight, usually from a reflected flash

Speedlite – a highly portable flash – perfect for on-location photography

TIFF – a tagged image file format (also known as tiff or tif) file is a lossless image file; larger in size than a JPEG file, but allow you to save and open the file as many times as you like without degrading image quality

TTL – "through the lens" — a flash technology where the camera measures the actual flash output as seen by the lens

vignette/vignetting – in some circumstances, filters or lenses can shield light along the corners of the frame, which makes the corners look slightly darker than the rest of the image

washing out – white area in an overexposed image

white balance – a way to tell your camera which color is supposed to be 'white'; See chapter 5 for more in-depth discussion on white balance

white balance bracketing – an in-camera setting that saves a captured image several times, with several preset white balance settings;

zoom lens – a photographic lens that has more than one possible focal length, such as 28-135mm; opposite of prime lens

APPENDIX B

WEBSITES
WORTH VISITING

Figure B-1: *This is our new puppy Hunter. The picture was taken with a Canon EOS 5D Mark II, 15mm f/2.8 fisheye lens, 1/125th of sec, f/5.6 and ISO 250. The on camera flash was a Canon 580EX II in E-TTL II mode using a Ray Flash ring flash light modifier. Using the Fisheye lens allows you to see the glow from the Ray Flash ring flash giving it this unique look.*

Recommended websites

Bob & Dawn Davis

I invite you to come have a look at my own websites. I keep a blog with some of my most recent photo projects on *bobanddawndavis.info*. There is a site especially for photographers wanting to learn more in our workshops on *davisworkshops.com* – and please do feel free to look us up on Facebook: *tinyurl.com/BobDawnFacebook*

Canon Flash Work

The Canon Flash Work site is a collection of tips, techniques, and photos aimed at explaining and exploring the technology of Canon's Speedlite flash technology. By the time you've finished this book, you're probably beyond the scope of this site, but it's a good refresher either way! *web.canon.jp/imaging/flashwork*

Joe McNally

I'm a big fan of McNally's work. He works with equipment and techniques similar to mine and keeps me on my toes with his creative and fresh approach to lighting. *www.joemcnally.com/blog*

The Strobist

David Hobby keeps a blog called the Strobist, which focuses on everything to do with Speedlite photography, including everything from basic introductions to technical discussions. Check out his blog on *strobist.blogspot.com*. Also have a look at the Strobist group on Flickr as well at *flickr.com/groups/strobist*. This is a collection of photos taken by readers of the Strobist blog. Such a blog can be a source of inspiration when you feel you're ready for new challenges with your current lighting setup!

Equipment manufacturers

Radio triggers

Radiopopper
Radiopopper.com

Pocket Wizard Flex & Mini
Pocketwizard.com

Quantum Free X-wire
tinyurl.com/FreeXWire

Flashes

Canon
tinyurl.com/CanonSpeedlites

Quantum Qflash
tinyurl.com/QuantumQFlash

Nikon
tinyurl.com/NikonFlashes

Camera Bags

ThinkTankPhoto
www.thinktankphoto.com

Light Modifiers

Bruce Dorn IDC Photo Video
http://www.idcphotovideo.com/

Gary Fong Lightsphere
tinyurl.com/GaryFongLS

FJ Westcott
tinyurl.com/FJWestcott

Honl Photo
honlphoto.com

Light Stands:

Bogen Manfrotto Nano stands
tinyurl.com/NanoStand

Bogan Manfrotto Umbrella adapter
tinyurl.com/BMUmbrella

Magic Slipper
tinyurl.com/MSlipper

Stroboframe Universal Shoe Mount
tinyurl.com/SUSMount

Adorama Accessory Flash Shoe with PC socket & test button
adorama.com/FAS.html

DVD APPENDIX

Lighting, by its very nature, is hard to describe or illustrate in a two dimensional format. It is not enough to merely explain it all with words, without showing you how lighting works in a three dimensional space. In order to fulfill this need for more dynamic examples, we have provided a DVD with examples of Bob's techniques as taught at one of his recent workshops. You'll not only hear Bob teach students in a classroom setting, but you'll see him put the very techniques you've been reading about into action in real world settings. The DVD starts with a brief introduction into the world of a Bob Davis lighting workshop and then delves further into putting Bob's theories and techniques into practice.

INTRODUCTION:
- Get to know Bob
- See example shoots
- Hear feedback from Bob's workshop participants

BEHIND THE WORKSHOP:
- Behind the scenes looks at a renowned Bob Davis workshop

SEEKER OF LIGHT:
- Hear Bob's overall theory on lighting
- Learning to "see the light"

EVOLUTION OF LIGHT:
- Examples of video that can be made during the getting ready stage

ETTL vs. MANUAL:
- Understanding ETTL
- Learning the nuts and bolts of flash modes

SETTING UP STROBES:
- Discover Bob's suggestions for setting up strobes

HIGH SPEED FLASH SYNC:
- Learn the benefits of high speed flash sync and when to use it

MASTERING CAMERA MODES:
- Choosing the best camera mode

READING THE HISTOGRAM:
- Identify whether your images are appropriately exposed using a histogram

LESSONS LEARNED:
- Summary of lessons learned

CREDITS

System Requirements

Make sure that your computer meets the minimum system requirements listed in this section. If your computer doesn't match up to most of these requirements, you may have a problem using the contents of the DVD.

- PC running Windows 98 or later or a Macintosh running Mac OS X
- An Internet connection
- A DVD drive

Using the DVD

To access the content from the DVD, follow these steps.

1. Insert the DVD into your computer's DVD drive.

 Note to Windows users: The DVD won't automatically play if you have autorun disabled. In that case, click Start–>Computer (or My Computer), and then double-click the LightsCameraCapture icon. (In Windows Vista and Windows 7, the icon appears in the Devices with Removable Storage category).

 Note for Mac Users: By default, DVD Player automatically opens and displays the disc's DVD menu screen. If your computer is configured differently, double-click the LightsCameraCapture DVD icon that appears on your desktop after inserting the disc.

Troubleshooting

If you have difficulty installing or using any of the materials on the companion DVD, try the following solutions:

- Turn off any anti-virus software that you may have running. Installers sometimes mimic virus activity and can make your computer incorrectly believe that it is being infected by a virus. (Be sure to turn the anti-virus software back on later.)
- Close all running programs. The more programs you're running, the less memory is available to other programs. Installers also typically update files and programs; if you keep other programs running, installation may not work properly.
- Reference the ReadMe: Please refer to the ReadMe file located at the root of the DVD for the latest product information at the time of publication.

Customer Care

If you have trouble with the DVD, please call the Wiley Product Technical Support phone number at (800) 762-2974. Outside the United States, call 1(317) 572-3994. You can also contact Wiley Product Technical Support at http://support.wiley.com. John Wiley & Sons will provide technical support only for installation and other general quality control items. For technical support on the applications themselves, consult the program's vendor or author.

To place additional orders or to request information about other Wiley products, please call (877) 762-2974.

Wiley Publishing, Inc.
End-User License Agreement

READ THIS. You should carefully read these terms and conditions before opening the software packet(s) included with this book "Book". This is a license agreement "Agreement" between you and Wiley Publishing, Inc. "WPI". By opening the accompanying software packet(s), you acknowledge that you have read and accept the following terms and conditions. If you do not agree and do not want to be bound by such terms and conditions, promptly return the Book and the unopened software packet(s) to the place you obtained them for a full refund.

1. **License Grant.** WPI grants to you (either an individual or entity) a nonexclusive license to use one copy of the enclosed software program(s) (collectively, the "Software") solely for your own personal or business purposes on a single computer (whether a standard computer or a workstation component of a multi-user network). The Software is in use on a computer when it is loaded into temporary memory (RAM) or installed into permanent memory (hard disk, CD-ROM, or other storage device). WPI reserves all rights not expressly granted herein.

2. **Ownership.** WPI is the owner of all right, title, and interest, including copyright, in and to the compilation of the Software recorded on the physical packet included with this Book "Software Media". Copyright to the individual programs recorded on the Software Media is owned by the author or other authorized copyright owner of each program. Ownership of the Software and all proprietary rights relating thereto remain with WPI and its licensers.

3. **Restrictions on Use and Transfer.**

 (a) You may only (i) make one copy of the Software for backup or archival purposes, or (ii) transfer the Software to a single hard disk, provided that you keep the original for backup or archival purposes. You may not (i) rent or lease the Software, (ii) copy or reproduce the Software through a LAN or other network system or through any computer subscriber system or bulletin-board system, or (iii) modify, adapt, or create derivative works based on the Software.

 (b) You may not reverse engineer, decompile, or disassemble the Software. You may transfer the Software and user documentation on a permanent basis, provided that the transferee agrees to accept the terms and conditions of this Agreement and you retain no copies. If the Software is an update or has been updated, any transfer must include the most recent update and all prior versions.

4. **Restrictions on Use of Individual Programs.** You must follow the individual requirements and restrictions detailed for each individual program in the "About the CD" appendix of this Book or on the Software Media. These limitations are also contained in the individual license agreements recorded on the Software Media. These limitations may include a requirement that after using the program for a specified period of time, the user must pay a registration fee or discontinue use. By opening the Software packet(s), you agree to abide by the licenses and restrictions for these individual programs that are detailed in the "About the CD" appendix and/or on the Software Media. None of the material on this Software Media or listed in this Book may ever be redistributed, in original or modified form, for commercial purposes.

5. **Limited Warranty.**

 (a) WPI warrants that the Software and Software Media are free from defects in materials and workmanship

under normal use for a period of sixty (60) days from the date of purchase of this Book. If WPI receives notification within the warranty period of defects in materials or workmanship, WPI will replace the defective Software Media.

(b) WPI AND THE AUTHOR(S) OF THE BOOK DISCLAIM ALL OTHER WARRANTIES, EXPRESS OR IMPLIED, INCLUDING WITHOUT LIMITATION IMPLIED WARRANTIES OF MERCHANTABILITY AND FITNESS FOR A PARTICULAR PURPOSE, WITH RESPECT TO THE SOFTWARE, THE PROGRAMS, THE SOURCE CODE CONTAINED THEREIN, AND/OR THE TECHNIQUES DESCRIBED IN THIS BOOK. WPI DOES NOT WARRANT THAT THE FUNCTIONS CONTAINED IN THE SOFTWARE WILL MEET YOUR REQUIREMENTS OR THAT THE OPERATION OF THE SOFTWARE WILL BE ERROR FREE.

(c) This limited warranty gives you specific legal rights, and you may have other rights that vary from jurisdiction to jurisdiction.

6. Remedies.

(a) WPI's entire liability and your exclusive remedy for defects in materials and workmanship shall be limited to replacement of the Software Media, which may be returned to WPI with a copy of your receipt at the following address: Software Media Fulfillment Department, Attn.: Lights, Camera, Capture: Creative Lighting Techniques for Digital Photographers, Wiley Publishing, Inc., 10475 Crosspoint Blvd., Indianapolis, IN 46256, or call 1-800-762-2974. Please allow four to six weeks for delivery. This Limited Warranty is void if failure of the Software Media has resulted from accident, abuse, or misapplication. Any replacement Software Media will be warranted for the remainder of the original warranty period or thirty (30) days, whichever is longer.

(b) In no event shall WPI or the author be liable for any damages whatsoever (including without limitation damages for loss of business profits, business interruption, loss of business information, or any other pecuniary loss) arising from the use of or inability to use the Book or the Software, even if WPI has been advised of the possibility of such damages.

(c) Because some jurisdictions do not allow the exclusion or limitation of liability for consequential or incidental damages, the above limitation or exclusion may not apply to you.

7. U.S. Government Restricted Rights. Use, duplication, or disclosure of the Software for or on behalf of the United States of America, its agencies and/or instrumentalities "U.S. Government" is subject to restrictions as stated in paragraph (c)(1)(ii) of the Rights in Technical Data and Computer Software clause of DFARS 252.227-7013, or subparagraphs (c) (1) and (2) of the Commercial Computer Software - Restricted Rights clause at FAR 52.227-19, and in similar clauses in the NASA FAR supplement, as applicable.

8. General. This Agreement constitutes the entire understanding of the parties and revokes and supersedes all prior agreements, oral or written, between them and may not be modified or amended except in a writing signed by both parties hereto that specifically refers to this Agreement. This Agreement shall take precedence over any other documents that may be in conflict herewith. If any one or more provisions contained in this Agreement are held by any court or tribunal to be invalid, illegal, or otherwise unenforceable, each and every other provision shall remain in full force and effect.

Index

Symbols

A

B

D

E

S

Z